Kathleen Raine,
poet and critic, was born in 1908 and
educated at Girton College, Cambridge. She has loved Blake
throughout her long and distinguished literary career, and her
A. W. Mellon Lectures in Washington in 1962, which
became the basis of her two-volume study *Blake and Tradition*
(1968), played a vital part in establishing that Blake, pre-
viously known mainly as a self-taught eccentric, belongs to a
long and coherent tradition of Platonic, hermetic and
mystical thought. She has written a number of books of
poetry, and her second volume of *Collected Poems* appeared in
1981. Her other books include *From Blake to a Vision* (1979),
Blake and the New Age (1979), *The Human Face of God: William
Blake and the Book of Job* (Thames and Hudson, 1982)
and three volumes of autobiography.

WORLD OF ART

This famous series
provides the widest available
range of illustrated books on art in all its aspects.
If you would like to receive a complete list
of titles in print please write to:
THAMES AND HUDSON
30 Bloomsbury Street, London WC1B 3QP
In the United States please write to:
THAMES AND HUDSON INC.
500 Fifth Avenue, New York, New York 10110

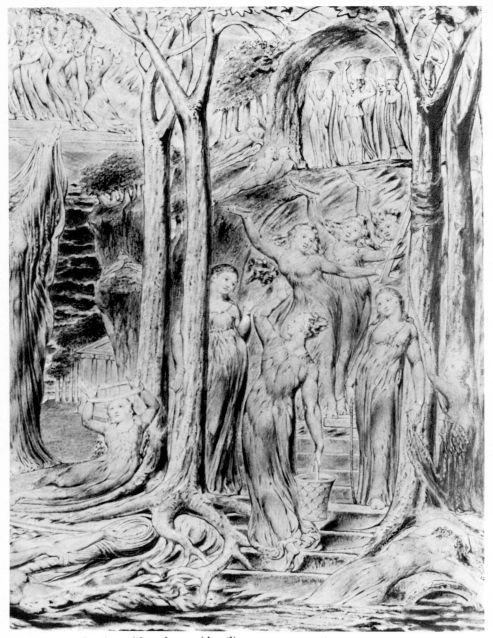

1 *De Antro Nympharum* (detail), 1821

William Blake

KATHLEEN RAINE

156 illustrations, 28 in color

THAMES AND HUDSON

To Kerrison Preston,
honoured friend and interpreter to all
who come to learn from Blake

© *1970 Thames and Hudson Ltd, London*

*Published in the United States in 1985 by
Thames and Hudson Inc., 500 Fifth Avenue,
New York, New York 10110
Reprinted 1988*

Library of Congress Catalog Card Number 88-50882

*Printed and bound in Spain by
Artes Graficas Toledo S.A.
D.L. TO−1302−1988*

Contents

Introduction

Prophet, poet, painter, engraver – and according to tradition a composer of melodies as well – Blake's unique greatness lies in no single achievement, but in the whole of what he was, which is more than the sum of all that he did. It belongs to a few great imaginative minds that they can create a world which seems to possess a reality, a coherence, a climate and atmosphere of its own. Shakespeare, Dante, Dürer, Blake's own favourite painters Fra Angelico, Claude and Michelangelo, seem to offer us fragments of worlds whose bounds extend beyond any of those portions their work has embodied; and that is one of the delights of the kind of art I have in mind. Blake was such an artist; and his work, as he believed, represents 'portions of eternity' seen in imaginative vision. Blake himself writes of 'ever Existent Images' which may be seen 'by the Imaginative Eye of Every one according to the situation he holds' – a collective archetypal world whose reality is more credible in our century than it was in his own. 'To different People it appears differently, as everything else does.' Such art comes from a source deeper than the individual experience of poet or painter, and has a power of communication to that same level in the spectator. To our superficial selves this is a source of the 'obscurity' of visionary art; to our deepest selves, of its lucidity.

Blake's work is on a small scale. His engravings and illuminated pages are measurable in inches; his paintings too tend to be small. But though he executed nothing monumental, his imaginings were on the grandest scale. 'The Artist having been taken in vision into the ancient republics, monarchies and patriarchates of Asia, has seen those wonderful originals called in the Sacred Scriptures the Cherubim, which were sculptured and painted on the walls of Temples, Towers, Cities, Palaces and erected in the highly cultivated states of Egypt, Moab,

7

Edom, Aram, among the Rivers of Paradise. . . .' There is in Blake's minutest designs the sense that he is showing us a portion of those 'stupendous originals' of his vision, fragments of some unfallen world 'among the Rivers of Paradise' – a world of the unhindered energy of spiritual life. It is his gift of communicating his vision, rather than his technical accomplishment as a painter or engraver, that entitles Blake to so high a place.

'The Nature of Visionary Fancy, or Imagination, is very little Known. . . .' Very little known because consciously possessed by few in our materialist civilization. Yet, with the aid of those who possess a faculty latent in all, we can participate through art in the enjoyment of an interior universe whose exploration is the theme of the religious and mythological art of all ages. For those to whom the outer world of the senses alone seems real, Blake, in common with all symbolic art, offers little; for others 'the end of a golden string' to thread the labyrinth of the psyche. Nor is this world cloudy or vague. 'A Spirit and a Vision are not, as the modern philosophy supposes, a cloudy vapour, or a nothing: they are organized and minutely articulated beyond all that the mortal and perishing nature can produce. He who does not imagine in stronger and better lineaments, and in stronger and better light than his perishing mortal eye can see, does not imagine at all. The painter of this work [*The Bard*, from Gray] asserts that all his imaginations appear to him infinitely more perfect and more minutely organized than anything seen by his mortal eye. Spirits are organized men.'

Not content with defending the 'minute particulars' of vision, Blake pointed out that the copying of nature must lead in the end to loss of form: 'Men think they can Copy Nature as Correctly as I copy Imagination. This they will find Impossible, & all the Copiers or Pretended Copiers of Nature, from Rembrandt to Reynolds, Prove that Nature becomes to its Victim nothing but Blots & Blurs. Why are Copiers of Nature Incorrect, while Copiers of Imagination are Correct?'

8

Blake calls to witness the greatest art of the world, which depicts not what is seen by the 'mortal eye', but an imagined perfection: 'The connoisseurs and artists who have made objections to Mr B's mode of representing spirits with real bodies, would do well to consider that the Venus, the Minerva, the Jupiter, the Apollo, which they admire in Greek statues are all of them representatives of spiritual existences, of Gods immortal, to the mortal perishing organ of sight; and yet they are embodied and organized in solid marble.'

This is the Platonic view of art; and indeed Plotinus' *On the Beautiful* (in Thomas Taylor's translation) was early known to Blake. Essentially this is an aesthetics which sees wholes as determining parts, and ideas (which are wholes) as the organizing principles of the medium in which they are executed. Plotinus asks: 'What is the similitude between the beauties of sense, and that beauty which is divine?' And he answers that form gives unity to matter. 'Hence beauty is established in multitude, when the many is reduced to the one; and in this case it communicates itself both to the parts, and to the whole. . . . Thus at one and the same time it communicates itself to the whole building, and its several parts. . . . And hence body becomes beautiful, through the communion supernally proceeding from divinity.'

Blake's aesthetics belong to a greater extent than has generally been realized to the Greek revival; to which we shall presently return. But his earliest formation must first be considered.

2 Illustration for
Thornton's *Virgil*, 1820

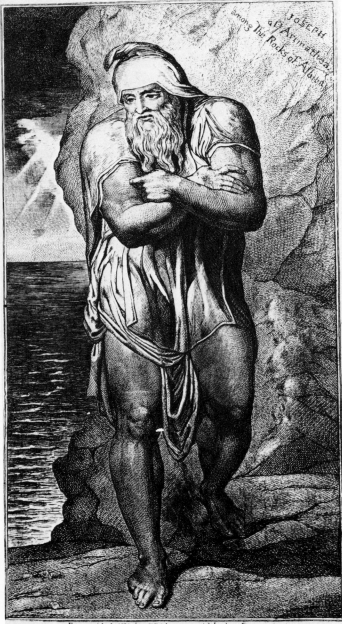

Within the illustration:

JOSEPH
of Arimathea
among The Rocks of Albion

Engraved by W Blake 1773 from an old Italian Drawing
This is One of the Gothic Artists who Built the Cathedrals in what we call the Dark Ages
Wandering about in sheep skins & goat skins of whom the World was not worthy
 such were the Christians
Michael Angelo Pinxit in all Ages

3 *Joseph of Arimathea,*
1773, engraved
by Blake
after Michelangelo

Apprentice to Antiquity

Blake was first and last a Londoner. He was born on 28 November 1757, at 28 Broad Street, Golden Square, the second child of 'a moderately prosperous hosier of some twenty years' standing,' according to his biographer, Alexander Gilchrist. The poverty of Blake's background and the meanness of his education have been exaggerated. The Blake family occupied a spacious old London house in a district, half private houses, half respectable shops, which was (Gilchrist again) in an 'ex-fashionable highly respectable condition'. Blake was not 'a man of the people', though his political views were radical, and in his youth revolutionary. He belonged to the lower section of that stable middle class which has in fact produced most of the talent and genius of the nation. From the point of view of his family Blake was a failure; his brother James, who inherited the family business, stopped seeing William altogether in their later years.

It is true that Blake never went to school; but this probably indicates, beside his own strong objection to being sent to school, his father's enlightened tolerance of his son's artistic bent. 'The Schoolboy' of *Songs of Innocence* is represented as a victim of parental tyranny, not as for Gray, 'redolent of joy and youth'. 'There is no use in education,' he said as an old man to Crabb Robinson the diarist; 'I hold it wrong – it is the great Sin.' An aphorism in *The Marriage of Heaven and Hell* reflects Blake's thankfulness to have escaped the instruction of the schoolmaster: 'Improvement makes strait roads; but the crooked roads without Improvement are roads of Genius.'

'As soon as the child's hand could hold a pencil it began to scrawl rough likenesses of man or beast, and make timid copies of all the prints he came near.' In those days there was

education or its want; there was no bad education, no trash. The prints Blake saw as a child were of authentic works of art. At the age of ten, he was sent to the best and most fashionable preparatory school for young artists: Henry Pars' drawing-school in the Strand. Pars' younger brother, William, accompanied the architect Revett to Athens and Ionia, to study and draw 'ruined temple and mutilated statue, and to return with portfolios, a mine of wealth to cribbing "classic" architects – contemporary Chambers and future Soane.' Blake was later to make engravings of several of William Pars' plates for the famous Stuart and Revett portfolios of *The Antiquities of Athens and Ionia*. Blake's spirited Lapiths and Centaurs from the Parthenon frieze belong to that mythological world which was his native element.

Blake's Victorian biographer Gilchrist reflects the current fashion of his own time in his evident regret that 'At Pars' school as much drawing was taught as is to be learned by copying plaster-casts of the Antique, but no drawing from the living figure.' But this suited Blake's natural preference for ideal form. Blake's father bought him a few casts: the Gladiator, the Hercules Farnese, the Venus de Medici, and wooden models of heads, hand and arm. He also gave him pocket-money with which the boy, a haunter of print-dealers' shops and auction-rooms, laid the foundation of a modest collection. A collector Blake remained throughout his life, though at a time of pressing poverty he sold his fine collection of prints. Samuel Palmer remembers being taken to visit Blake, then an old man: 'I can never forget the evening when Mr Linnell took me to Blake's house, nor how the quiet hours passed with him in the examination of antique gems, choice pictures, and Italian prints of the sixteenth century.'

Blake was, in fact, from his boyhood to the end of his life, as highly cultured, not to say learned, in the visual arts as it is possible for any artist to be who was never able to visit Europe.

Pars' school had been founded by William Shipley, also the virtual founder of the Society of Arts; the Society's exhibition

rooms, before its removal to the Adelphi over the way, were in the same building as the school. Blake must have seen there exhibitions of the most famous painters of the day. George Stubbs exhibited there, and it is pleasing to imagine Blake as a boy enthralled by Stubbs' *Tiger*, conceived so much more in the spirit of Blake's famous poem than the toy-like creature of his own design.

At the age of fourteen Blake was apprenticed to Basire, engraver to the Society of Antiquaries. In this, the middle-class caution of Blake's father the hosier is evident. The career of a painter was altogether too vague to appeal to his practical sense; let his son at least be assured of a living by his skill in a craft, and become a painter if he could. Perhaps this decision was a mistaken one; it may be that Blake's great imaginings were cramped somewhat by the limitations of the engraver's art, which inevitably influenced his style as a painter. But any loss to painting was to be compensated for by the enrichment of the art of engraving by Blake's unsurpassed *Illustrations of the Book of Job*. His craftsman's training was also, almost accidentally, to put into his hands the technique which enabled him to create his unique illuminated books. But the strong and lasting influence of Basire's flat, old-fashioned and formal style of engraving with the 'dot and lozenge' technique he had inherited from Vertue, engraver to the Society of Antiquaries before him, may have had much to do with Blake's later want of success in finding employment as an engraver. The 'smooth' technique of Woollett, Strange, Bartolozzi and his pupil Schiavonetti, so scorned by Blake, was more agreeable to the new taste.

As Basire's apprentice Blake found himself in an environment of Antiquity. The 'ancient republics, monarchies and patriarchates of Asia' of his visions owed much to his prentice-work for Basire on such books as Bryant's *New System of Mythology*, as famous a work in its day as Frazer's *Golden Bough*. Ruthven Todd first discerned Blake's hand in several of the plates, some of which contain details later discoverable in

4 Moon-ark
Jerusalem
1804–20

120 Blake's own designs. In Plate 16 of his *Job* series, *When the Morning Stars sang Together*, the raised and crossed arms and parted feet are a reflection of the frieze-figures of a Persian
6 Temple of Mithras illustrated in one of the Basire plates – possibly one Blake himself worked on. The archaeological premises of Bryant's monumental work were probably no more absurd than many since: that all the pantheons of Antiquity must be related to the eight human beings who survived the Deluge in Noah's Ark. Ruthven Todd first put side by side
5 the moon-ark of the tail-piece of volume three of Bryant's
4 *Mythology* and the several moon-arks of Blake's mythological works. It was to Bryant Blake owed his realization – a bold one at that time – that 'the antiquities of every Nation under Heaven, is no less sacred than that of the Jews. They are the same thing, as Jacob Bryant and all antiquaries have proved. . . . All had originally one language, and one religion: this was the

5 Moon-ark and dove of peace
from Bryant's *Mythology*,
1774–6, probably by Blake

F I N I S.

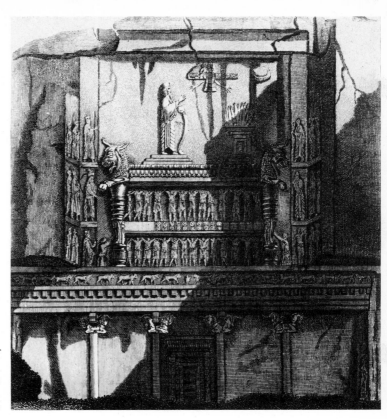

6 Temple of
Mithras from
Bryant's
Mythology,
1774–6

religion of Jesus, the everlasting Gospel. Antiquity preaches the
Gospel of Jesus.' The *Mythology* was a gold-mine, upon which
Blake drew in the composition of his own pantheon of mytho-
logical lore; a universal language (as Bryant himself had
understood) of the human imagination, with dialectical
variations according to time, place, and local tradition.

Blake's dreams of the colossal were perhaps in part a reflec-
tion of a moment at which there was talk of a colossal statue by
Flaxman at Greenwich (never carried out); but they must also
have reflected those Persian temples and sculptures of Greece
and Egypt which had impressed his imagination during his
seven years in Basire's workshop. '. . . Those wonderful

15

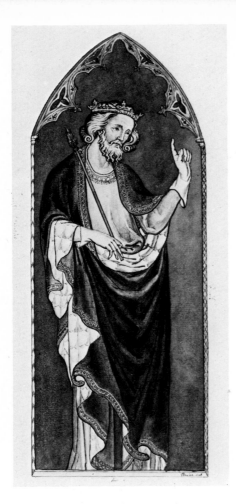

7 *King Sebert*, Blake's copy of a mural in Westminster Abbey, later engraved in *Vetusta Monumenta*

originals seen in my visions, were some of them one hundred feet in height; some were painted as pictures, and some carved as basso relievos, and some as groupes of statues, all containing mythological and recondited meaning, where more is meant than meets the eye. The Artist wishes it was now the fashion to make such monuments, and then he should not doubt of having a national commission to execute these two Pictures [the Spiritual Forms of Nelson and Pitt] on a scale that is suitable to the grandeur of the nation. . . .'

16

Two years after Blake's apprenticeship, kindly Basire, to get him out of the way of two troublesome new apprentices, sent him to make drawings of monuments and buildings in the various old churches of London, and especially at Westminster Abbey. Blake was always grateful to Basire for this opportunity to study Gothic architecture and sculpture. Basire was at that time working on the plates of the *Archaeologia* and the *Vetusta Monumenta* of the Society of Antiquaries. According to Gilchrist, Blake engraved some of the plates which bear the name of Basire, among them those of Edward III, Queen Philippa, and Aveline of Lancaster. Anthony Blunt also attributes to Blake the watercolour copies of the murals of two English kings in Westminster Abbey, known as Henry III and King Sebert, which were engraved in the second volume of *Vetusta* 7 *Monumenta*. Blake's work may also be traced in the *Memoir* of Thomas Hollis; and in Gough's *Sepulchral Monuments*, not published until 1786 and 1796. Gilchrist records that Blake discovered for himself, then or later, the important part colour once played in Gothic churches; in his imagination the Abbey once more became 'a radiant Temple of God' which was 'now a bleached dishonoured skeleton'.

Blake's lifelong love of Gothic art dates from this time; almost by chance he was able to study a style which was already becoming fashionable, notably through Horace Walpole and his friend the poet Gray. For Blake it was spiritual affinity rather than fashion which drew him to the aristocratic linear style of Late Gothic sculpture. He discovered in this noble art the central tradition of Catholic Christian art as it flourished in England at a time when the English style was a living branch of the great European tradition.

For Blake, the Gothic style was the Christian style *par excellence*; a view Ruskin was later to share, but not one current in the eighteenth century. Commenting on Virgil in 1820 he wrote: 'Grecian is Mathematical Form: Gothic is living form, Mathematic Form is eternal in the Reasoning Memory: Living Form is Eternal Existence.' In Wren's St

Paul's Cathedral he saw a monument of Deism, the 'natural religion' of the Enlightenment, of 'Newton's Pantocrator', *117* demiurge of the mechanistic universe of science. Plate 32 of Blake's *Jerusalem* shows beside Vala 'the Goddess Nature' the dome of St Paul's, while the soul-figure, Jerusalem, and her children keep guard over his beloved Westminster Abbey. In 1773, when Blake was not yet sixteen, he made a drawing after Michelangelo (which he later engraved) entitled *Joseph* *3* *of Arimathea among the Rocks of Albion*; below he wrote: 'This is One of the Gothic Artists who Built the Cathedrals in what we call the Dark Ages, Wandering about in sheep skins & goat skins, of whom the World was not worthy; such were the Christians in all Ages.' Only Blake could have seen a Gothic hero in Michelangelo's soldier.

'Let them look at Gothic Figures & Gothic Buildings & not talk of Dark Ages or of any Age. Ages are all Equal. But Genius is Always Above the Age,' he wrote in the margins of Reynolds' *Discourses on Painting*. In his poem 'I saw a monk of Charlemaine' included in the preface to *Jerusalem*, Chapter 3, Blake challenged the current fashion of the Enlightenment which held medieval Christendom in contempt. Voltaire, Rousseau and Gibbon, he says, 'charge the poor Monks & Religious with being the causes of War, while you aquit & flatter the Alexanders & Caesars, the Lewis's & Fredericks who alone are its causes & its actors.' 'The Classics! it is the Classics & not Goths nor Monks, that Desolate Europe with Wars.'

The intention of Gothic portrait-sculpture was not naturalistic, nor the reproduction of every detail and blemish of the physical form, but rather the expression of the essence of the spiritual tenant of the earthly body, and, in addition, of kingship, sanctity, military courage or feminine grace, as such. So Blake, too, was to conceive portraiture. His many Bible illustrations represent the lineaments of some spiritual state, whether good or evil, and as such invite comparison with the sculptures of Chartres, and Gothic depictions of the lineaments of human feeling.

18

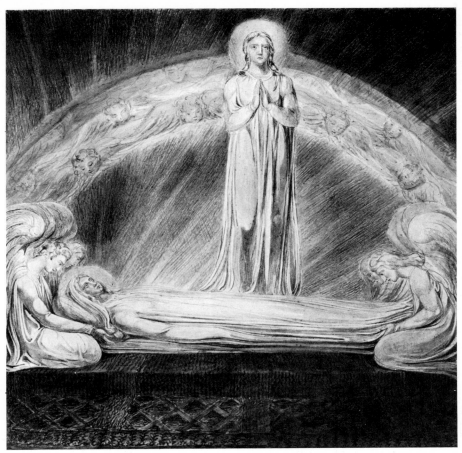

8 *Death of the Virgin Mary*, 1803

Nikolaus Pevsner in his 1955 Reith Lectures spoke of Blake's 'flaming line' as distinctively English. The sinuous flowing lines of his drapery, the elongation of his figures, derive from the Decorated or Flamboyant Gothic architecture and sculpture which he knew in Westminster Abbey. The static and monumental was not natural to Blake; yet when he depicts death *8* it is in terms of the calm recumbence of the figures on the royal tombs.

More congenial to his natural bent was the vital linear character of Gothic art, whether in the human form, the foliate decoration of stone, or the pages of illuminated books. For Blake, the essence of art was the line: 'firm and determinate lineaments unbroken by shadows'. 'The Beauty proper for sublime art is lineaments, or forms and features that are capable of being receptacles of intellect.' This description fits no style so well as the Gothic; it was Blake's implicit standard of comparison with that 'chiaro oscuro' which he hated: 'Such art of losing the outlines is the art of Venice and Flanders; it loses all character, and leaves what some people call expression; but this is a false notion of expression; expression cannot exist without character as its stamina; and neither character nor expression can exist without firm and determinate outline.' Of colouring, he wrote that this 'does not depend on where the colours are put, but where the lights and darks are put, and all depends on Form or Outline, on where that is put; where that is wrong, the colouring never can be right; and it is always wrong in Titian and Correggio, Rubens and Rembrandt.' A summary dismissal, by any standard.

The linear style is, in fact, characteristic of religious art; and always Blake insists that the 'spirits', whether of men or

9 'Gothic' designs from Blake's Notebook, c. 1793

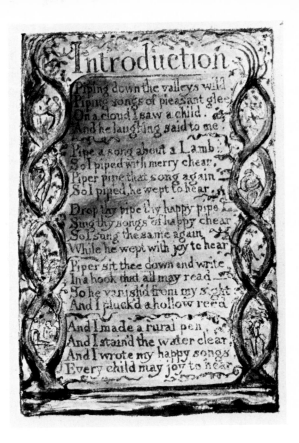

10 *Songs of Innocence*, 1789
Introduction

gods, should be 'organized', within a 'determinate and bounding form'.

The 'tendrils of the wandering vine', the interlacing linear forms which adorn the pages of *Songs of Innocence* (1789), *10* are obviously influenced by medieval illuminated books; here again, the character is the line, whose controlled freedom accompanies and surrounds the script in so harmonious a way. Even in the closely written pages of *Jerusalem* (1804–20), tendrils creep into whatever space they can find, and insects, birds, fishes and serpents occupy those visual vacuums which Blake, like nature, abhors. The formalized vine-leaves have the look of Gothic foliage. On many plates the human figures,

too, are formalized into decoration in a way reminiscent of the
fantasies of Gothic stonemasons. In Blake's Notebook (and
sometimes later elaborated in his designs), we find letters and
formalized designs obviously derived from Gothic lettering,
or from corbels and capitals of Gothic sculpture.

Blake's admiration for Gray, for Chatterton, for Percy's
Reliques of Ancient English Poetry and for early British history
was consistent with his Gothic enthusiasm. His first-hand,
exact knowledge of Gothic sculpture and painting was incom-
parably greater than that of Horace Walpole or Beckford,
whose 'follies' in the Gothic style were mere fantasies. Blake
often expressed himself wildly on subjects he knew exactly,
in contrast with those measured Augustan periods which lend
weight to often superficial knowledge.

One might guess that Blake's early passion for Shakespeare
was a consequence of his acquaintance with sculptured linea-
ments of the kings and queens of the historical plays. *Poetical
Sketches*, his earliest work, contains fragments of historical
drama in rough-hewn Shakespearian blank verse. Still more
fruitful was the influence of Shakespeare's lyrics, already
evident in these early poems, and soon to flower in *Songs of
Innocence and Experience* – the most vitally 'linear' lyric poetry
since Shakespeare himself. So it is with the 'crooked roads of
Genius' – one vital interest leads to another: the royal tombs to
Shakespeare, and both (ultimately) to Blake's own national
myth of 'the Giant Albion', the collective Being of the English
nation. Blake's historical sense was derived less from history-
books (though he read Froissart, Geoffrey of Monmouth, and
such writers) than immediately from the great works of earlier
ages. His learning was none the less exact and extensive for
being that of a draughtsman rather than a man of books.

It was no doubt under the inspiration of English history,
whose atmosphere he had absorbed during his long hours in the
company of England's dead kings and queens, that Blake, as
Basire's apprentice and immediately afterwards, worked on
elaborate historical compositions somewhat in the style of

11 *The Penance of Jane Shore, c.* 1779. As the mistress of Edward IV she was forced to walk in penance in St Paul's Church. Blake's sympathy is apparent in this drawing. He himself thought well of this work, and included it in his exhibition of 1809

Angelica Kauffmann and John Hamilton Mortimer: *The Penance of Jane Shore, Edward and Eleanor, The Ordeal of Queen Emma, The Death of Earl Godwin.* Anthony Blunt has no high opinion of these productions: 'As a painter, if he had died at the age of thirty [Blake] would be thought of as a minor and rather incompetent member of a group of artists in revolt against Sir Joshua Reynolds and the official doctrine of the Royal Academy.' He describes this current manner as 'on the border-line between Late Rococo and Neoclassicism'; and points out that in costume, Blake, like the painters whom he imitated, 'followed contemporary stage productions of Shakespeare's plays dealing with medieval themes, which consisted of a mixture of Elizabethan and eighteenth-century elements with the

11

occasional addition of a medieval suit of armour rendered with considerable freedom'.

Blake left Basire's studios at the end of his seven years' apprenticeship at the age of twenty-one, and set to work to earn his living as an engraver. The descent into the world of commercial art must have come as a rude awakening for the young man who had dreamed away seven industrious years among the royal tombs and still more ancient monuments of Antiquity. He continued to live in his father's house, but was now engaged on plates for the *Novelist's Magazine*, the *Ladies' Magazine* and the like. For a time he enrolled himself as a student at the newly-founded Royal Academy, which was then (in Gilchrist's words) 'in an uncomfortable chrysalis condition, having had to quit its cramped lodgings in Somerset Palace (pulled down in 1775); and awaiting the completion of the new building in which more elbow room was to be provided.' But it was not the cramped physical conditions which irked him so much as the cramped imaginative environment. Besides drawing from the Antique, life-drawing was the order of the day, and this, to Blake, was anathema: 'Natural Objects always did & now do weaken, deaden & obliterate Imagination in Me.' So he wrote many years later in his manuscript notes on Wordsworth. Gothic stylization had formed his taste to another conception of art, and in the Academy drawing-school he was out of his element. No doubt his antipathy to Reynolds dates from those uneasy months. As a man of fifty, he wrote scathing annotations in his copy of Reynolds' *Discourses on Painting*. With the illusory triumph of a *pensée d'escalier*, he describes a clash with Moser, the first Keeper of the Academy, who naturally assumed that his words would be gospel to such obscure young men as William Blake: 'I was once looking over the Prints from Raffael & Michael Angelo in the Library of the Royal Academy. Moser came to me & said: "You should not Study these old Hard, Stiff & Dry, Unfinish'd Works of Art – Stay a little & I will shew you what you should Study." He then went & took down Le Brun's and Rubens' *Galleries*.

How I did secretly Rage! I also spoke my Mind . . . I said to Moser, "These things that you call Finish'd are not Even Begun: how then can they be Finish'd? The Man who does not know The Beginning never can know the End of Art."'

In particular Blake hated 'that infernal machine called Chiaro Oscuro, in the hands of Flemish and Venetian Demons'. Against 'blotting and blurring demons' Blake waged a lifelong war; though he was forced, on his own admission, to give ground a little by 'the spirit of Titian'. 'The spirit of Titian was particularly active in raising doubts concerning the possibility of executing without a model, and when once he had raised the doubt, it became easy for him to snatch away the vision time after time, for, when the Artist took his pencil to execute his ideas, his power of imagination weakened so much and darkened, that memory of nature, and of Pictures of the various schools possessed his mind . . . like walking in another man's style, or speaking, or looking in another man's style and manner, unappropriate and repugnant to your own individual character. . . .'

Rubens, too, forced Blake's reluctant admiration: 'Rubens is a most outrageous demon, and by infusing the remembrance of his Pictures and style of execution, hinders all power of individual thought: so that the man who is possessed by his demon loses all admiration for any other Artist but Rubens. . . .'

Samuel Palmer rectifies our picture of Blake as a narrow fanatic, unwilling to enjoy art in styles other than those in which he himself found nourishment: 'Those who may have read some strange passages in his Catalogue, written in irritation, and probably in haste, will be surprised to hear, that in conversation he was anything but sectarian or exclusive, finding sources of delight throughout the whole range of art; while, as a critic, he was judicious and discriminating.'

Palmer is recalling Blake as an old man; perhaps his tastes had broadened with time. But the impression we gain is that it was not so much Rubens and Titian, as their academic admirers, who aroused Blake's prophetic rage.

Among Blake's early friends were the 'wild' Fuseli, and James Barry, who executed the fine mural paintings in the Royal Society of Arts, and who shared Blake's passion for Michelangelo. Anthony Blunt has pointed out several close parallels between Blake's early work and that of Barry, whose *King Lear*, and *Job*, in particular, seem to have fired his imagination. Barry was an Irishman, a Catholic, and a visionary, and their friendship may provide a clue to Blake's sympathy (minimized by Gilchrist, his biographer) with the 'Romish Church'. The No-Popery Riots of 1780 made a deep impression on Blake, who always championed the cause of the persecuted. Blake's revolutionary sympathies have been so often recorded (and exaggerated) that this less often noted sympathy seems worth mentioning here. Our greatest Christian artist never went to church, but 'ever professed his preference of the Church to any sort of sectarianism'. 'He used to ask how it was that we heard so much of priestcraft, and so little of soldier-craft and lawyercraft' – so Samuel Butler recollected. He had a 'preference for ecclesiastical governments', among which he explicitly admired the Papacy. The *Life* of St Teresa was among his favourite books, and he admired the Quietist Mme Guyon, and Fénelon.

Such views are not strange when we consider that Blake was saturated in the greatest art of the medieval Catholic tradition; the many examples of Tudor vulgarity which deface Westminster Abbey found no place in his admiration.

12 Illustration for Thornton's *Virgil*, 1820

'The lost art of the Greeks'

So strong was the influence upon Blake of the Gothic style that another, and apparently contrary influence, that of the Greek Revival, has tended to be overlooked. But, with that infallible gift of genius for being open to the significant – which is not necessarily to say, the fashionable – influences at any moment of time, Blake found himself at its centre. In about 1782 Thomas Stothard, an older fellow-engraver, introduced Blake to John Flaxman, then newly married and living at 27 Wardour Street, not far from Broad Street and Golden Square. Blake came for a time to share his friend's enthusiasm for Greek art. With the same whole-heartedness he showed in his love of Gothic, we find Blake in 1799 writing to another Greek enthusiast, George Cumberland of Bristol (one of the founders of the National Gallery), that his 'Genius or Angel' was guiding his inspiration to the fulfilment of 'the purpose for which alone I live, which is . . . to renew the lost Art of the Greeks'. He was later to write very hard things about 'the Greek and Roman slaves of the sword', but his love for Greek art and Greek mythology remained. Blake and Flaxman shared a passion for the linear, the 'clear and determinate outline', though Flaxman derived chiefly from the Greek, Blake from the Gothic. Blake's lifelong love of 'the human form divine', the nude of art unblurred by the nudity of nature, is in part a reflection of his undiminished admiration of those Antique sculptures he had delighted to copy in his student days, and later discovered in the company of Flaxman.

Blake married in 1782. His wife was the illiterate daughter of a Battersea market-gardener. He married beneath him, and his father who had, after all, done everything in his power to encourage his gifted son, was displeased. William left his

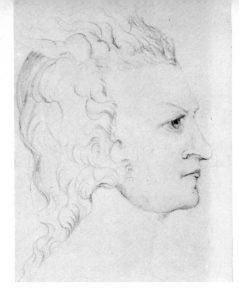

13 Catherine Blake's drawing of William at the age of twenty-eight

father's house under a cloud to set up house with his Catherine at 23 Green Street, Leicester Fields; 'in which Fields or Square, the junior branches of Royalty had lately abode', besides 'the great Hogarth'.

Just as Blake's want of education has been exaggerated, so, probably, has his happiness in his marriage. That Catherine was to be no help to him socially probably did not trouble him. But he had married her on the rebound from an unrequited passion for a dark-eyed girl of whom we can surmise only (from a song in *Poetical Sketches*) that she was his social superior:

> *I curse my stars in bitter grief and woe,*
> *That made my love so high, and me so low.*

After the death of his father in 1784, Blake moved back to Broad Street, setting up at No. 27, next door to his old home (where his brother James had now inherited the hosiery business). He took a former fellow-apprentice, James Parker, as partner, and his talented younger brother, Robert, as a pupil and member of his household. For two and a half happy, if financially unsuccessful years, this much-loved brother was an intellectual companion; but Robert Blake died, at the age of

28

twenty or a little more: the greatest personal bereavement in Blake's life. On the internal evidence of *Songs of Experience* and other poems unpublished, it seems Blake began to find his marriage irksome; no doubt Catherine bored him, and she was childless. There is mention of 'a handmaiden' whom Blake at one time wished to introduce into the household, a practice permitted (as Desirée Hirst has described in her book on Blake, *Hidden Riches*) by the Swedenborgian Society, of which Blake and his wife were members. On the slender internal evidence of the poem 'Mary', and *Visions of the Daughters of Albion* (Blake's equivalent of Milton's tract on divorce) it is just possible that Blake was attracted by Mary Wollstonecraft, whose views on free love he shared. To judge from the bitterness of some of the *Songs of Experience*, and, still more, from the evidence of the unpublished poem 'William Bond' (and also from the guarded Gilchrist), it seems that the trouble in Blake's marriage was serious. Whether because of Mary Wollstonecraft or some other woman, there was a time of sorrow for both William and Catherine:

> '*O William, if thou dost another Love*
> *Dost another Love better than poor Mary,*
> *Go & take that other to be thy Wife*
> *And Mary Green shall her Servant be.*'

The conclusion is a triumph of mutual generosity: William Bond is won by his wife's sublime gesture of renunciation, and in his turn renounces his intention of leaving her. The poem ends on a note never touched by any poet of merely romantic love:

> *Seek Love in the Pity of other's Woe,*
> *In the gentle relief of another's care,*
> *In the darkness of night & the winter's snow,*
> *In the naked & outcast, Seek Love there!*

In their later years Mr and Mrs Blake lived in a simple harmony which won the respect of those young painters for whom Blake was a master not only of painting, but of the good life.

It was during the early years of Blake's friendship with him that Flaxman persuaded Josiah Wedgwood to make his famous replicas of the Portland Vase, the first of his many replicas and imitations of Graeco-Roman vases. In a letter dated 5 February 1784, Flaxman urged Wedgwood to come to London to 'see Sir Wm. Hamilton's vase, it is the finest production of Art brought to England'. In 1790, after the vase had been purchased by the Duke of Portland in 1786, several replicas were made at the Wedgwood pottery and exhibited at the Wedgwood showrooms in Green Street. In 1791 Erasmus Darwin (grandfather of the naturalist and friend of the Wedgwoods) published in Part 1 of his *Botanic Garden* a long essay in which he argued,

14, 15 From Blair's *The Grave*, 1808: left, *The Soul exploring the Recesses of the Grave*; right, *Death's Door*

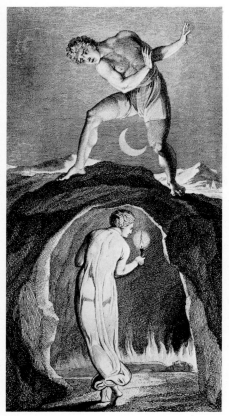
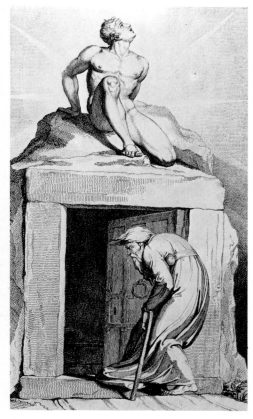

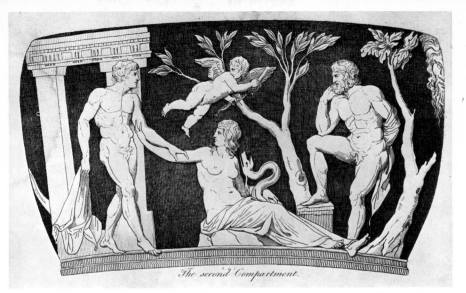

The second Compartment.

16 The Portland Vase, second compartment, engraved by Blake for Darwin's *Botanic Garden*, 1791

probably mistakenly, that the vase figures are emblems of the Eleusinian Mysteries. Blake made the fine set of engravings for *16* Darwin's work, and must, therefore, have had either the original vase or one of the replicas in his workroom for some time. The theme of *The Soul exploring the Recesses of the Grave*, *14* used by Blake in his illustrations to Blair's *The Grave* and in several later compositions, certainly owes something to the second compartment of the Portland Vase. In one of the illustrations to *The Grave*, the vigorous male figure above bears *15* some resemblance to the youth entering the Kingdom of Hades through what is (according to Darwin's interpretation) 'the door of death'. And in the Frontispiece to *Jerusalem*, *17* while the door is Gothic (it suggests, indeed, one of those low doors into crypt or cloister that Blake knew well in Westminster Abbey), the figure's tentative advance still carries a suggestion of the youth on the Portland Vase. We can see it in the drawing of the left foot, and perhaps (taken from another figure on the vase), the right foot cut off just above the ankle;

31

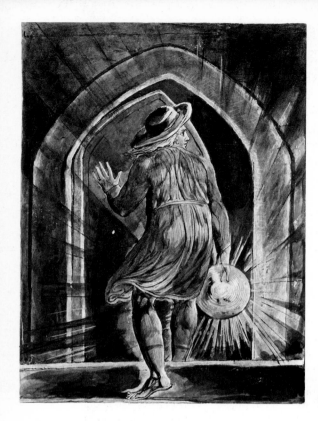

17 *Jerusalem*. Frontispiece: *Los
exploring the Recesses
of the Grave*, 1804–20

and (if we mentally remove the eighteenth-century hat) the
eager profile of the face, half afraid, half exalted with wonder.

18　　Also for Darwin's book, Blake engraved Fuseli's drawing of
The Waters of the Nile, into which he introduced a figure of his
own invention: an aged figure with vast beard and outstretched
arms who advances like a low cloud across the heavens.
Anthony Blunt discovered the Roman relief of Jupiter Pluvius
which was clearly Blake's inspiration, and the source of what
was to be one of his favourite depictions of the aged figure of
his own (often 'weeping') demiurge Urizen. Flaxman in one
of his Dante illustrations derives from the same figure, or from
Blake, or both.

32

In 1791 Blake made from drawings by William Pars a set of engravings from the Parthenon frieze for Stuart's and Revett's *Antiquities of Athens and Ionia*. In accepting the commission offered him by William Reveley, Blake wrote: 'he is glad to embrace the offer of engraving such beautiful things & will do what he can by the end of January.' Flaxman spent seven years in Italy between 1787 and 1794, returning with his famous series of drawings for Homer, Aeschylus and Dante. His plates for the *Odyssey*, said to have been lost on the voyage to England, were re-engraved by Blake.

18 *The Nile*, after Fuseli, from Darwin's *Botanic Garden*, 1791

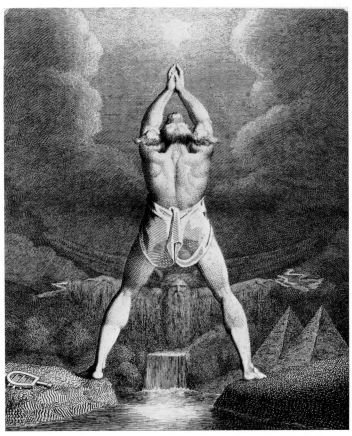

Certain other visual themes are reminiscent of Greek sculp-
117 ture or reliefs. The veiled figure of Vala (*Jerusalem*, Plate 32)
recalls a convention of Graeco-Roman iconography in which
the long veil is held loosely above the head. Blake's friend
George Cumberland published, in 1795, a series of drawings
illustrating the story of Cupid and Psyche; eight of these Blake
19 engraved, including one in which Psyche's veil floats above her
somewhat in the manner of the figure of Vala; probably so
named from her attribute, the Greek peplos, or veil. The
absurd butterfly wings of Cumberland's Psyche can be recog-
20 nized in the fairy-figure illustrating Blake's own 'Infant Joy.'
113 But on the title-page of *Jerusalem*, the wings of the soul have
become gorgeous with sun, moon and stars. Caterpillar,
chrysalis and butterfly is a Greek symbolic theme to which Blake
often returned. There are, in Bryant's *Mythology*, emblems
21 from antique gems, seals and intaglios representing this wide-
spread Hellenistic emblem of the 'second birth' of the soul.
22 The unforgettable first emblem of *The Gates of Paradise*,

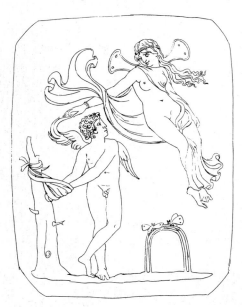

19 *The Conjugal Union of
Cupid*, 'From an Original
Invention by G. Cumberland
Engd. by W. Blake', 1794

20 *Songs of Innocence*, 1789
Infant Joy

34

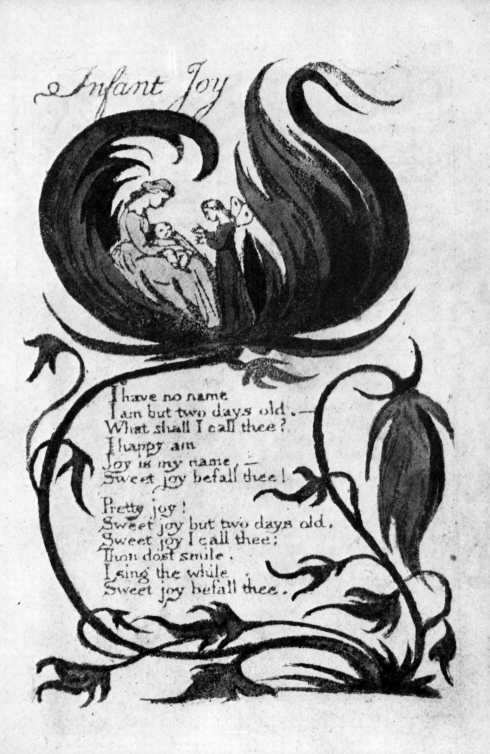

Infant Joy

I have no name
I am but two days old. —
What shall I call thee?
I happy am
Joy is my name, —
Sweet joy befall thee!

Pretty joy!
Sweet joy but two days old.
Sweet joy I call thee;
Thou dost smile.
I sing the while
Sweet joy befall thee.

depicting the caterpillar of the 'natural man' and the dreaming infant soul in its chrysalis of metamorphosis, derives no doubt from these, or from some of those antique gems in Blake's own collection, mentioned by Samuel Palmer, besides literary sources.

Cumberland's *Thoughts on Outline*, published in 1796, exalts 'the inestimable value of chaste outline' characteristic of ancient art, a phrase suggestive of Blake's influence, or of a point of view current in their circle. Cumberland remained a friend to Blake to the end of his life.

Thomas Taylor the Platonist, known as 'the English Pagan', was a friend of George Cumberland's, and Blake must have known him too; Taylor is probably 'Sipsop the Pythagorean' of the satirical fragment *An Island in the Moon*. Cumberland was not the only probable link between Blake and Taylor: Taylor gave a series of lectures on the Platonic philosophy 'before a distinguished audience' at Flaxman's house shortly before Flaxman's departure for Italy in 1787, and Blake most likely attended. Taylor's friend, William Meredith, has described Taylor giving Blake a lesson on the fifth proposition of Euclid: 'Taylor was going through the demonstration, but was interrupted by Blake, exclaiming "ah never mind that – what's the use of going to prove it. Why I see with my own eyes that it is so, & do not require any proof to make it clearer."' His

21 Graeco-Roman seals from Bryant's *Mythology*, 1774–6, with typical emblems of metamorphosis

 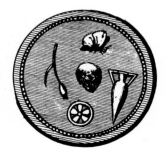

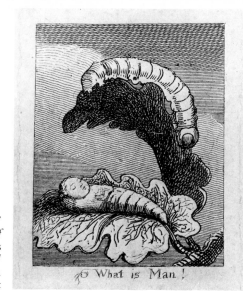

22 'What is Man!' Frontispiece to *The Gates of Paradise*, 1793. The Sun's Light when he unfolds it/ Depends on the Organ that beholds it

mythological painting illustrating Porphyry's *De Antro Nympharum* (Taylor's translation), made many years later, in 1821, gives the impression (as do the *Illustrations of the Book of Job* made about the same time) of a symbolic theme long considered; one, indeed, which runs through his own poetry and belongs to the very structure of his thought. The painting depicts Porphyry's myth of the 'descent' of souls into generation, and their 'return'; the life-cycle as conceived by the Neoplatonic philosophers. The figure of Athene (who stands behind Odysseus) is veiled and draped in the Classical manner. The four horses which draw the goddess Leucothea (and still more, those drawing the sun god in his car) recall the Parthenon frieze; while the winged figures on the upper right of the picture, bearing urns on their heads, suggest, perhaps, the caryatids of the Acropolis. Blake was remembering themes current in his circle in the 1790s.

1, 119

The strongest Greek influence on Blake was not visual but mythological. Since it often happened that he reclothed Greek themes in modern (or Gothic) dress, the extent to which he

37

participated in the Greek Revival has not been generally
37 recognized. The title-page of *Songs of Experience* (1794) shows
the recumbent dead executed in the style of the royal tombs,
but the underlying myth is the Platonic theme: that men 'die'
into this world from a kingdom of immortal life, 'For who
knows whether to live be not to die, and to die, to live?' Blake
uses the same Gothic depiction, in the same Platonic sense, in
122 his illustrations to Blair's *The Grave*.

'The Little Girl Lost' and 'The Little Girl Found' (first
included in *Songs of Innocence* and later transferred to *Songs of
Experience*) are a retelling of the Greater and Lesser Mysteries of
Eleusis – the descent of the Kore into Hades, and the nine
mystic nights of the Mother's search for her child. The poems

23 *Tiriel supporting Myratana.* Before 1789

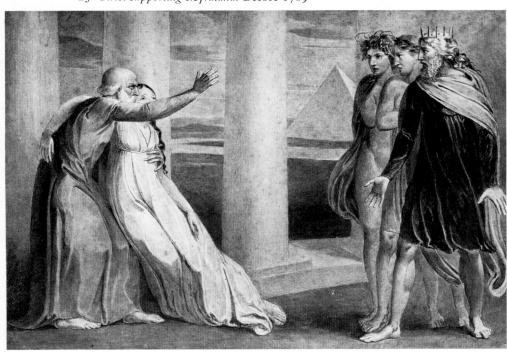

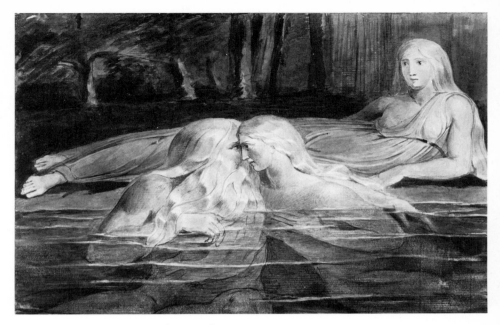

24 *Tiriel: Har and Heva Bathing.* Before 1789

are based upon Thomas Taylor's *Dissertation on the Eleusinian and Bacchic Mysteries,* and also upon the figures of the Portland Vase and Erasmus Darwin's account of them. Many of Blake's themes, both mythological and philosophic, especially in his early Prophetic Books (the Lambeth Books), derive from Taylor's writings and translations.

The dramatic poem *Tiriel,* written in about 1789, is a strange blend of Greek and alchemical themes with Rousseau's and Mary Wollstonecraft's new theories of education. The figure of Tiriel himself has many affinities with the Sophoclean Oedipus Coloneus; and Blake's (typically tenuous) plot suggests the conflict between aged Oedipus and the sons whom he cursed. Needless to say Blake's sympathies are entirely with the sons. The illustrations of *Tiriel* reflect Blake's Neoclassical interests: there are suggestions of Classical architecture in several plates, and the costumes – those of Hela and Tiriel in Plate VII for example – are more or less Greek in intention.

23, 24

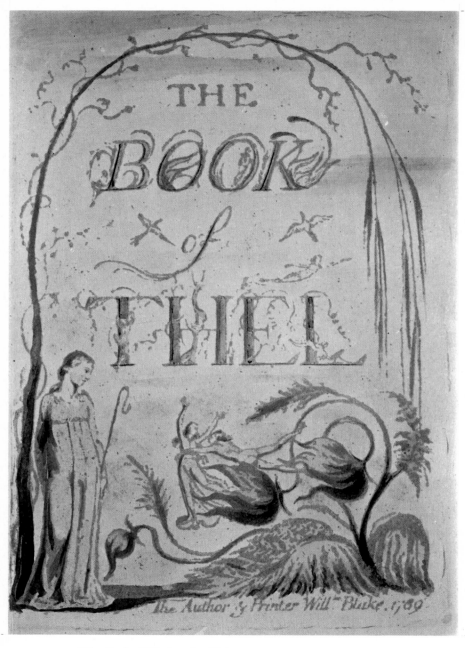

The Author & Printer Will^m Blake. 1789

25 *The Book of Thel*, 1789. Title-page

A New Mode of Printing

Poetical Sketches, Blake's first collection of poems (including some written in his boyhood), was published in 1783 through the patronage of a Mrs Mathew, a clergyman's wife who had 'taken up' Flaxman, and, on Flaxman's introduction, for a time extended her patronage to Blake. Mrs Mathew and her husband paid half the cost of printing Blake's poems, Flaxman apparently paying the rest. Gilchrist records that Mrs Mathew used to read Homer to Flaxman; but when it became apparent that Blake came not to learn but to teach, his welcome in Mrs Mathew's circle of admirers became less warm. Blake did not suffer patrons gladly, and the comedy of Mrs Mathew was to be repeated fifteen years later (with Flaxman again the well-meaning intermediary) in the episode of his three years' employment by the poet and country squire Hayley. Blake was never an easy man socially. 'A mental Prince', he was proud, argumentative, and violently opposed to current fashion, in his art and his philosophic and religious ideas alike. His only tenable role in his world was that of the venerated teacher he became, in his old age, to the group of young painters known as the 'Shoreham Ancients'.

Artists who work for quick success must rise on a tide of fashion, or possess social graces and tact, or private means. Blake, who was ready to speak his mind to Moser on the subject of 'Venetian and Flemish demons', was 'a priest and king in his own household', but no courtier. A radical in politics, Swedenborgian in religion, with no interest whatever in making money, Blake was clearly destined for worldly failure. He was a man of tireless industry; he carried out his commissions as an engraver laboriously and conscientiously. But his thoughts were elsewhere.

From whatever combination of causes and circumstances, it came about that he was without a publisher for his subsequent books of verse. True, *The French Revolution*, an unreadable verse narrative and commentary whose turgid style recalls Carlyle's later prose work of the same name, was actually set up in type by Blake's friend and employer Johnson the radical bookseller; but it was then considered too dangerous to publish.

The political and moral subversiveness of his early works provides one possible explanation of how Blake came to be his own publisher; but were there deeper reasons? Did he wish to produce books of an entirely new kind? Books as beautiful as some medieval psalter, the words enhanced by decoration of design and colour? Geoffrey Keynes points out that the germinal idea of such books was already in Blake's mind when in about 1784 he wrote his dramatic farce, *An Island in the Moon*. The first part is missing from the manuscript of a passage which begins abruptly:

'". . . thus Illuminating the Manuscript."

'"Ay," said she, "that would be excellent."

'"Then," said he, "I would have all the writing Engraved instead of Printed, and at every other leaf a high-finish'd print – all in three Volumes folio – & sell them a hundred pounds apiece. They would print off two thousand."'

Far from being a child of necessity, the idea was to make a great deal of money.

Keynes thinks that this idea may have been suggested to Blake by George Cumberland, who early in 1784 wrote to his brother Richard with 'the enclosed specimen of my new mode of Printing – it is the amusement of an evening and is capable of printing 2000 if I wanted them – you see here one page which is executed as easily as writing and the cost is trifling.' Cumberland's letter goes on to point out that you need print no more than are needed at one time, and that the copper plates can be used again – the only difficulty being that work of this kind can only be read with the aid of a looking-glass, as the letters are reversed. 'However we have a remedy for this

26 From *There is no Natural
Religion, c.* 1788–94
Blake's first illuminated book

defect also,' he adds. Can this 'we' conceivably have included
Blake, or may Blake have been the real originator of the idea?
Cumberland concludes: 'the expense of this page is 1/6 without
reckoning time, wh. was never yet worth much to authors, and
the Copper is worth 1/– again when cut up. In my next I will
tell you more and make you also an engraver of this sort, till
when keep it to yourself.'

Blake first used the method of 'illuminated printing' in about
1788. Three small tractates entitled *There is no Natural Religion* 26
seem to have been his first experiments in this art. They are
crudely executed in comparison with his later work, very small
(copper was expensive), and simple in design. The title-page of
Songs of Innocence bears the date 1789, and it is likely that, 27
satisfied with his new method, Blake in a hopeful mood began
work on the title-page of his next book of poems.

A contemporary account (by J. T. Smith) tells of visionary
aid. When Blake's brother Robert had died in 1787, Blake had
seen his spirit rising 'through the matter-of-fact ceiling, "clap-
ping his hands for joy"'. His brother's spirit continued to be
present to him. After Blake 'had deeply perplexed himself as
to the mode of accomplishing the publication of his illustrated
songs, without their being subject to the expense of letter-press,

43

his brother Robert stood before him in one of his visionary imaginations, and so decidedly directed him in the way in which he ought to proceed, that he immediately followed his advice, by writing his poetry, and drawing his marginal subjects of embellishments in outline upon the copper-plate with an impervious liquid, and then eating the plain parts or lights away with aqua fortis considerably below them, so that the outlines were left as a stereotype.'

Ruthven Todd, with the help of Joan Miró, has experimented in the production of a reversed image of this kind. This is done by writing in the varnish on a sheet of paper, then reversing the paper on to the copper-plate, under pressure: a very delicate process.

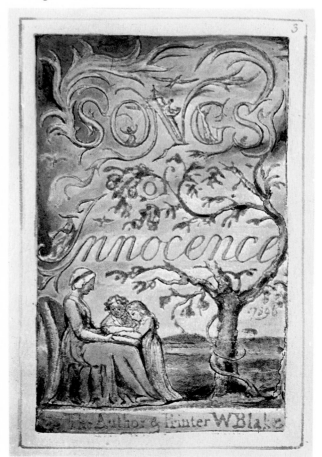

27 *Songs of Innocence,* 1789
Title-page

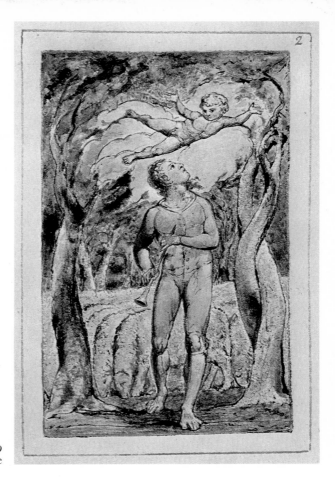

28 *Songs of Innocence,* 1789
Frontispiece

Blake's watercolour illumination, carried out by hand, also owed something to supernatural inspiration. According to Gilchrist, 'He ground and mixed his watercolours himself on a piece of statuary marble, after a method of his own, with common carpenter's glue diluted, which he had found out, as the early Italians had before him, to be a good binder. Joseph, the sacred carpenter, had appeared in vision and revealed *that* secret to him.' Ruthven Todd thinks that 'carpenter's glue' would have been too coarse and that some more refined substance was used. 'The colours he used were few and simple,'

Gilchrist continues, 'indigo, cobalt, gamboge, vermilion, Frankfort-black freely, ultramarine rarely, chrome not at all. These he applied with a camel's hair brush, not with a sable which he disliked.'

Blake never printed off his two thousand copies, or made his fortune, but for the rest, Cumberland's letter foretold some of the advantages of the method. He could print copies as he needed them: he continued to print *Songs of Innocence*, and later *Songs of Innocence and Experience*, from time to time to the end of his life, as he did his later books, whenever he found a purchaser. The inks he used were various: blue, green, bluish green, golden brown or black. Occasionally inks of two colours are combined in the same plate. But the unique character of each copy is created by the watercolour 'illumination'. There are great variations: each copy has its own colour-range and is a unique creation. Early copies of *Songs of Innocence* often have the transparency and delicacy of a rainbow, while some later copies are richly sombre, glowing with gold paint, like those medieval psalters which were doubtless Blake's inspiration.

10, 20, *Songs of Innocence* comprises thirty-one plates in all, but their
27–30 number and order varies in the twenty-three known copies of the book. 'The Little Girl Lost' and 'The Little Girl Found' were later transferred to *Songs of Experience*. As with others of his books – including *Milton* and *Jerusalem* – a final order was never absolutely determined.

The writing, engraving, printing and colouring – even the mixing of the pigments – was all Blake's work; the binding was done by Mrs Blake, who also learned to take off impressions from the plates. Some of the copies which have survived are also thought to be coloured with a rather heavy hand by Mrs Blake.

Songs of Innocence may have been planned as a book for children, but once he was involved in its making, Blake soon lost sight of any purpose but the creation of beauty. However, *The Gates of Paradise*, a book of emblems engraved in 1793, is entitled *For Children*. At the end of the eighteenth century

46

books for children were much in evidence, most of them, like Anna Letitia Barbauld's *Hymns in Prose for Children* and Isaac Watts' *Divine and Moral Songs for Children*, having a moral and religious character. Mary Wollstonecraft translated from the German Salzmann's *Elements of Morality for the Use of Parents and Children*, a book of simple incidents from real life, with a great number of illustrations, some of which were engraved by Blake. No doubt Mary's own *Original Stories from Real Life* (for which Blake drew ten and engraved five illustrations) was suggested by Salzmann's book. Mary Wollstonecraft (who worked as French editor for Blake's friend Johnson the radical bookseller) was under the influence of Rousseau, whose view of childhood as a law unto itself contrasted strongly with the pedagogic habit of mind in the Age of Reason. It must have been during his association with Mary that Blake formed the idea of making books for children, and about childhood, which should reflect the belief he shared with Rousseau that the unfolding of the imagination of every creature, in freedom, is the only true education.

In *Tiriel*, a poem illustrated with drawings but not published, Blake had already denounced the current view of childhood – deriving in great measure from Locke, that early forerunner of behaviourism and brain-washing – as a passive state to be 'formed' by 'instruction'. The poem describes with scathing indignation the consequences of 'forming' a child according to the laws of mechanistic rationalism, imposed all from outside and regardless of the mysterious formative laws of life itself. Tiriel, the blind parental tyrant, is himself the product of such an education, and dies cursing those who, by compelling him into conformity, had denied him life. For Rousseau, every child was unique; and Blake's aphorism – illustrated, in *The Marriage of Heaven and Hell*, by Nebuchadnezzar compelled to eat grass – 'One Law for the Lion and Ox is Oppression', might summarize Rousseau's and Mary Wollstonecraft's views on education as well as his own. For 'Infancy', Rousseau wrote, 'has a manner of perceiving, thinking and feeling peculiar to

itself.' Premature instruction is 'without regard to the peculiar genius of each. For, besides the constitution common to its species, each child at its birth possesses a peculiar temperament, which determines its genius and character; and which it is improper either to pervert or restrain, the business of education being only to model and bring it to perfection. All the vices imputed to malignity of disposition are only the effect of the bad form it has received . . . there is not a villain upon earth, whose natural propensity, well directed, might not have been productive of great virtues.'

So also thought Blake, who many years later said that he had never known a bad man who had not something very good about him. Blake's realization, 'Every man's genius is peculiar to his individuality', is one he shared with Rousseau and Mary Wollstonecraft.

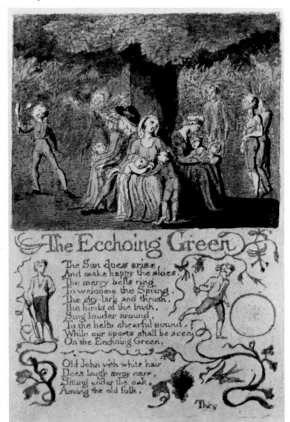

29 *Songs of Innocence*, 1789
The Ecchoing Green

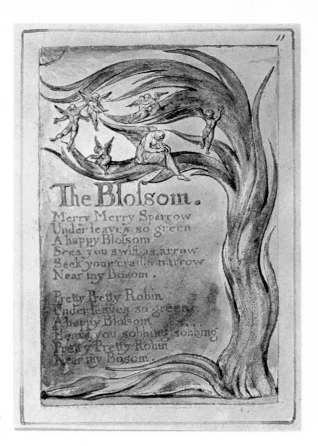

30 *Songs of Innocence*, 1789
The Blossom

Blake was also a Platonist; he attacked Locke in his first engraved aphorisms, *There is no Natural Religion*, precisely for his refusal to accept Plato's view that there are innate ideas. 'Knowledge of Ideal Beauty is Not to be Acquired. It is Born with us. Innate Ideas are in Every Man. Born with him; they are truly Himself,' wrote Blake in about 1808 in the margins of Reynolds' *Discourses on Painting*; and again, in his old age, he wrote in the margin of his copy of Berkeley's *Siris*: 'the Spiritual Body or Angel as little Children always behold the Face of the Heavenly Father'.

This, of course, goes beyond Rousseau – beyond Plato, indeed. For the essence of Blake's Christianity was his vision

of the 'God within', 'Jesus the Imagination'. Childhood, for Blake, is the purest essence of the spirit of life; the thing itself. The instructions of education can add nothing to Being. 'Everything that lives is holy', not by virtue of any added qualities, but in its essence:

> *'I have no name,*
> *'I am but two days old.'*
> *What shall I call thee?*
> *'I happy am,*
> *'Joy is my name.'*

Blake in these seemingly naïve lines is describing the nature of life as he conceived it. Joy – delight – is the essence of life, and all life seeks joy as its natural state. For him, the mechanistic view of the universe – the popular mentality of the Enlightment under the guise of Deism ('natural religion'), the philosophy of Bacon, Newton and Locke – was the enemy of life; life which is immeasurable, not to be captured or contained within the quantitative 'laws of nature' – a view which Bergson was later to develop in more strictly philosophic terms.

'The hours of folly are measured by the clock; but the hours of wisdom no clock can measure.' As against the Newtonian universe, overwhelming man's sense of his own value by awe-inspiring vistas of space and time, Blake affirmed the holiness of life, omnipresent, no less in the tiny than in the vast:

> *To see a World in a Grain of Sand,*
> *And heaven in a Wild Flower,*
> *Hold Infinity in the palm of your hand*
> *And Eternity in an hour.*

All Blake's most characteristic and beautiful images are of the minute: the wild thyme and the meadowsweet – 'And none can tell how from so small a centre comes such sweets.' 'The little winged fly', the worm, the ant, the grasshopper and spider; the little bird – lark or nightingale or robin redbreast; the 'moment in each day that Satan cannot find' in which the

poet's work is done; and, above all, the supreme symbol of the *multum in parvule*, the Divine Child. Life is neither great nor small, and the dignity of every living essence is not relative but absolute. Childhood – innocence – was for him not a state of inexperience and ignorance, but the state of pure being.

In *Songs of Innocence* the energy and spontaneity of life runs through every line of Blake's leaping, running, flying figures, the tendrils of his 'wandering vine', symbol of the one life in all things, which is, in the world of Innocence, not a theory but a state of being. Simple as these poems may be in form, they contain a great wisdom and rest upon the firm ground of philosophy. They embody essential knowledge more enduring than the imposing structures of conceptual thought elaborated by the philosophers of the Enlightenment and their French counterparts, Voltaire, Diderot and the Encyclopedists. This is no less a miracle of imaginative insight for the fact that Blake was deeply and widely read, not only in the works of those whom he attacked, but also in the writings of Plato and Plotinus, Berkeley and the *Hermetica*, Paracelsus and Fludd, and the mystical theology of Boehme and Swedenborg.

The apparent weightlessness of Blake's figures, the ease with which they fly without the use of those cumbrous wings Baroque, and still more, Victorian angels required, arises from the realization that life, as Blake understood it, is not subject to the forces of nature. Life – consciousness – moves freely where it wills. To leap in thought along the line of a hill, or on to a cloud, is to be there in imagination.

Already in *Songs of Innocence* Blake's figures have attained freedom from the gravitational forces which constrain material objects: the characteristic, thereafter, of all his depictions of the human form, a quality essentially Blakean, and shared by none of his contemporaries. Again, he may have been influenced in this by Early Christian art, and those angels and heavenly personages who are essentially, and not merely in name, immaterial beings occupying mental and not physical space.

In the five years between *Songs of Innocence* and *Songs of Experience* Blake produced two illuminated books of outstanding beauty: *The Book of Thel* (1789) and *The Marriage of Heaven and Hell* (1790–3). *Thel* is close in spirit to the paradisal world of *Songs of Innocence*. It consists of seven engraved plates, about six inches by four and a quarter; the larger size suggests that Blake was now more confident about his technique. The designs express, even more than those of *Songs of Innocence*, the easy grace, freedom and expressive sweetness characteristic of Blake's vision of 'Innocence'. The 'fair luminous mist' of the colour-washes Blake now began to use over the whole page seems to illuminate words and designs alike with the light of Paradise. The theme of the poem is Neoplatonic, and draws much upon Thomas Taylor's recently published paraphrased translation of Plotinus' *On the Beautiful*, and on the idea of the 'descent' of the soul into generation as described in this and other works of Taylor which appeared about this time.

The Marriage of Heaven and Hell, engraved about a year later, reflects in its fiery forms and colours the ideas of 'Hell, or Energy', no less characteristic of Blake's thought. Before the Terror and the ensuing slaughter of so many of the early liberal supporters of the French Revolution – members of the Gironde, friends of Mary Wollstonecraft and of Paine – Blake had worn the *bonnet rouge* in the streets of London. He was a Republican, and had hailed revolution first in America, then in France, as an expression of freedom, and of that spirit of life which was, for him, in whatever guise, holy. When in France the reality proved to be otherwise, Blake changed his mind about the value of political solutions. 'I am really sorry to see my Countrymen trouble themselves about Politics,' he wrote in about 1809, having seen twenty years of 'glorious revolution' and its ensuing wars. 'If Men were Wise, the Most arbitrary Princes could not hurt them; if they are not wise, the Freest Government is compell'd to be a Tyranny.' Politics seemed to him 'to be something Else besides Human Life'. He at all times hated war, believing that the arts could only flourish in peaceful

25, 31

32–4

But he that loves the lowly, pours his oil upon my head,
And kisses me, and binds his nuptial bands around my breast,
And says: Thou mother of my children, I have loved thee,
And I have given thee a crown that none can take away
But how this is sweet maid, I know not, and I cannot know,
I ponder, and I cannot ponder; yet I live and love.

The daughter of beauty wip'd her pitying tears with her white veil,
And said. Alas! I knew not this, and therefore did I weep:
That God would love a Worm I knew, and punish the evil foot
That wilful, bruis'd its helpless form: but that he cherish'd it
With milk and oil, I never knew; and therefore did I weep,
And I complaind in the mild air, because I fade away,
And lay me down in thy cold bed, and leave my shining lot.

Queen of the vales, the matron Clay answerd; I heard thy sighs,
And all thy moans flew o'er my roof, but I have calld them down:
Wilt thou O Queen enter my house, 'tis given thee to enter,
And to return; fear nothing, enter with thy virgin feet.

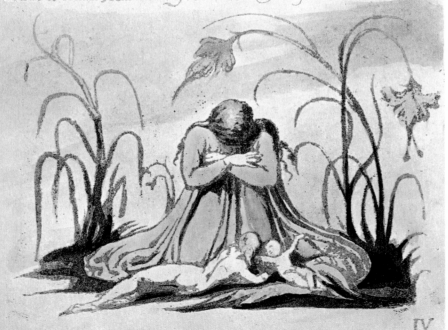

IV

31 *The Book of Thel*, 1789. Matron Clay

States. 'Rome & Greece swept Art into their maw & destroy'd it; a Warlike State never can produce Art. It will Rob & Plunder & accumulate into one place, & Translate & Copy & Buy & Sell & Criticise, but not Make.' *Europe: a Prophecy* is an indictment of war written at a time when Blake and his friends hoped that England would not go to war with France; but later, in his 'apotheoses' of Pitt and Nelson (1809) it seems that Blake was a supporter of the national cause against Napoleon, if not in the conventional sense, at least in the prophetic region of spiritual causes. But the 'happy country' of which he called himself a citizen was the 'Kingdom not of this world'.

125

Meanwhile, in *The Marriage of Heaven and Hell* 'the new-born terror', Orc, the child who burns in the flames of his own energy, is hailed as the Messiah of the New Age whose prophet Blake believed himself to be. Of all Blake's books, this has perhaps the greatest power of word and of design. The literary form is no longer lyric, but aphorism and parable of visionary events experienced 'behind the veil'. 'Energy is eternal delight'; and life – no less holy in 'the new-born terror' of 'the fiery limbs, the flaming hair', than in the unhampered child on its cloud in *Songs of Innocence* – obeys the law of its innate energies. Free, life is mild and loving; impeded, it is rebellious and

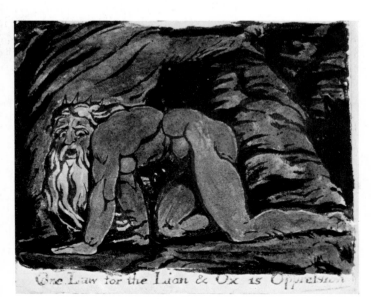

32 *The Marriage of Heaven and Hell,* c. 1790–3. Nebuchadnezzar

33 *The Marriage
of Heaven and Hell*,
c. 1790–3. Title-page.
In the lower part
an Angel in clouds
and a Devil in
flames embrace.
Above is the
surface of the earth

violent. Energy enchained, like Nebuchadnezzar, whose royal *32*
humanity was compelled into the grass-eating nature of the
'patient ox', becomes warlike and fierce. All Blake's sym-
pathies, in this book, are with lion and devil, giant and fiery
serpent of 'the nether deep'. His tyrants are kings, churches,
parents, schoolmasters. 'The tygers of wrath are wiser than the
horses of instruction.'

No doubt this book is an expression of Blake's mood of sympathy with the forces of revolution, seen as an expression of the irrepressible energy of life. But it is, at the same time, the fruit of his profound studies of the mystical theology of Boehme, the alchemical writings of Paracelsus, Fludd and Agrippa, and his knowledge of the Western Esoteric tradition both orthodox and heterodox. Christianity, in its popular forms at all events, has never sufficiently understood what Jung has called the ambivalence of the archetypes. No psychic energy, or mood of the soul, is merely good or merely evil; the face turned depends upon circumstances. This is a truth well understood in Mahayana Buddhism, whose deities have their peaceful and angry aspects; and also in Hinduism, where Kali and Shiva have their mild and their terrible faces; or in the ancient Greek religion; or in the Jewish mystical tradition of the Cabbalistic Tree of the Sephiroth. Boehme, perhaps more profoundly than any other Christian mystic, had understood this truth, and Blake followed him. Far beyond merely 'religious' thought, the *Marriage* is a work of prophetic vision

34 *The Marriage of Heaven and Hell, c.* 1790–3. Ugolino and his sons in prison

35 *Songs of Experience,*
1789–94.
Frontispiece

into the nature of vital causes; 'inspired' in the sense in which
we use the word of the Hebrew prophets, as Blake himself
claimed. It is the 'Poetic Genius', Blake declared, that spoke
through the prophets Isaiah and Ezekiel, of whom all the 'gods'
of the Gentiles are tributaries; 'it was this that our great poet,
King David, desired so fervently & invokes so pathetic'ly,
saying by this he conquers enemies & governs kingdoms'. And
here Blake's 'Jesus, the Imagination' appears for the first time
in opposition to Milton's 'Messiah, or Reason': 'in the Book
of Job, Milton's Messiah is call'd Satan'. Jesus, Blake concludes,
'was all virtue, and acted from impulse, not from rules'. The
premiss is the same as that of *Songs of Innocence,* but more bold
in its extension.

57

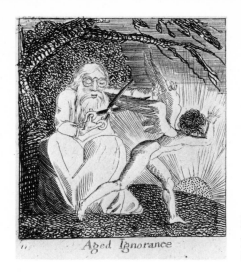

36 *The Gates of Paradise*, 1793.
'Aged Ignorance'.
Perceptive Organs closed,
their Objects close

Because Blake wrote in *The Marriage of Heaven and Hell* that 'Without Contraries is no progression', it has often been assumed that the states of Innocence and Experience represent a pair of contraries like his Reason and Energy, or the peace of Heaven and the 'fires of genius'. This is not so, for 'a negation is not a contrary', he says. The state of Innocence was not, for Blake, one of ignorance, as compared with the wisdom of 'experience' so highly valued by Voltaire's Candide or Dr Johnson's Rasselas, types of the Enlightenment. The state of Innocence is that of unclouded, unhindered life; and as Blake's symbol of that state is the child, so 'aged ignorance', clipping the wings of youth, is his symbol of Experience. The title-page of *Experience* shows two weepers by a 'gothic' tomb, where the 'dead' – the spiritually dead – lie like effigies on their own tombs. Blake's 'Hell, or Energy' is one of the modes of life; 'the roaring of lions, the howling of wolves, the raging of the stormy sea, and the destructive sword, are portions of eternity, too great for the eye of man'. Experience is the antithesis of life. Life may be impeded and denied: by unrequited love as in 'The Angel' or 'Ah! Sunflower'; by childhood oppressed, as in 'Nurse's Song' and 'The Chimney Sweeper'; by moral oppression as in 'The Garden of Love' and 'A Little Girl Lost'; or

36
37

58

by social injustice, as in 'London'. The 'net of religion' spread by
'aged ignorance' runs through all; and the dark face of the
human city evoked in 'London' is but the sum of inhumanity
and of the perversion and restraint of life for which every
individual is in some measure responsible:

> *In every cry of every Man,*
> *In every Infant's cry of fear,*
> *In every voice, in every ban,*
> *The mind-forg'd manacles I hear.*

It is these 'mind-forg'd manacles' (sometimes depicted as shack-
ling the feet of Urizen, the false god) which make thorns where

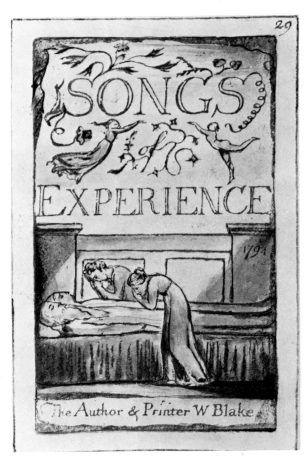

37 *Songs of
Experience,*
1789–94.
Title-page

there should be roses, furtive 'whisperings' instead of childish laughter, 'tombstones where flowers should be'. Blake indicts Church and State, parents, nurses and schoolmasters; but also, and above all, the tortuousness of 'the Human Brain', whose reasonings confound the simplicity of life, and which 'knits a snare' in which souls become inextricably entangled, as in a spider's web of prohibitions and hypocrisy. Many of the poems of *Experience* are antithetical to those of *Innocence*; the difference between 'Infant Sorrow' and 'Infant Joy' is that between love and the absence of love. The 'Ecchoing Green' is a childhood world surrounded by sympathy, 'Nurse's Song' is childhood clouded by the sick thoughts of the Nurse: an anticipation of

29

38 *Songs of Experience*, 1789–94. The Sick Rose

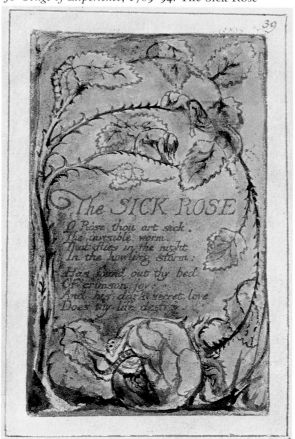

Henry James' *Turn of the Screw*. The 'Holy Thursday' of
Experience is an indictment of cold charity; the poverty of the
children is above all in the absence of love:

> *And their sun does never shine,*
> *And their fields are bleak & bare,*
> *And their ways are fill'd with thorns:*
> *It is eternal winter there.*

'The Chimney Sweeper' of *Innocence* can escape in dreams into
a heavenly country; but *Experience* reminds us that the crimes
of society against the children of the poor are none the less for
that. Nor is it only the poor who are oppressed, but the

39 *Songs of Experience*, 1789–94. London

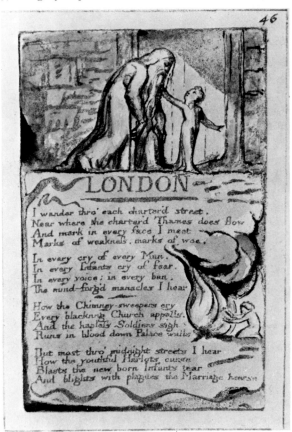

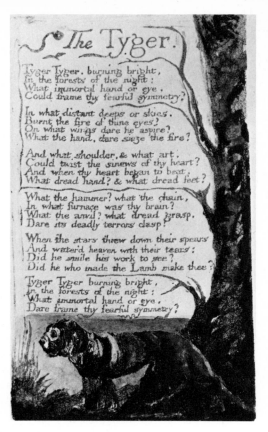

The Tyger.

Tyger Tyger. burning bright,
In the forests of the night:
What immortal hand or eye.
Could frame thy fearful symmetry?

In what distant deeps or skies.
Burnt the fire of thine eyes?
On what wings dare he aspire?
What the hand, dare seize the fire?

And what shoulder, & what art.
Could twist the sinews of thy heart?
And when thy heart began to beat,
What dread hand? & what dread feet?

What the hammer? what the chain,
In what furnace was thy brain?
What the anvil? what dread grasp,
Dare its deadly terrors clasp?

When the stars threw down their spears
And water'd heaven with their tears:
Did he smile his work to see?
Did he who made the Lamb make thee?

Tyger Tyger burning bright,
In the forests of the night:
What immortal hand or eye,
Dare frame thy fearful symmetry?

schoolboy, forced to the joyless routine of learning; or 'A Little
Boy Lost' oppressed by the Calvinist morality which immolates
souls if no longer bodies.

 The figures of *Experience* are entangled, burdened, listless or
40 dead. A burning jewel in that sombre setting is 'The Tyger'.
81 In this great poem, as in 'To Tirzah' (added about 1801), we
again find Blake seeking to rend the veil and to bring to light
the meaning and the mystery of evil. In 'To Tirzah' we find,
as in *Thel*, the Neoplatonic view of 'mortal birth' as itself the
greatest of evils. In 'The Tyger' there are traces of the *Hermetica*,
of the mystical theology of Boehme, of the esoteric philosophy
of alchemy. But the poem ends with the question unanswered:
'Did he who made the Lamb, make thee?'

'Lovely Lambeth'

Blake had left Poland Street in 1790, soon after the death of his mother, from which we may surmise that it was his affection for her that had kept him in the neighbourhood of his family. Blake is said to have spoken little of his parents later in life – only of his brother Robert. Blake and Catherine now moved to 13 Hercules Buildings, Lambeth, on the south bank of the Thames. Gilchrist describes the house as a humble one-storeyed building; but Frederick Tatham, a friend of Blake's later years, remembers it as 'a pretty, clean house of eight or ten rooms', a typical London terrace house of the eighteenth century, with the usual strip of garden behind. In this garden grew a 'wandering vine', unpruned, to form the arbour where, according to one of those legends which no official denial can kill, Mr and Mrs Blake were once surprised by a friend in the dress of Eden, with the addition only of helmets (a detail which comes through the painter George Richmond), occupied in the reading aloud of *Paradise Lost*.

The seven years at Lambeth were both productive and happy; the Lambeth Books include all Blake's finest illuminated books with the exception of *Milton* and *Jerusalem*. In *Jerusalem*, most of which was written in South Molton Street, the poet recalls 'Lovely Lambeth':

> . . . *There the secret furniture of Jerusalem's chamber*
> *Is wrought. Lambeth! The Bride, the Lamb's Wife, loveth thee.*
> *Thou art one with her & knowest not of Self in Thy supreme joy.*
> *Go on, builders in hope, tho' Jerusalem wanders far away.*

And again:

> *There is a Grain of Sand in Lambeth that Satan cannot find,*
> *Nor can his Watch Fiends find it; 'tis translucent & has many*
> > *Angles,*

But he who finds it will find Oothoon's palace; for within
Opening into Beulah, every angle is a lovely heaven.
But should the Watch Fiends find it, they would call it Sin.

(Beulah, in Blake's symbolic language, represents the married state.) The second of these passages suggests that Lambeth was a place and time not only of happy toil but of happy love.

But if this was a creative and, it seems, a happy time in Blake's life, the Lambeth Books are the most turbulent, sombre and pessimistic of all his writings. Blake is less persuasive when he speaks with the voice of revolutionary violence than when he works in the clear light of the vision of eternity. Perhaps he was trying to persuade himself that the political violence of the time was a short cut to spiritual liberation; or it may be simply that the clouds and thunders of the age are reflected in his poetry and designs: 'In troubled mists, o'erclouded by the terrors of struggling times.'

22, 36, In 1793 Blake engraved and published *The Gates of Paradise*, 41–5 a little book of emblems with seventeen plates, each one of them unforgettable. Their theme is Job's question, engraved on the frontispiece: 'What is Man?' Blake's answer is indicated

41, 42 *The Gates of Paradise*, 1793. *Water*: 'Thou waterest him with Tears'; and *Earth*: 'He struggles into Life'

by the symbol of metamorphosis. A caterpillar, symbol of 22
'natural man', consumes the leaf of our native Druid tree, the
oak; and on another leaf, an infant sleeping in a chrysalis
signifies the 'second birth' of the 'spiritual body' of humanity,
latent in the human animal. It was the Jews' discovery and
exploration of that new Kingdom of the Human, the revelation
of its laws, the living of life in accordance with the 'divine
humanity', the 'Imagination', that, for Blake, entitled them to
their title of a 'chosen people'. 'We of Israel taught that the
Poetic Genius (as you now call it) was the first principle and all
the others merely derivative, which was the cause of our
despising the Priests & Philosophers of other countries, and
prophecying that all Gods would at last be proved to originate
in ours & to be the tributaries of the Poetic Genius.' For the
emblem of metamorphosis, however, Blake was indebted to
the Greeks.

The four Michelangelesque figures of Earth, Air, Fire and 41–4
Water anticipate those Four Zoas whose mythological adven-
tures form the substance of the Prophetic Books which were
to follow. The number four, as C. G. Jung has pointed out, is

43, 44 *The Gates of Paradise*, 1793. *Air*: 'On Cloudy Doubts of Reasoning
Cares'; *Fire*: 'That end in endless Strife'

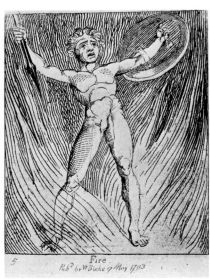

by no means arbitrary, but corresponds to the four functions, or energies, of the psyche; the 'four living creatures' of the Book of Ezekiel and the Apocalypse of St John. To these Biblical theriomorphic forms Blake was to give human attributes and features that are unforgettable. The Four Zoas seem likely to become figures as familiar in our national mythology as Hamlet and Lear.

Some of these mythological figures are already discernible in the *Songs*. Chief among them is the figure of the soul, or psyche (the *anima*, in Jung's terminology). As 'The Little Girl Lost' she clearly has an affinity with the Kore of the Eleusinian Mysteries. She reappears as the gentle Thel, reluctant to 'descend' into the Underworld of Generation; and in *Visions of the Daughters of Albion* (1793) she becomes Oothoon, who, more heroic than Thel, makes the 'descent' and suffers. In later works (1795–1804) she is Vala, and in the poem which originally bore her name (afterwards entitled *The Four Zoas*), she re-enacts Apuleius' legend of Cupid and Psyche. Her final form (1804–20) is as Jerusalem, the Bride of the Lamb. There is a deepening and development of the figure, but the story is essentially the same in all the versions. The soul 'descends' into the cave, or grave, of this world; willingly in the case of Lyca ('The Little Girl Lost'), reluctantly in the case of Thel. In both these poems

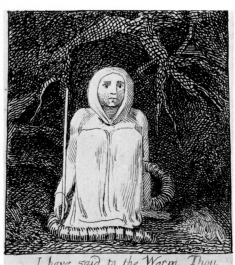

45 *The Gates of Paradise*, 1793. 'I have said to the Worm: Thou art my mother and my sister'

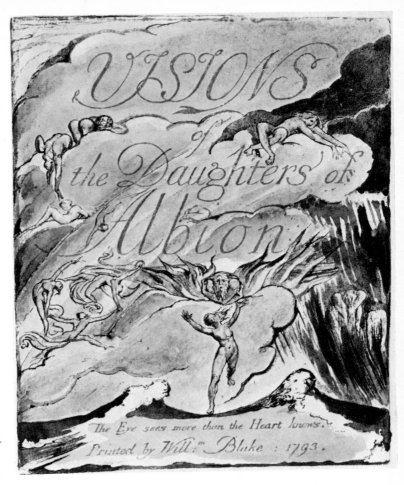

46 *Visions of the Daughters of Albion*, 1793. Title-page

it is implied that the soul has a task to perform in the World of Generation. In *Visions of the Daughters of Albion* we see her, as Oothoon, bitterly lamenting, like Debussy's Melisande, and protesting that on earth the laws are not those of the spirit. This poem is Blake's indictment of the cruelty of the sexual morality of the world. The unmarried are driven into sorrowful fantasies, and for woman, indissoluble marriage is an enslavement to lust when law and not love is the bond. Blake was surely thinking of his friend Mary Wollstonecraft and her

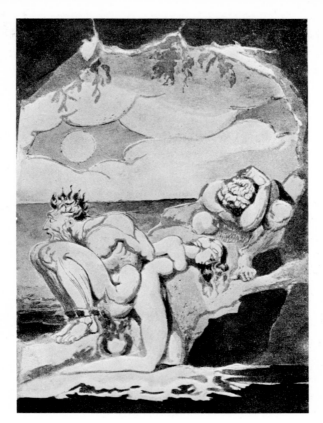

47 *Visions of the Daughters of Albion*, 1793. Frontispiece: Oothoon and Bromion tied back to back in a cave, while Theotormon mourns

heroic protest on behalf of women, leading to her own tragedy and early death. The poem contains some magnificent passages of poetry, developing Blake's conception of every creature as a unique expression of ever-various life. The law each creature must obey is innate; therefore 'one Law for the Lion & Ox is Oppression'.

46 On the title-page of *Visions of the Daughters of Albion* appears the figure later named Urizen: the blind tyrant, 'aged ignorance', the rational law-giver, in pursuit of the soul of life. Under the tyranny of Blake's grey-bearded Prince of this World, a travesty of God the Father, whose laws are imposed upon the energies of life that is its own law, Oothoon is bound
47 to her ravisher by the fetters of legality. Her lover, Theotormon,

unable to see that the soul is in its essence incorruptible (a Plotinian rather than a Christian doctrine), 'converses with shadows dire'.

Blake's depiction of Urizen advancing with outspread arms and vast beard derives, as mentioned earlier, from a Roman sculpture of Jupiter Pluvius. The same figure had appeared in an engraving made by Blake in 1791 for his friend Fuseli, as an illustration for Erasmus Darwin's *Botanic Garden*, where it represented the advancing flood of the Nile. This figure gradually developed – in *The First Book of Urizen* (1794) especially – the familiar features of Blake's unhappy, blind, self-deluded world-ruler: not God but misguided human reason. This is one among a number of such visual sources common to Blake, Flaxman, Fuseli and others of their circle.

18

The figure of Urizen is already present in *Songs of Experience* (1789–94), entangled in the 'net of religion'; he is 'starry jealousy' of 'Earth's Answer', the 'Jealous God' of Puritanism:

> *Selfish father of men!*
> *Cruel, jealous, selfish fear!*
> *Can delight,*
> *Chain'd in night,*
> *The virgins of youth and morning bear?*

In *The Marriage of Heaven and Hell* (1790–3) he is 'the starry king' who is overcome by the fiery child, later developed as 'Red Orc', spirit of the energy of life. Orc is Eros, but he is also violence and revolution; for 'When Thought is closed in Caves Then love will shew its root in deepest Hell.'

Like the gods of any ancient mythology, the Zoas, in their acts, attributes and appearances, have an archetypal quality to which we respond, not as to a work of art, but as to the spiritual realities themselves, as if these had existence in their own right. We recognize in them the images of gods in the world of modern industrial England; they are not figments of Blake's personal fantasy, but embodiments of the moods and energies of the collective life of the nation. They are ourselves.

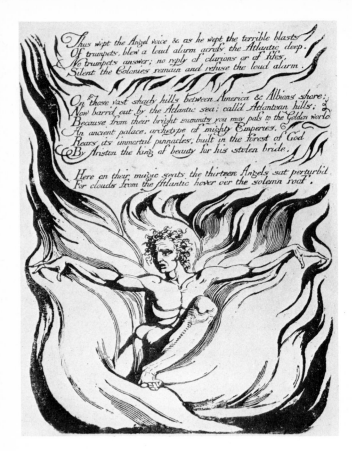

Thus wept the Angel voice & as he wept the terrible blasts
Of trumpets, blew a loud alarm across the Atlantic deep.
No trumpets answer; no reply of clarions or of fifes,
Silent the Colonies remain and refuse the loud alarm.

On those vast shady hills between America & Albions shore;
Now barrd out by the Atlantic sea: calld Atlantean hills:
Because from their bright summits you may pass to the Golden world
An ancient palace, archetype of mighty Emperies,
Rears its immortal pinnacles, built in the forest of God
By Ariston the king of beauty for his stolen bride.

Here on their magic seats the thirteen Angels sat perturbd
For clouds from the Atlantic hover oer the solemn roof.

48 *America: A Prophecy*, 1793. Orc in the fires of energy. For Blake, 'War is energy enslav'd'

48–50, 52 In *America* (1793), we find Blake's natural mythological genius uneasily harnessed to a specific political theme – the American War of Independence, which is treated in the same manner as *The French Revolution*. Nothing more effectively ensures the obscurity of poetry to later generations than those very topical allusions which are at the time as clear as the head-lines in a daily paper and as soon forgotten. Figures of the day, Washington, Franklin, Paine, Warren, Gates, Hancock and Green, 'show', in Gilchrist's words, 'small and remote, per-plexed and busied in an ant-like way'; while Orc, 'the Shadowy Female', and Urizen live on with a fierce and turbulent life into our own world. Several of the plates are very fine.

70

Preludium

The shadowy daughter of Urthona stood before red Orc,
When fourteen suns had faintly journey'd o'er his dark abode;
His food she brought in iron baskets, his drink in cups of iron;
Crown'd with a helmet & dark hair the nameless female stood;
A quiver with its burning stores, a bow like that of night,
When pestilence is shot from heaven; no other arms she need;
Invulnerable tho' naked, save where clouds roll round her loins,
Their awful folds in the dark air; silent she stood as night;
For never from her iron tongue could voice or sound arise;
But dumb till that dread day when Orc assay'd his fierce embrace.

Dark virgin; said the hairy youth, thy father stern abhorr'd;
Rivets my tenfold chains while still on high my spirit soars;
Sometimes an eagle screaming in the sky, sometimes a lion,
Stalking upon the mountains, & sometimes a whale I lash
The raging fathomless abyss, anon a serpent folding
Around the pillars of Urthona, and round thy dark limbs,
On the Canadian wilds I fold, feeble my spirit folds.
For chain'd beneath I rend these caverns; when thou bringest food
I howl my joy, and my red eyes seek to behold thy face
In vain! these clouds roll to & fro, & hide thee from my sight.

49 *America: A Prophecy*,
1793. Orc fettered by Los
and Enitharmon (time and
space)

Blake's admirers are divided into those who see him as a
political propagandist who regrettably strayed away from
direct engagement in the issues of his day into incomprehensible
mysticism; and those for whom he was a mystic and visionary
who discerned, as did the Hebrew Prophets, the spiritual causes
behind history. According to David Erdman and J. Bronowski,
Blake's prophetic allegories were a disguise he was forced to
adopt by the danger of speaking openly on political issues at the
time of the French Revolution (especially after this country had
declared war on France). To others, Blake's spiritual vision
seems clearer than his politics. Blake was not at any time
thinking on the same plane as Paine or Godwin; like Shelley

Silent as despairing love, and strong as jealousy.
The hairy shoulders rend the links, free are the wrists of fire;
Round the terrific loins he siez'd the panting struggling womb;
It joy'd: she put aside her clouds & smiled her first-born smile:
As when a black cloud shews its lightnings to the silent deep.

Soon as she saw the terrible boy then burst the virgin cry.

I know thee, I have found thee, & I will not let thee go;
Thou art the image of God who dwells in darkness of Africa;
And thou art fall'n to give me life in regions of dark death.
On my American plains I feel the struggling afflictions
Endur'd by roots that writhe their arms into the nether deep:
I see a serpent in Canada, who courts me to his love;
In Mexico an Eagle, and a Lion in Peru;
I see a Whale in the South-sea, drinking my soul away.
O what limb rending pains I feel. thy fire & my frost
Mingle in howling pains, in furrows by thy lightnings rent;
This is eternal death; and this the torment long foretold.

50 *America: A Prophecy*, 1793. Orc: 'The hairy shoulders rend the links'

(who may possibly have seen some of Blake's Prophetic Books at Godwin's house), he saw the warfare in 'heaven' – that is, the inner worlds – in whose engagement the mortal actors are mere puppets in some great drama of the collective consciousness.

For Blake, outward events and circumstances were the *expressions* of states of mind, ideologies, mentalities, and not, as for the determinist-materialist ideologies of the modern world, their causes. Blake's 'dark Satanic Mills', so often invoked in the name of social reform, prove, when we read *Milton* (the poem in which these mills are most fully described) to be the mechanistic 'laws' of Bacon, Newton and Locke, of which the

Enitharmon slept,
Eighteen hundred years: Man was a Dream!
The night of Nature and their harps unstrung:
She slept in middle of her nightly song,
Eighteen hundred years, a female dream!

Shadows of men in fleeting bands upon the winds:
Divide the heavens of Europe:
Till Albions Angel smitten with his own plagues fled with his bands
The cloud bears hard on Albions shore:
Fill'd with immortal demons of futurity:
In council gather the smitten Angels of Albion
The cloud bears hard upon the council house: down rushing
On the heads of Albions Angels.

One hour they lay buried beneath the ruins of that hall:
But as the stars rise from the salt lake they arise in pain,
In troubled mists oerclouded by the terrors of struglling times.

51 *Europe, 1794. Mildew blighting ears of corn*

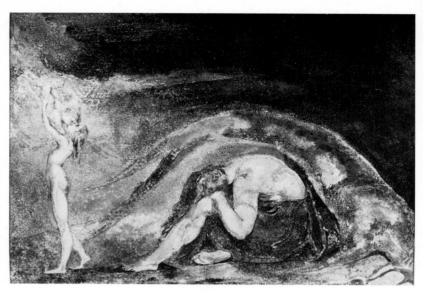

52 *America: A Prophecy*, 1793. Cancelled plate: *A Dream of Thiralatha*

industrial landscape was a reflection and expression. Man has made his machines in the image of his ideology. So, always, Blake seeks to discover the source of social and private ills within man. Only a change of the heart and mind of the nation can create a new society and new cities less hideous than those created by an atheist and mechanistic rationalism.

Blake gradually renounced politics for something more radical: not religion, in the sense of a system of beliefs and observances, but a transformation of the inner life, a rebirth of 'the true man'. Politics and religion alike came to seem to him an evasion of the 'one thing needful'.

This is not to say that Blake's 'prophetic' poems no longer related to current history; rather, he saw history from within; in the succession to the Prophets of Israel, he addressed the English nation at the level of spiritual causes, not of day-to-day policy. 'Every Natural Effect has a Spiritual Cause Not a Natural; for a Natural cause only seems.'

74

His *Europe: A Prophecy* followed *America* a year later, in 1794. 51, 53–4
It contains seventeen quarto pages, among them some of the
most beautiful Blake ever made. The Frontispiece, *The Ancient
of Days*, published also as a separate plate, bears little relation 54
to the theme of the poem, which describes the fiery activities
of 'Red Orc' trampling the grapes of wrath in the 'vineyards' of
France. *The Bellman*, *The Plague*, and the companion plates
War and *Famine* are more topical and illustrate the horrors of
war. The more decorative designs include one of the gayest of
Blake's depictions of the untrammelled energies of life: two
'spiritual bodies or angels', or perhaps fairies, blowing flower– 51
like trumpets as they speed through a minute world of grass-
blades and ears of barley. Tendrils endowed with the energy of
serpents advance to meet lines of verse much inferior to the
accompanying designs.

53 *Europe*, 1794. Insect
webs

55–7 The title of *The First Book of Urizen*, also of 1794 (there was never a 'second' Book of Urizen), suggests on the analogy of the 'first' and 'second' Books of Kings, Samuel, etc. that it belonged to Blake's 'Bible of Hell', promised to the world in *The Marriage of Heaven and Hell*. In this cosmological picture-book, Blake deserts politics to depict and describe his tyrant-demon Urizen. Some of the most effective plates have no text: as Gilchrist says, 'the volume seems to be a carefully finished selection of compositions from his portfolios and engraved books'. It was for this work that Blake first used an admixture of glue and paint as a colour-printing medium. The poem itself is a sombre satire of Milton's account of the Creation; according to Blake, the Seven Days of Creation represent seven phases of the imprisonment and 'binding' of 'the caverned man' within the limitations of a world experienced only through the five senses. Urizen, thus limited, becomes the self-deluded and anxious demiurge, engaged in the 'enormous labours' of imposing his 'ratio of the five senses' on rebellious life, whose nature he has not understood. Such, according to Blake, is 'human reason', the false God of the Enlightenment, and, in France, of Rousseau and Voltaire.

There are terrible and powerful depictions of constricted and distorted forms of life, suffering under the tyranny of Urizen's 'laws of nature' and a morality based upon natural, not spiritual law. Spirits of life are drawn down from the region of consciousness which is, for every soul, its own place, into the
55 dizzying abyss of time and space, Newton's 'soul-shuddering vacuum' – in terms of life, 'outside existence'. Into this realm of tyranny is born Orc, the Burning Babe, the spirit of life destined everywhere and always to defy the systematization of the rationalist.

With *The Song of Los*, *The Book of Ahania* and *The Book of Los* (all dated 1795) Blake seems to have exhausted the vein of his 'Bible of Hell'. In these later books other figures of his pantheon emerge: Los, spirit of time and of prophecy; and his consort Enitharmon (who is at once space, and the mother of

76

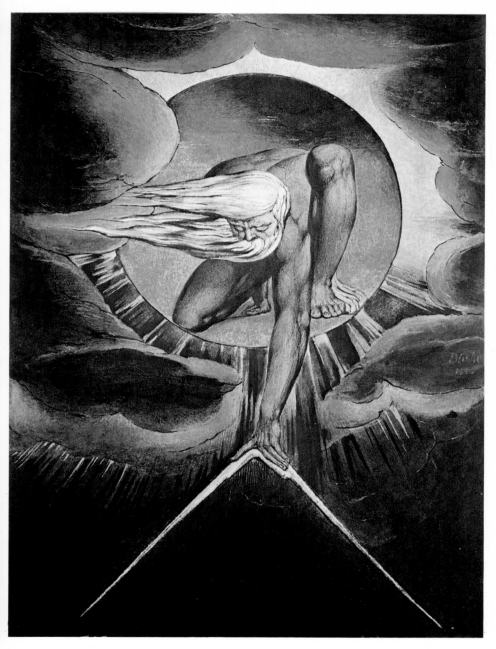

54 *The Ancient of Days*, 1794. From *Europe: A Prophecy*. 'When he sets a compass upon the face of the deep' (*Proverbs* 8: 27)

those forms in which the imaginings of the artist are embodied). These figures were named (though scarcely realized, and not depicted) in *Europe* (1794). In *The First Book of Urizen* Los is the reluctant agent of the 'binding' of Urizen, and is himself 'rent apart' when Urizen is separated from the wholeness of humanity. Separated likewise from Enitharmon by this fall of man into division, he begets upon her the child Orc, who is (as in the archaic Greek pantheon where each succeeding generation of gods overthrows the heaven-ruler) destined to overcome Urizen.

In *The Four Zoas* (1795–1804), *Milton* (1804–8) and *Jerusalem* (1804–20), Los and Enitharmon are more fully realized, and – with Blake's progressive loss of faith in revolution – Orc, spirit of revolution, recedes into the background. Urizen, still retaining the venerable features of 'aged ignorance', becomes the Satan of *Milton*. He makes his last, terrible appearance as the cloven-footed false image of God, who, in the *Illustrations of the Book of Job*, torments Job with his pretence to being the supreme God. Throughout Blake's work, the true world-ruler is 'Jesus, the Imagination', the 'God within', whose mystical marriage with the soul is celebrated in the last plate of *Jerusalem*.

59, 75 Probably much of the *Vala* manuscript (later called *The Four Zoas*) was written in Lambeth. The poem is a palimpsest; additions, insertions and deletions were built round an earlier *Vala* poem, probably begun in 1791. *The Four Zoas* in its relatively final form represents a new beginning, incorporating portions of the earlier manuscript, which itself represents more than one attempt. There are a few striking pencil drawings – some of them so 'strange' that Tatham (to whom Mrs Blake bequeathed Blake's papers) tried to rub them out; but the poem was never engraved or made into an illuminated book.

The interest of the manuscript is mainly literary. A beautiful passage in Night the Ninth retells, in a style reminiscent of *The Book of Thel* (1789), the story of Cupid and Psyche in terms of Blake's own pantheon, with Vala as the soul-figure, and Luvah (the 'eternal' form of Orc) as Eros. The poem contains

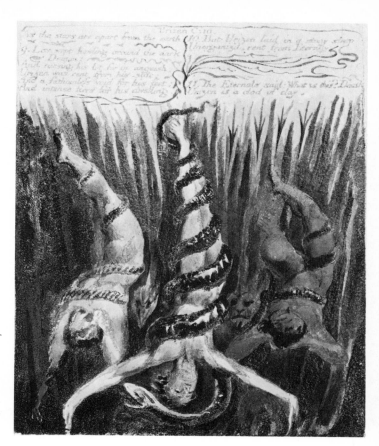

55 *The Book of Urizen*, 1794. Immortals falling into the abyss of time and space created by the materialist philosophy of Bacon, Newton and Locke

some magnificent poetry; the passages spoken by Enion, the earth-mother, beginning 'What is the price of Experience?' (line 397 of Night the Second), and her speech at the end of Night the Seventh on resurrection of the 'eternal man', are unsurpassed in Blake's later works.

In this poem the Four Zoas and their Emanations – the pantheon of Blake's interior cosmos – take their final forms. Urizen and Orc remain, but the active agents of the soul's recovery from the 'sleep of death' are now the poetic genius (Los) and his 'Emanation', Enitharmon, who gives form to the imaginings of the 'Poetic Genius'. Two new figures – Enion

79

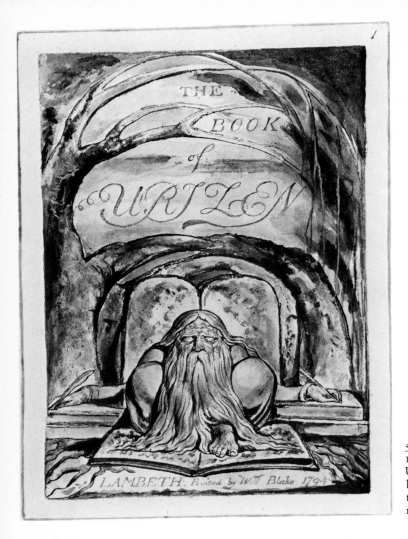

56 *The Book of Urizen,*
1794. Title-page:
Urizen with tables and
book of law beneath
the enrooted tree of
nature

and Tharmas – complete the 'fourfold' pattern of the psyche
by the introduction of the mutable form, and formless energy,
of the physical body.

Blake's poetic descriptions of the acts and attributes of these
mythological beings are in themselves pictorial; we seem to
know their appearance, behaviour, voices almost, as they
existed in Blake's vivid visualizations.

80

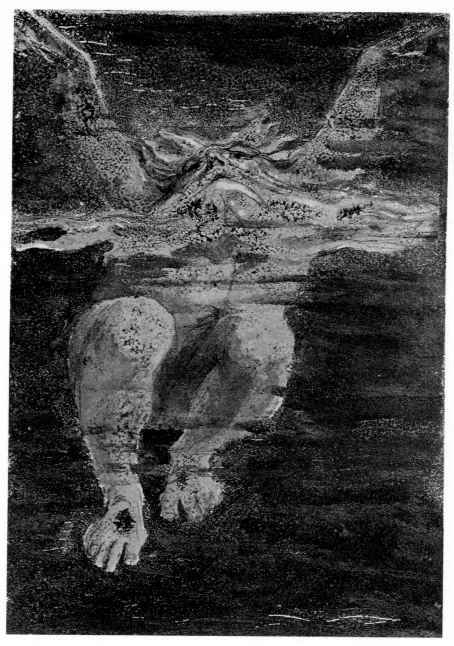

57 *The Book of Urizen*, 1794. Urizen struggling in the waters of materialism

During his seven years at Lambeth Blake produced, besides illuminated books, a number of designs. He had shown at the Royal Academy exhibition of 1785 four watercolour drawings: one from Gray, *The Bard*, the other three from the story of Joseph. A prospectus etched in 1793 advertises for sale 'at Mr Blake's, No. 13 Hercules Buildings, Lambeth', besides the illuminated books and *The Gates of Paradise*, 'Job, a Historical Engraving', 'Edward and Elinor, a Historical Engraving', and 'The History of England, a small book of Engravings'. Blake's first essay on the theme of *Job* illustrates the text which inspired *The Gates of Paradise*: 'What is man, that thou shouldst try him every Moment.' In the equally splendid companion print, on the death of Ezekiel's wife: 'Take away from thee the desire of thine eyes,' Blake has introduced one of those recumbent marmoreal figures reminiscent of the royal tombs; another mourning figure, bowed, with falling hair, shows a characteristic pose of Blake's invention.

58

58 *Death of Ezekiel's Wife*, 1794

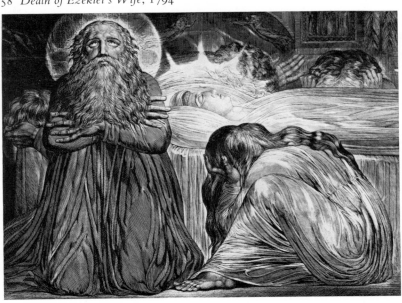

Vala incircle round the furnaces where Luvah was clos'd
In joy she heard his howlings, & forgot he was her Luvah
With whom she walkd in bliss, in times of innocence & youth

Hear ye the voice of Luvah from the furnaces of Urizen

If I indeed am Valas King & ye O sons of Men
The workmanship of Luvahs hands: in times of Everlasting
When I calld forth the Earth-worm from the cold & dark obscure
I nurturd her I fed her with my rains & dews, she grew
A scaled Serpent, yet I fed her tho' she hated me
Day after day she fed upon the mountains in Luvahs sight
I brought her thro' the Wilderness, a dry & thirsty land
And I commanded springs to rise for her in the black desart
Till she became a Dragon winged bright & poisonous
I opend all the floodgates of the heavens to quench her thirst

And

59 *Vala* manuscript, 1795–1804

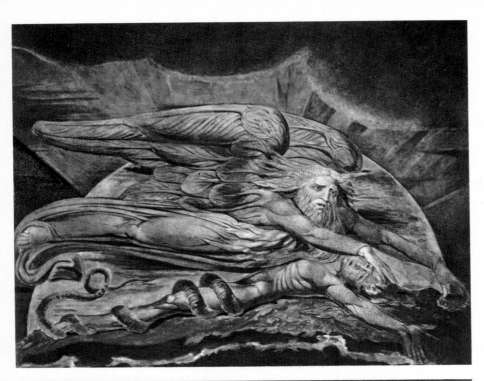

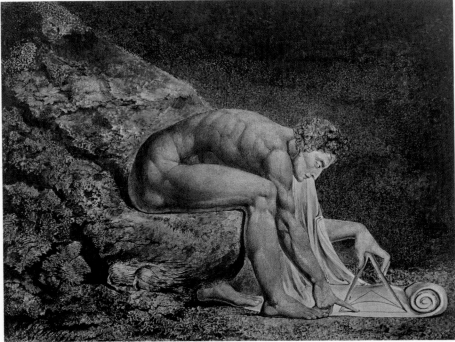

In 1795 Blake made a series of designs in a new technique, the result of experiments found in certain copies of *Urizen*, probably executed in the previous year. Lawrence Binyon described the method Blake used as being 'to make the design roughly and swiftly on mill-board in distemper (not oil-colours) and while it was wet to take an impression from it on paper. The blotted ground-work of this impression was coloured up by hand. The design could be revived on the mill-board when another impression was wanted.' According to Anthony Blunt the medium was probably egg tempera, and the printing was done in two stages, first in a black outline, then in colour. The effect is darker and richer than that of the illuminated books; the texture is mottled.

The first of this series is *God creating Adam*. The creator of 60
Adam, the 'mortal worm' or natural man, is Blake's demiurge

60 *God creating Adam*, 1795

61 *Newton*, 1795

62 *Nebuchadnezzar*, 1795

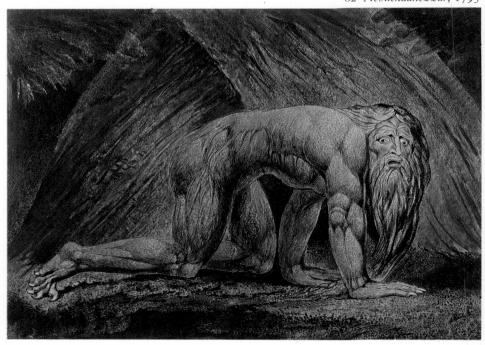

Urizen; 'thinking as I do that the Creator of this World is a very Cruel Being, and being a Worshipper of Christ, I cannot help saying: "The Son, O how unlike the Father! First God Almighty comes with a Thump on the Head, and then Jesus Christ comes with balm to heal it."'

61 Others in this series are *Satan exulting over Eve, Newton,*
62–5 *Nebuchadnezzar, The House of Death, Hecate, Pity,* from *Macbeth, Lamech and his two Wives, The Death of Abel* and *Ruth.* The print long known as *Elijah in the Chariot of Fire* is now thought
66 to be the supposedly lost print of *God judging Adam.*

67 *Good and Evil Angels,* the last of the series, is, like the *Nebuchadnezzar,* developed from a design which first appeared
68 in *The Marriage of Heaven and Hell.* The figures may illustrate an idea taken from Blake's admired spiritual master Jakob Boehme, who describes the impassable barrier that divides the principles of Heaven and Hell as a 'blindness' which prevents the devils from seeing the things of Heaven, or the angels those

63 *Hecate, c.* 1795

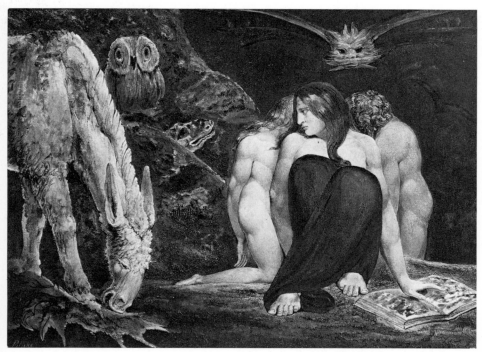

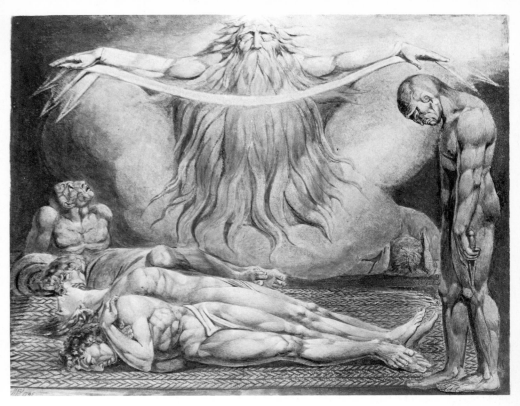

64 *The House of Death, c.* 1795

of Hell. Even though their worlds should occupy the same place, they are in states of being which cannot meet. 'Each Spirit is cloathed with his own World's Property wherein it dwells. The Beginning of each World's Source is that Limit divides one World from the View and Observation of the other.'

Newton shows the 'spiritual state' of the great scientist; he is *61* absorbed in mathematical calculations, his eyes fixed on the diagrams he draws on the bottom of that 'sea of time and space' which is the principle to which he is confined. Urizen had been similarly represented (in one of the plates of *The First Book of Urizen*), immersed in the dark and dense medium of water, *57* traditional esoteric symbol of the material world. Blake in-

87

variably uses water and sea in this sense: as Noah's 'flood of the five senses' whose deluge overwhelmed the antediluvian world, from which only the six persons in the Ark survived in the possession of those spiritual faculties which in the Golden Age belonged to all mankind. (For this seemingly roundabout reason, Noah and his Sons, in Blake's mythology, preside over the arts; 'poetry, painting and music' are man's 'three ways of conversing with Paradise'.)

This series of magnificent colour prints marks Blake's full emergence as a master in the visual arts, and as if to mark this independence he also made a series of prints using the metal plates of some of the Lambeth Books without the text, applying colouring to the metal plates to obtain the same mottled effect as that produced by the mill-board.

65 *Pity, c.* 1795

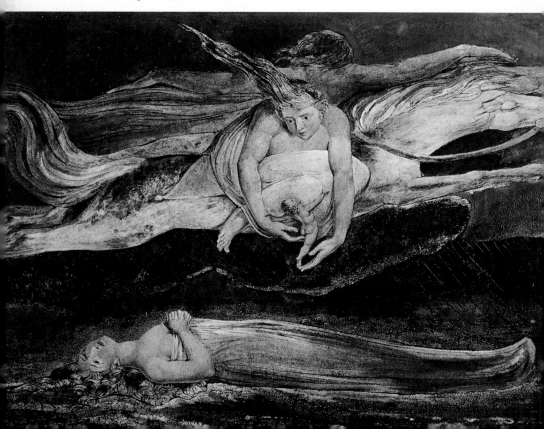

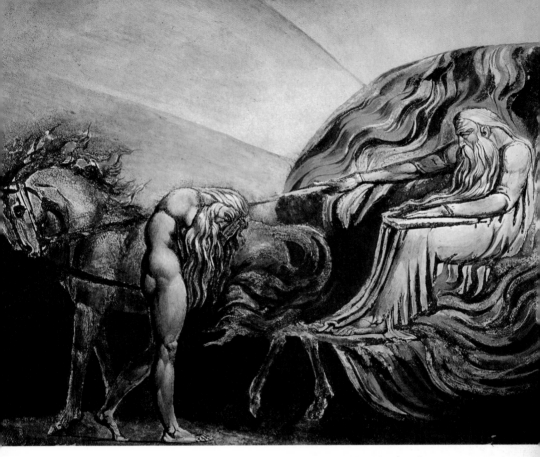

66 *God judging Adam*, 1795, formerly known as *Elijah in the Chariot of Fire*

In a letter written many years later, in 1818, Blake is probably referring to these designs when he speaks of 'a selection from the different Books of such as could be Printed without the Writing, tho' to the Loss of some of the best things. For they when Printed perfect accompany Poetical Personifications & Acts, without which Poems they never could have been Executed.'

Blake's *Small Book of Designs* (1796) was probably made for Ozias Humphrey the miniature-painter. His *Large Book of Designs* (*c.* 1796) contains coloured prints of the early works,

89

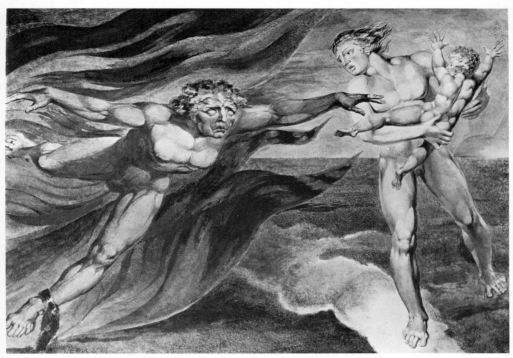

67 *Good and Evil Angels*, 1795

68 Design for *The Marriage of Heaven and Hell*, *c.* 1790–3

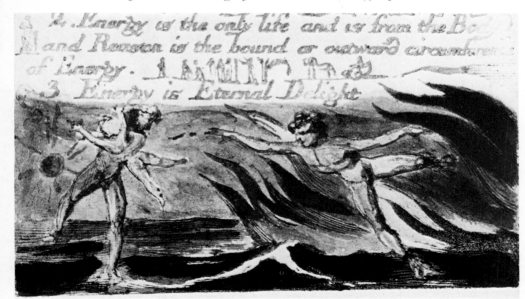

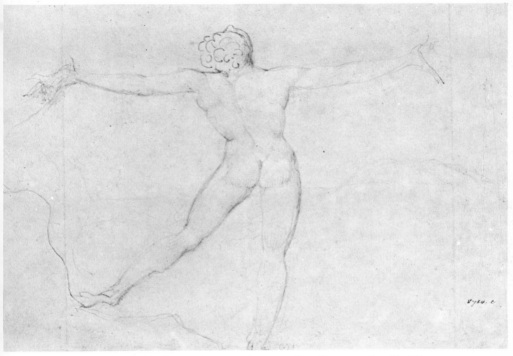

69 Drawing, probably from a Scamozzi proportion diagram, for *Glad Day*

Joseph of Arimathea and *Glad Day* (*c.* 1794), the second enlarged from an engraving made in 1780 – the first work to show those inimitable Blakean qualities of joyous energy and elegance of form. Mona Wilson in her *Life* of Blake suggests that this figure, with its fine wrists and aureole of flaming hair, is a self-portrait. Anthony Blunt sees the pose as suggested by the proportion-diagrams of Scamozzi, which Blake would have used as a student. There are similar figures, illustrating the human proportions in relation to square and circle, in Cornelius Agrippa's *Occult Philosophy*, a book he had certainly read. The Renaissance conception of the relation of microcosm to macrocosm would have interested so homocentric a thinker as Blake, and reappears in his own depictions and descriptions of 'the Giant Albion', the 'eternal man'.

70, 72

71

70 *Joseph of Arimathea preaching to the Inhabitants of Britain*, 1794. Blake's interest in English history extended into legendary prehistory. Joseph of Arimathea is said to have brought Christianity to England, accompanied, some say, by Jesus himself. This legend could give credibility to the lines: 'And did those feet in ancient time/Walk upon England's mountains green?'

71 Vitruvian man, from Cornelius Agrippa's *Occult Philosophy*, 1651

72 *Glad Day, c.* 1794

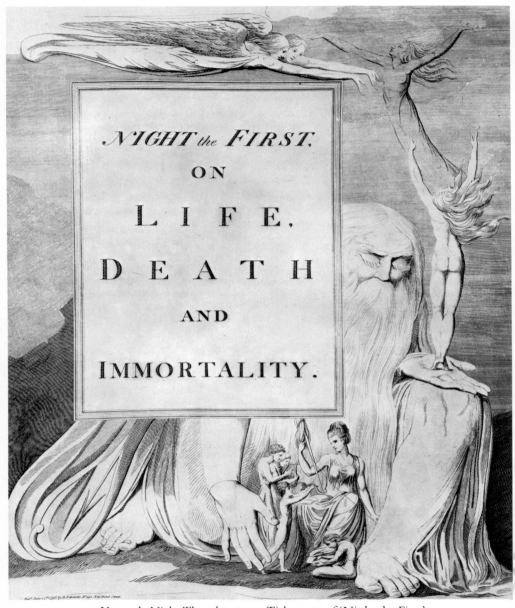

NIGHT the FIRST,

ON

LIFE,

DEATH

AND

IMMORTALITY.

73 Young's *Night Thoughts*, 1797. Title-page of 'Night the First'

Night Thoughts

Blake was by temperament an artist who must follow his own bent. But, always industrious, he accepted whatever work came his way. A commission offered by Edwards, a bookseller, to make and engrave designs to encircle the letter-press of that popular poem of the day, Young's *Night Thoughts*, seemed too good to refuse. A contemporary letter gives a glimpse of Blake as a businessman: 'There are about 900 pages. Blake asked 100 guineas for the whole. Edwards said that he could not afford to give more than 20 guineas to which Blake agreed.' For twenty guineas, therefore, Blake made five hundred and thirty-seven designs, of which he engraved fifty-three. These were for the first part of the edition, which was published in the autumn of 1797.

It may have been Fuseli who proposed Blake to Edwards, for it was he who praised Blake in the book's 'Advertisement', in the highest terms: 'To the eyes of the discerning it need not be pointed out; and while a taste for the arts shall continue to exist, the original conception, and the bold and masterly execution of this artist cannot be unnoticed or unadmired.'

But the project was a disastrous failure, abandoned after the first volume, which did not sell. The original coloured designs are now in the British Museum. In fact, the book is one of Blake's least pleasing works. The heavy designs seem too large and surround an awkward area of type. There is none of the delicacy of Blake's own illuminated books, with insect and tendril lovingly wandering among the lines of verse. His colleagues now began to speak of his 'extravagances', and his 'eccentric designs', with the usual Philistine addition (the words are quoted from Hoppner) that: 'Nothing would be more easy than to produce such. They were like the conceits of a drunken

A PINDARIC ODE. 97

'Hark, how each giant-oak, and desert-cave,
'Sigh to the torrent's awful voice beneath!
'O'er thee, oh King! their hundred arms
 'they wave,
'Revenge on thee in hoarser murmurs breathe;
'Vocal no more, since Cambria's fatal day,
'To high-born Hoel's harp, or soft Llewel-
 'lyn's lay.

 I. 3.
'Cold is Cadwallo's tongue,
'That hush'd the stormy main:
'Brave Urien sleeps upon his craggy bed:
'Mountains, ye mourn in vain
'Modred, whose magic song
'Made huge Plinlimmon bow his cloud-top'd
 'head.

 G 4 'On

74 Illustration to Gray's *Poems*: 'A Pindaric Ode'

fellow or a madman.' At least Blake put the proof-pages of Young to good use for the manuscript of his own 'Dream of Nine Nights': *Vala, or the Four Zoas.*

It was Blake's fate to be employed as the illustrator of poems far inferior to his own: Blair's *The Grave*, and Hayley's *Little Tom the Sailor*. Young's poem is the least bad of these best-sellers, whose readers have long gone to those graves which it was their melancholy pleasure to contemplate. For Blake, as for the Neoplatonists, the only grave of the universe was this world, the only death the spiritual death of its benighted inhabitants. He was the last artist to capture the *frisson* and the melancholy of the 'gothic' taste for mortality. And what, one wonders, would the author of *Night Thoughts* have made of Blake's 'Dream of Nine Nights'?

75 *Vala* manuscript, 1795–1804

Another set of illustrations belonging to the Lambeth period, that to Gray's poems, was a labour of love and an example of Blake's 'fun'. It was natural that Blake should have liked Gray; he did so for the same reasons that Dr Johnson, pundit of Augustan taste, disliked him. For in Gray there is the first sound of a new voice, of that 'inspiration' which was to bring to an end the smooth and complacent school of versifiers who preceded the Romantic movement.

It was Gray who in his 'Progress of Poesy' had invoked Shakespeare as supreme creator of:

> *Such forms as glitter in the Muse's ray*
> *With orient hues, unborrow'd of the Sun . . .*

The style is within the Augustan convention of polished elegance, but the content is new. 'One thing alone makes a poet,' Blake wrote, 'Inspiration, the divine vision.' Gray's interest in the antiquities of England, Wales and Ireland was in harmony both with Blake's interest in English history, and with his passionate mythological eclecticism. Perhaps, too, Blake was right in feeling that Gray's personifications were more than conventional. However that may be, Blake's Thames, guardian of the schoolboys of Eton, or his magnificent illustration to Gray's 'The Bard':

> *Hark, how each giant-oak, and desert cave*
> *Sigh to the torrent's awful voice beneath . . .*

at least shows what he could do as an illustrator of poetry which touched his imagination. His cat and goldfish, illustrating the 'Ode on the Death of a Favourite Cat' are gay and full of zest. There are 'little winged flies' and flower-elves, reminiscent of Doyle's later mischievous fancies, and – somewhat unexpectedly – a perfect observation of the boyish aristocratic elegance of the Etonians; gained, perhaps, from the pupils of another school, Westminster, when Blake, a nameless young draughtsman, was at work among the Abbey tombs. Blake was obviously moved by the weird mythology of 'The Descent of Odin';

76

77

ODE

ON THE DEATH OF A

FAVOURITE CAT.

Drowned in a Tub of Gold Fishes.

'TWAS on a lofty vafe's fide,
 Where China's gayeft art had dy'd
The azure flowers, that blow;
Demureft of the tabby kind,
The penfive Selima reclin'd,
 Gaz'd on the lake below.

Her confcious tail her joy declar'd;
The fair round face, the fnowy beard,
 The velvet of her paws,
 D 4 Her

76 Illustration to Gray's 'Ode on the Death of a Favourite Cat'. Early 1790s

his depictions of the Norns are powerful; and themes from Gray's Icelandic poem recur in *The Four Zoas*. The encounter of Urizen and his terrible Daughters in that poem is evidently based on a passage of Gray which he had illustrated. But as with all Blake's borrowings, whether from the Eleusinian Mysteries, Ovid, Swedenborg, or the Bible itself, the transformation is so radical that the seminal image is completely transformed.

Blake seems to have had no thought of publishing his illustrations to Gray's poems; eventually he presented the volume to Flaxman's wife as a mark of gratitude for yet another disastrous attempt to 'help' him, which was to lead to his removal from London during the years 1800–3: Flaxman's introduction of the poet to Hayley, 'the hermit of Eartham'.

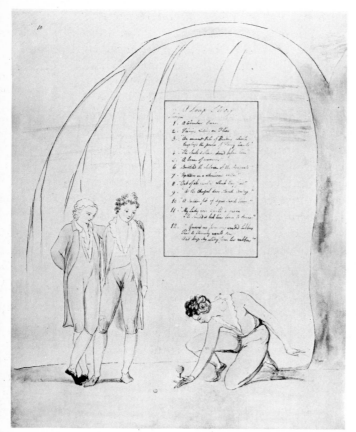

77 Illustration to Gray's 'On a Distant Prospect of Eton College'. Early 1790s

Natural Friends

Blake once wrote, in a moment of exasperation, that 'natural friends are spiritual enemies'. He was thinking at the time of Hayley's misguided attempts at patronage. George Cumberland, too, had tried to help Blake, introducing him to a clergyman, a Dr Trusler, who was in search of 'moral paintings' to illustrate a new book. But as Blake wrote to Cumberland in August 1799: 'I have made him a Drawing in my best manner; he has sent it back with a Letter full of Criticisms, in which he says It accords not with his Intentions, which are to Reject all Fancy from his Work. How far he Expects to please I cannot tell. But as I cannot paint Dirty rags & old shoes when I ought to place Naked Beauty or simple ornament, I despair of Ever pleasing one class of Men. Unfortunately our authors of books are among this Class; how soon we shall have a change for the better I cannot Prophecy. Dr Trusler says *"Your Fancy*, from what I have seen of it, & I have seen variety at Mr Cumberland's, seems to be in the other world, or the World of Spirits, which accords not with my Intentions, which, whilst living in This World, Wish to follow *the Nature of it."* I could not help smiling at the difference between the doctrines of Dr Trusler & those of Christ.'

But we owe to the Reverend Doctor some thanks for having elicited from Blake, if not one of his best designs, certainly one of his finest letters. Blake begins, 'I really am sorry that you are fall'n out with the Spiritual World'; and continues:

'I have therefore proved your Reasonings Ill proportion'd, which you can never prove my figures to be; they are those of Michael Angelo, Rafael & the Antique, & of the best living Models. I percieve that your Eye is perverted by Caricature Prints, which ought not to abound as much as they do. Fun

I love, but too much Fun is of all things most loathsom. Mirth is better than Fun, & Happiness is better than Mirth. I feel that a Man may be happy in This World. And I know that This World Is a World of Imagination & Vision. I see Everything I paint In This World, but Everybody does not see alike. To the Eyes of a Miser a Guinea is far more beautiful than the Sun, & a bag worn with the use of Money has more beautiful proportions than a Vine filled with Grapes. The tree which moves some to tears of joy is in the Eyes of others only a Green thing which stands in the way. Some see Nature all Ridicule & Deformity, & by these I shall not regulate my proportions; & some scarce see Nature at all. But to the Eyes of the Man of Imagination, Nature is Imagination itself. As a man is, So he sees. As the Eye is formed, such are its Powers. You certainly Mistake, when you say that the Visions of Fancy are not to be found in This World. To Me This World is all One continued Vision of Fancy or Imagination, & I feel Flatter'd when I am told so. What is it that sets Homer, Virgil & Milton in so high a rank of Art? Why is the Bible more Entertaining & Instructive than any other book? Is it not because they are addressed to the Imagination, which is Spiritual Sensation, & but mediately to the Understanding or Reason? Such is True Painting, and such was alone valued by the Greeks & the best modern Artists.'

On this letter Trusler wrote: 'Blake, dim'd with Superstition.'

One can imagine how Blake must have shrunk from Rowlandson's gross hideosities, to which he refers in his letter to Cumberland: 'for his own sake I am sorry to see that a Man [he is speaking of Dr Trusler] should be so enamour'd of Rowlandson's caricatures as to call them copies of life & manners'. As so often happens, a society which will accept the distortions of degradation, calls mad, extravagant, fanciful and so on, the rectifications of nature whose intention is in accordance with some norm of beauty – the elongations of Gothic statuary, or these departures from the proportions of 'the naked' by which the Renaissance sculptors (as Sir Kenneth Clark has

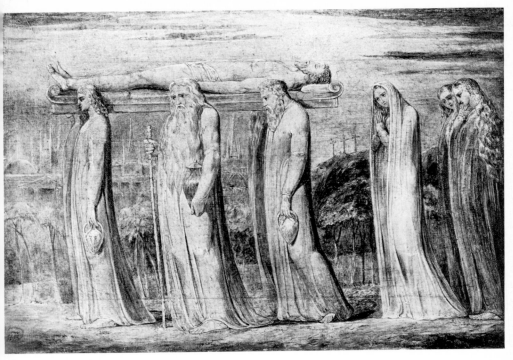

78 *The Procession from Calvary, c.* 1799–1800, one of Blake's many works
for Thomas Butts

shown) arrived at the fitting proportions of 'the nude'. The
way down is, on every level, easier than the way up; and the
public of eighteenth-century England was, when all is said,
coarse and provincial.

But Blake had one patron who never failed him; who left
him free to follow his own imaginative impulse, promising
only to buy from him whatever he should paint. This was
Thomas Butts, who is first referred to by Blake in the letter to
George Cumberland already quoted:

'As to Myself, about whom you are so kindly Interested, I
live by Miracle. I am Painting small Pictures from the Bible.
For as to Engraving, in which art I cannot reproach myself with
any neglect, yet I am laid in a corner as if I did not Exist, &

Since my Young's Night Thoughts have been publish'd, Even Johnson & Fuseli have discarded my Graver. But as I know that He who Works & has his health cannot starve, I laugh at Fortune & Go on & on. I think I forsee better Things than I have ever seen. My Work pleases my employer, and I have an order for Fifty small Pictures at One Guinea each, which is Something better than mere copying after another artist.'

Blake's 'employer' filled his house in Fitzroy Square with his works: Butts' house was to be the chief repository of Blake's output as a painter to the end of his life. Geoffrey Keynes has described him as 'a dumb admirer of genius, which he could see but not quite understand'. The greater his honour, if this be so, for his lifelong and single-minded devotion, honouring, as Blake says we should, the gifts of the spirit in other men. Gilchrist says he was 'Muster-master General'; but G. E. Bentley, jun. has found that he was in fact only chief clerk in the Muster-master's office, writing the letters dealing with the enlistment of soldiers. He did, however, die a wealthy man, probably having made his fortune by wise investment and in real estate.

Butts was more than a purchaser; to him Blake could open his heart, as we know from many letters addressed to him. Mr and Mrs Blake were frequent and welcome guests at the house in Fitzroy Square; and Butts even tactfully sought to increase Blake's income by sending his son Thomas to take drawing lessons. 'Tommy' must have been a secret rebel; on inheriting his father's Blake collection he sold a great part of it, including the original *Illustrations of the Book of Job*. The remainder he left to his son, Captain Butts, and his daughter, Mrs Graham Foster Piggot. Mrs Piggot stored her share in a loft where they are said to have been 'devoured by rats'; but Captain Butts appreciated Blake's work, and his share of the great Blake collection remained almost intact. His widow was obliged to sell the collection in 1903, by which time Blake's fame was beginning to rise. These pictures were bought by

Graham Robertson, who between 1885 and 1940 was Blake's most devoted and discerning collector. At the sale of his collection in 1949, many of Blake's greatest works went to public galleries. Graham Robertson had himself bequeathed seven, including five of the colour-printed drawings, to the Tate Gallery; and he left a fund to enable paintings to be bought for public collections.

Nearly all Blake's surviving Bible illustrations, in tempera, watercolour and colour-printed drawing, come from the Butts collection. They number one hundred and thirty-seven illustrations of Old Testament subjects and thirty-eight of the New Testament. Blake was selling regularly to Butts between 1799 and 1810. He writes to him with justifiable pride: '. . . the works I have done for You are Equal to Carrache or Rafael (and I am now Seven years older than Rafael was when he died), I say they are Equal to Carrache or Rafael, or Else I am Blind, Stupid, Ignorant and Incapable in two years' Study to understand those things which a Boarding School Miss can comprehend in a fortnight. Be assured, My dear Friend, that there is not one touch in these Drawings & Pictures but what came from my Head & my Heart in Unison; That I am Proud of being their Author and Grateful to you my Employer; & that I look upon you as the Chief of my Friends, whom I would endeavour to please, because you, among all men, have enabled me to produce these things.'

Blake had an antipathy to the oil medium because he thought it would not stand the test of time; 'oil became a fetter to genius, and a dungeon to art', he declared. He used what he called 'tempera', because he believed 'the colours would be as pure and permanent as precious stones', like those early Italian paintings he most admired. Unfortunately he was wrong. His temperas, painted on canvas, wood and sometimes on copper, were applied, not in egg medium, such as the Italian masters used, but in a solution of glue, with a light wash of glue laid on afterwards as varnish. All have darkened and cracked, and many have not survived. He must have improved

his tempera technique, however, for the later paintings in this
119 medium (for example the Arlington Court tempera, and
144 *Ugolino and his sons in Prison*) have not suffered to the same
extent. Not until 1941 was a method of cleaning and laying
down the surfaces discovered, making possible their restoration
and preservation.

Few of Blake's paintings are more than two feet square:
they are 'small pictures' to hang on the walls of his patron's
house. England neglected the talent of her greatest religious
artist, who would have rejoiced to decorate the churches of
London, making their walls brilliant as the Gothic mural
painters had done. George Goyder, in his Introduction to the
William Blake Trust illustrated catalogue of Blake's Bible
illustrations, writes that: 'It was Blake's ambition to make
England, like Italy, "respected on account of art".' Some years
ago Heming Vaughan tried to set in train a project of a Blake
Bible; perhaps the project may be revived someday, for no
other English artist has illustrated the Bible with comparable
understanding.

It was through no wish of his own that Blake worked in seclu-
sion. In his *Descriptive Catalogue* of 1809 he lamented that the
painters of England were not engaged on public works.
93 Four of the Bible series, his magnificent *Jacob's Ladder*, *The*
85 *Body of Abel found by Adam and Eve, Soldiers casting Lots for*
79 *Christ's Garments* and *Angels Hovering* were designed as frescoes
to adorn the altars of churches. These frescoes were to be
removable, for 'If the Frescos of *Apelles*, of *Protogenes*, of
Raphael or *Michael Angelo* could have been removed, we might,
perhaps, have them now in England. I could divide Westminster
Hall, or the walls of any other great Building, into compart-
ments and ornament them with Frescos, which would be
removable at pleasure.'

So wrote Blake on 'The Invention of a Portable Fresco' in the
advertisement for his one public exhibition, his last vain attempt
to persuade the visionless patrons of contemporary English art
to allow him to adorn our public buildings and churches.

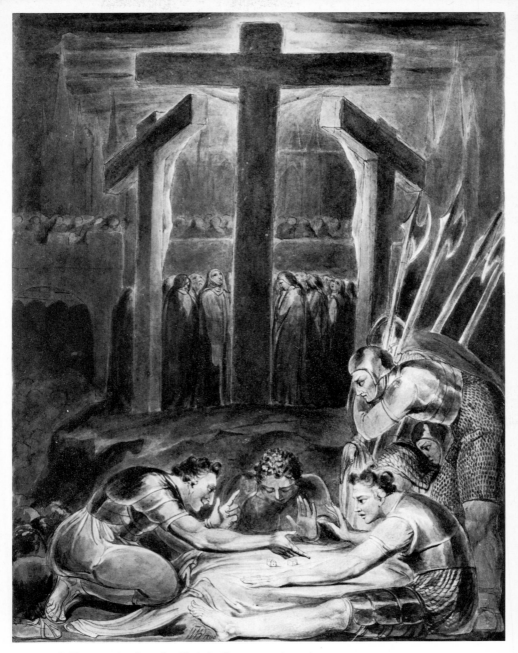

79 *Soldiers casting Lots for Christ's Garments*, 1800

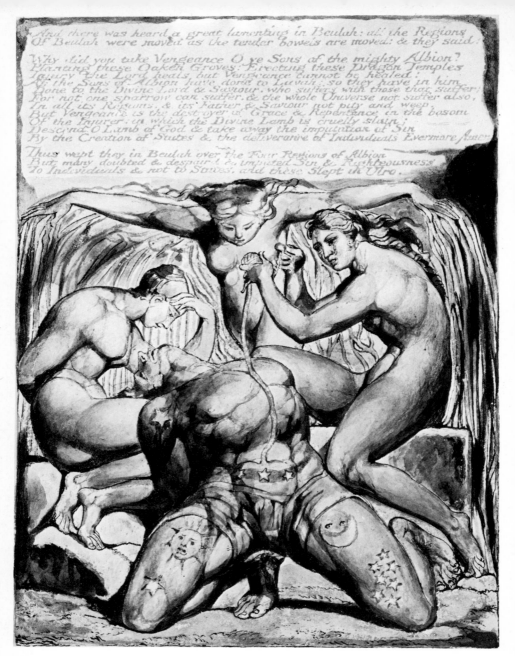

And there was heard a great lamenting in Beulah: all the Regions
Of Beulah were moved as the tender bowels are moved: & they said:

Why did you take Vengeance O ye Sons of the mighty Albion?
Planting these Oaken Groves: Erecting these Dragon Temples
Injury the Lord heals, but Vengeance cannot be healed:
As the Sons of Albion have done to Luvah, so they have in him
Done to the Divine Lord & Saviour, who suffers with those that suffer;
For not one sparrow can suffer, & the whole Universe not suffer also,
In all its Regions, & its Father & Saviour not pity and weep,
But Vengeance is the destroyer in Grace & Repentance in the bosom
Of the Injurer: in which the Divine Lamb is cruelly slain;
Descend O Lamb of God & take away the imputation of Sin
By the Creation of States & the deliverance of Individuals Evermore Amen

Thus wept they in Beulah over the Four Regions of Albion
But many doubted & despaird & imputed Sin & Righteousness
To Individuals & not to States, and these Slept in Ulro.

80 *Jerusalem*, 1804–20. Note sun, moon and stars on the body of the Cosmic
Man. (Kerrison Preston Collection)

The Line of the Almighty

In a lecture given at the Italian Institute in 1958, Professor Giorgio Melchiori answers many of the questions which arise from Blake's professions of enthusiastic admiration for Michelangelo. What did Blake learn from Michelangelo? Did he understand, or profoundly misunderstand, the master whose work he had never seen in the original, but only in engravings? Since Blake had never seen Michelangelo's sculpture, it is understandable that he should have seen his work in linear terms. But he was, in any case, a linear artist in practice and by conviction. Roger Fry, who did not like the linear, or Blake, nevertheless (according to Professor Melchiori) 'put the question of Blake's style in a nutshell: "Blake translated Michelangelo into mere line, line which does not evoke volume at all, but remains pure line; and he lets his lines wave about in those meandering, nerveless curves which were so beloved by Celtic craftsmen long before."'

'Nerveless curves' is equally insensitive as a description of Blake's line and of Celtic craftsmanship. Line was, for Blake, above all an expression of energy. Every solid form can be seen as the imprint and the product of a flow of energy, and it is certain that Blake saw line as energy, as the signature of life.

'The great and golden rule of art, as well as of life, is this,' he wrote, 'That the more distinct, sharp, and wiry the bounding line, the more perfect the work of art; and the less keen and sharp, the greater is the evidence of weak imitation, plagiarism, and bungling. Great inventors, in all ages, knew this: Protogenes and Apelles knew each other by this line. Rafael and Michael Angelo and Albert Dürer are known by this and this alone. The want of this determinate and bounding form evidences the want of idea in the artist's mind, and the pretence

of the plagiary in all its branches. How do we distinguish the oak from the beech, the horse from the ox, but by the bounding outline? How do we distinguish one face or countenance from another, but by the bounding line and its infinite inflexions and movements? What is it that builds a house and plants a garden, but the definite and determinate? What is it that distinguishes honesty from knavery, but the hard and wirey line of rectitude and certainty in the actions and intentions? Leave out this line, and you leave out life itself; all is chaos again, and the line of the almighty must be drawn out upon it before man or beast can exist.'

Hogarth had discovered the 'line of beauty' in the waving or serpentine line, the meander, and as Professor Melchiori relates, 'he was delighted when a friend pointed out to him that his theory of the pre-eminence of the serpentine line corresponded exactly to a precept of Michelangelo's'. In his preface to his *Analysis of Beauty* he quoted from G. P. Lomazzo's treatise on painting (in an English translation of 1598) the passage in which Michelangelo's view is given. Blake must have read Hogarth's work, and, finding in Michelangelo what he had discerned in Gothic, and Flaxman in Greek art, he added Michelangelo to the circle of those spiritual friends (like Boehme and Paracelsus, Socrates, Milton and the Hebrew prophets) who sometimes 'dined with him' on 'the bread of sweet thought and the wine of delight'. According to Lomazzo: 'It is reported that Michael Angelo upon a time gave this observation to the Painter *Marcus da Sciena*, his scholler: that he should alwaies make a figure Pyramidall, Serpent like, and multiplied by one two and three. In which precept (in mine opinion) the whole mysterie of the arte consisteth. For the greatest grace and life that a picture can have, is, that it expresses Motion: which the Painters call the Spirite of a picture. Nowe there is no forme so fitte to expresse this *motion*, as that of the flame of the fire, which according to *Aristotle* and the other Philosophers, is an elemente most active of all others; because the forme of the flame thereof is most apt for motion: for it hath a *Conus* or

sharpe pointe wherewith it seemeth to divide the aire, that so it may ascend to his proper sphere. So that a picture having this forme will be most beautiful.'

If for no other reason, Blake would have loved Michelangelo for the observation in this passage. For Blake, volume and weight belonged to the mechanistic concept of a natural world subject to the quantitative 'laws of nature' as these operate in time and space; the universe of 'Bacon, Newton and Locke', of the 'Satanic mills' of natural causality – to all, in fact, which he himself opposed with all the energy of his prophetic mission. Against the mechanistic view of nature, product of the rational mind of Urizen, Blake proclaimed life. Life is non-spatial and non-temporal; gravity does not weigh it down, nor bulk contain it. There are, for Blake's human figures, essentially two conditions – the unconfined freedom of unimpeded energy; and the constricted, fettered, weighted and cramped state of the prisoners of Urizen's universe of mechanized nature. Michelangelo's prisoners, struggling from their rocky confinement, would have signified, for Blake, life freeing itself from the oppression of matter, like the figure of Earth in his own *42* *Gates of Paradise.*

Even had Blake seen Michelangelo in the original, it is not possible to imagine that he would have followed him in mass and volume, since these had no part in his own imaginative vision. The figures of a spiritual art, whether Gothic, Byzantine or Buddhist, whether of men or angels, are situated in mental, not corporeal, space. The weightlessness of a Chinese landscape likewise expresses a vision of nature unconditioned by physical bulk and volume. The naturalism of Western European art, against whose restrictions Blake was in revolt, is indeed rather the exception than the rule in the art of the world.

The spirit is already free; and 'the spiritual body or angel' is the true man, released from its 'excrementitious husk and covering'. Here Blake is close to Swedenborg, whose disembodied spirits are fully human but liberated from the restrictions of a material body. Swedenborg taught that the Resurrection of

the Dead is the freeing of the spiritual body from its earthly
envelope, the 'rotten rags' of mortality. Like Swedenborg,
Blake had himself seen spirits of another plane of existence: his
brother Robert, 'clapping his hands for joy' as he rose through
the ceiling, and other spiritual visitants, real or imagined,
throughout his life. The physical body was beautiful to Blake
in so far as it reflected the lineaments of an informing soul or
spirit, the 'celestial body' of a famous passage of St Paul's First
Epistle to the Corinthians, which Blake invokes in his emblem
81 accompanying the poem 'To Tirzah' (*c.* 1801): *It is raised a
spiritual body*. Blake's human figures are already such. 'Man
has no Body distinct from his Soul; for that call'd Body is a
portion of Soul discern'd by the five senses.' He held that 'the
Poetic Genius is the true Man, and that the body or outward
form of Man is derived from the Poetic Genius'.

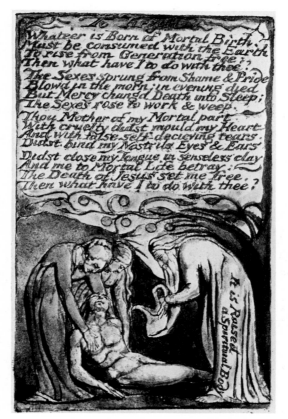

81 *Songs of Experience.*
'To Tirzah', *c.* 1801

Like Plato, Blake uses the symbol of the Cave. For him the Cave is the body, lit by the five windows of the senses. 'If the doors of perception were cleansed every thing would appear to man as it is, infinite. For man has closed himself up, till he sees all things thro' narrow chinks of his cavern.'

This traditional esoteric teaching seemed strange to Blake's contemporaries, and seems scarcely less so to ours.

Blake by no means shared the British love of landscape-painting. He loved natural forms – tendril and leaf, and the stranger forms of insect, worm and spider – as he did the human, but these he loved as embodiments of life. 'Everything that lives is holy', from 'the little winged fly' to man. The generalized impression of landscape was by no means the way in which Blake saw nature. For him the 'minute particulars' were all-important, and form the boundaries of some living energy. For Blake, all is human, since in this world man is central, made in the 'image of God', as the microcosm:

> . . . Each grain of Sand,
> Every Stone on the Land,
> Each rock & each hill,
> Each fountain & rill,
> Each herb & each tree,
> Mountain, hill, earth & sea,
> Cloud, Meteor & Star,
> Are Men Seen Afar.

Blake returns to a concept fundamental in all spiritual traditions: man is not 'part of nature', but all natural phenomena have their existence in consciousness. The human world is the world presented by human consciousness. He invokes the symbolic Adam Kadmon, of the Jewish esoteric tradition:

'You [the Jews] have a tradition that Man anciently contain'd in his mighty limbs all things in Heaven & Earth: this you received from the Druids.

'But now the Starry Heavens are fled from the mighty limbs of Albion.'

The universe of Newtonian science Blake condemned as a universe of abstractions and formulae, not of experience. Man's earth is what he perceives; and, as such, 'though it appears without, it is within/In your Imagination'. In a Michelangelesque figure Blake illustrates Albion's 'mighty limbs' with sun, moon and stars, about to be externalized by the 'cruel' female principle of nature:

80

> *Thou Mother of my Mortal part*
> *With cruelty didst mould my Heart*
> *And with false self-deceiving tears*
> *Didst bind my Nostrils, Eyes and Ears:*
>
> *Didst close my Tongue in senseless clay,*
> *And me to Mortal Life betray.*

Since the City is the expression of humanity, Blake's (or the Giant Albion's) 'Great Work' is the building of the 'spiritual fourfold London':

> *. . . for Cities*
> *Are Men, fathers of multitudes, & Rivers & Mountains*
> *Are also Men; everything is Human, mighty! sublime!*

That which Blake and the Florentine painters, Raphael and Michelangelo in particular, have in common is in reality the Neoplatonic – and specifically Plotinian – aesthetics, upon which the concept of 'ideal form' depends; identified by Blake, of course, with his 'divine humanity'. 'To whom all lineaments tend and seek in love & sympathy.'

Whether from his early training, or from the fact of being a Londoner, or for deeper reasons, 'the human form divine' was for Blake at all times supreme.

Burke in *A Philosophical Enquiry into the Origin of the Sublime and the Beautiful* had drawn a distinction which gave rise to a style common to Blake and his contemporaries, intended to express 'the sublime' as distinct from 'the beautiful'. According to Burke, the basis of beauty is pleasure; that of sublimity,

pain. Obscurity, grandeur, disorder, terror, power, vastness, infinity, difficulty and magnificence, by producing painful impressions, lead to the sublime. Blake rejected Burke's application of these ideas to picturesque landscape; but in common with Barry, Fuseli, Stothard and other contemporaries, he was not slow to attempt 'the sublime' in terms of the human form. Anthony Blunt points out that Blake, Barry, Stothard and Fuseli all attempted an example cited by Burke in illustration of his meaning, Milton's description in *Paradise Lost* of *Satan, Sin and Death*. In this context the grandeur and *terribilità* of Michelangelo takes its natural place. Those tormented and falling figures of his *Last Judgment* were the source of many visual themes to be found in Blake, including his own

82

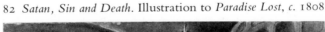

82 *Satan, Sin and Death*. Illustration to *Paradise Lost, c.* 1808

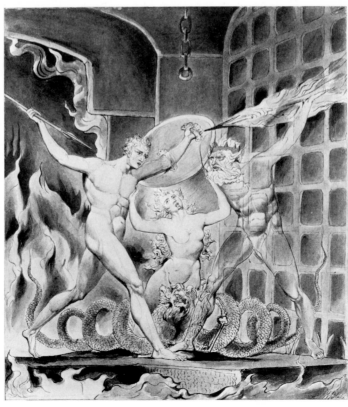

83 *Famine*, 1805 (Museum of Fine Arts, Boston)

96 *Last Judgment*. Professor Melchiori suggests that Blake's 'visions' of the Four Zoas are re-creations, probably unconscious, of the Michelangelesque works with which he was familiar. Blake's visual memory for both words and pictorial themes was remarkable, as anyone who studies his works soon discovers. Anthony Blunt has described many such visual borrowings; and the present author was guided in the discovery of many of Blake's literary sources by the 'minute particulars' of word and phrase borrowed – again probably unconsciously – from works he loved.

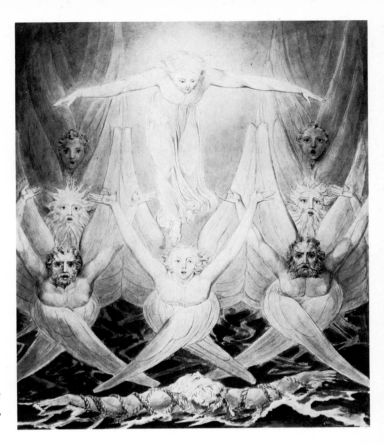

84 *David delivered out of Many Waters,* c. 1800–5

Blake's Bible illustrations, many of which were made during his residence at Lambeth, are unequal in quality. Anthony Blunt thinks that Blake's early choice of Biblical theme sometimes tended to underline his revolutionary views on sexual morality: there were, for instance, his *David and Bathsheba, Potiphar's Wife, Susannah and the Elders.* Be this as it may, each will find among them what he seeks. To the present writer, those profoundly esoteric depictions of the Seven Spirits of God – *The Creation of Light, God creating Adam, The Lord answers Job out of the Whirlwind, David delivered out of Many* 60 88, 84

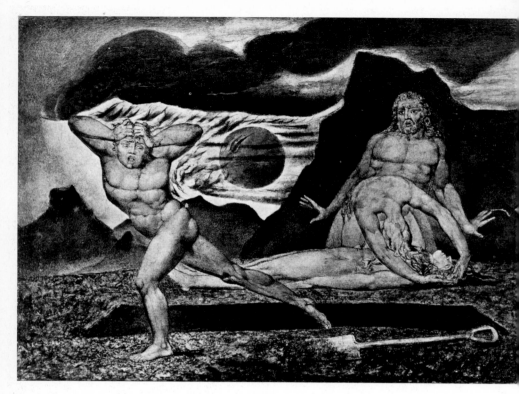

85 *The Body of Abel found by Adam and Eve*, c. 1826–7. Cain, who was about to bury the body, flees from the face of his parents

86 *Waters* or *Ezekiel's Vision* – speak of spiritual mysteries in a pictorial language lost since the Ages of Faith. There is the
93 superb heavenly ladder of Jacob's dream with its ascending and descending angels; the paradisal beauty of *Adam naming the Beasts* and *Eve naming the Birds*. The fleeing figure of Cain in
85 *The Body of Abel found by Adam and Eve* is almost Expressionist
83 in quality, and the desolate dream-landscape of *Famine* anticipates the best of Surrealism. Fine as are many of Blake's more naturalistic paintings, these might have been the work of one or other of his contemporaries; those of the interior vision, no one but Blake could then have attempted.

118

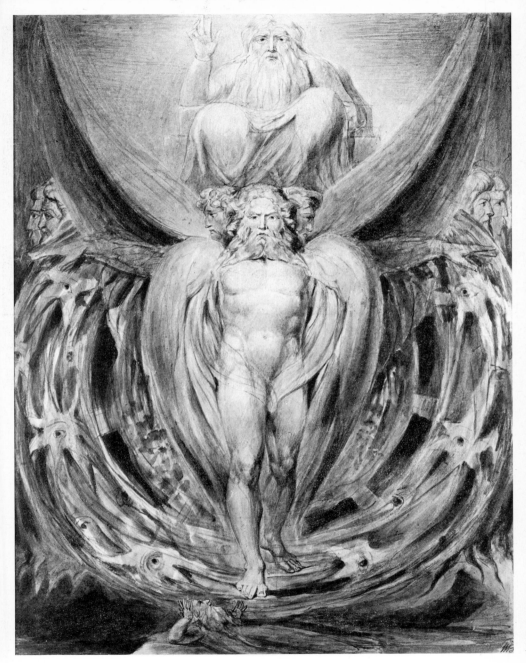

86 *Ezekiel's Vision* (Museum of Fine Arts, Boston)

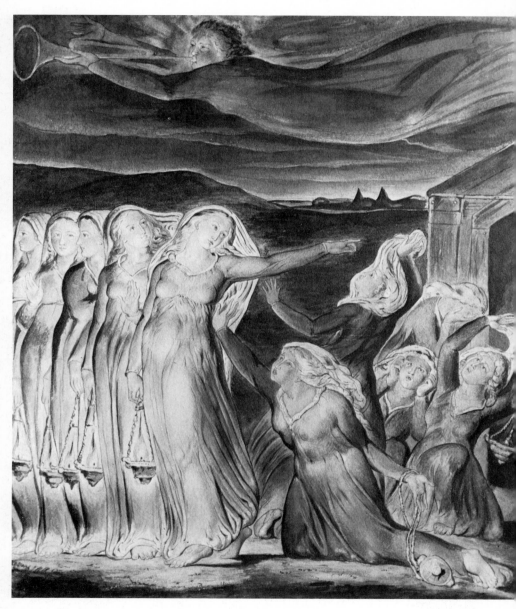

87 *The Wise and Foolish Virgins, c.* 1826

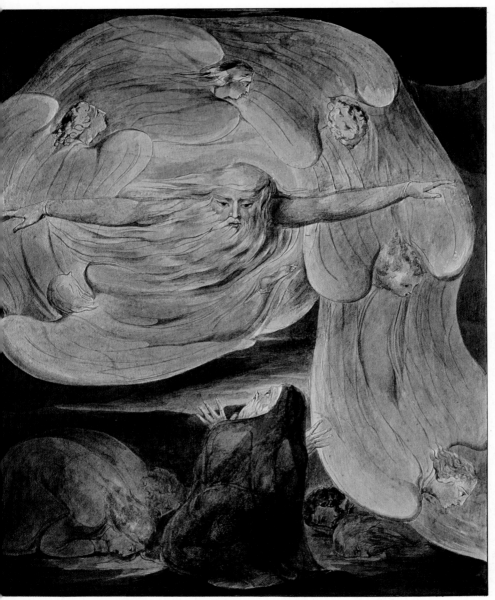

88 *The Lord answers Job out of the Whirlwind, c.* 1799

Of his New Testament subjects, few are more beautiful than
his depictions of the Holy Child. In *The Nativity*, a child enve-
loped in light (as Orc in his flames) hovers above the reclining
figure of the Virgin, conveying, as in no other painting known
to me, the realization that the Christ-child who 'descends' into
generation comes not from the Virgin's womb but from
another order of being. Similarly with the *Adoration of the
Kings* and *Christ asleep on the Cross*. For Blake the Holy Child
is not so much one of those Renaissance descendants of the
Classical Eros so beloved by the Italian schools, as the *multum
in parvule* of a spiritual mystery:

> *And Jehovah stood in the Gates of the Victim, & he appeared*
> *A weeping Infant in the Gates of Birth in the midst of Heaven.*

Both Virgin and Child of Blake's 'black' Madonna seem closer
in spirit to Early Christian art than to any post-Renaissance
work.

89 *The Nativity, c.* 1800

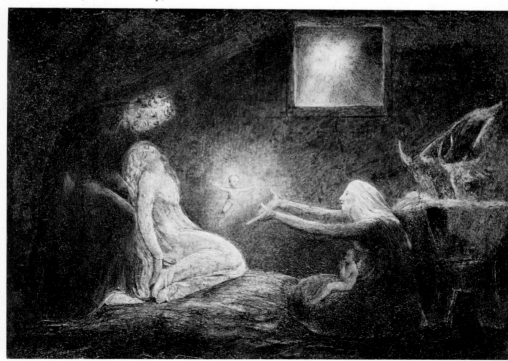

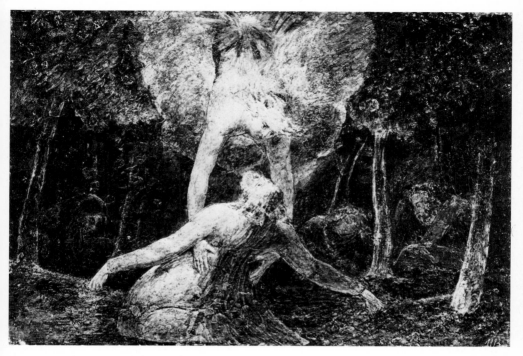

90 *The Agony in the Garden, c.* 1799–1800

Blake's depictions of Jesus as a man, on the other hand, have all too much in common with those sentimental Counter-Reformation illustrations associated with the cult of the Sacred Heart. But there are magnificent exceptions; above all, the majestic tragedy of *The Agony in the Garden*, with the grandeur *90* of the descending angel who supports the figure of Christ. The *Last Supper* invites, and sustains, comparison with those *95* Italian masters Blake admired. The lyrical *Wise and Foolish Virgins* is one of the most beautiful illustrations of parable. *87* Again, with his illustrations to the *Book of Revelation* (the *Michael binding Satan* or *The River of Life*), Blake is in his true *91–2* element of 'spiritual vision'.

123

96 *The Last Judgment* – on the last of several versions of which Blake continued to work until the time of his death – has a character altogether unprecedented. Both this work and the closely related *Meditation among the Tombs* have a diagrammatic structure more common in Tibetan Buddhist art than in Christian iconography. The flowing figures, ascending to the radiant Christ Enthroned, or falling headlong into Hell as in Michelangelo's *Last Judgment*, seem less like individuals than cells circulating in the life-stream of cosmic life. While for single figures or groups of figures we can find parallels in works by Michelangelo, for the composition as a whole I know none later than the Gothic Middle Ages. We are reminded by this work that Blake was a Swedenborgian; his *Judgment* is a superb depiction of Swedenborg's conception of the Grand Man, prototype of Blake's own 'divine humanity' or 'Jesus, the Imagination', the one God in all, and the all in the One.

From an aesthetic point of view, it was unfortunate for Blake that the tradition within which he was working offered him no precedent. We see the grandeur of his conception through the medium of an almost primitive clumsiness. Comparison with those Tibetan painted mandalas, which (though Blake never saw them) are depictions of similar spiritual realization, demonstrates the immense advantage of an inherited traditional language. Blake's spiritual vision – Swedenborg's also, it may be – needed – demanded – a new form; but it was too much for a solitary artist to create, against the trend of history, a new pictorial language. In his *Job* engravings, indeed, Blake went far towards creating such a language; one in which he has had no successors. It may be that the New Age of which he knew himself a prophet will yet discover in Blake the forerunner of a new way of expressing the non-spatial interpenetration of spiritual worlds, and that spiritual collectivity of life of which he had so strong an intuition.

Perhaps it is because Blake's Jesus is so essentially the one God in all, rather than the Jesus of history, that his imagination takes fire in his great Judgment more than in his illustrations of

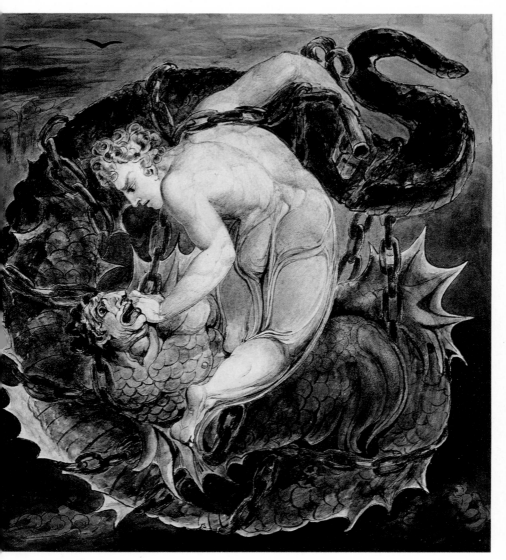

91 *Michael binding Satan, c.* 1805

episodes in the life of Christ. His two magnificent descriptions of the composition give us in some ways a clearer view of the grandeur of his vision than do the two surviving versions, or the drawings:

'The Last Judgment is not Fable or Allegory, but Vision. . . . The Hebrew Bible & the Gospel of Jesus are not Allegory, but Eternal Vision or Imagination of All that Exists. . . . The Last Judgment is one of these Stupendous Visions. I have represented it as I saw it; to different People it appears differently as everything else does; for tho' on Earth things seem Permanent, they are less permanent than a Shadow, as we all know too well. . . .

92 *The River of Life, c.* 1800–5

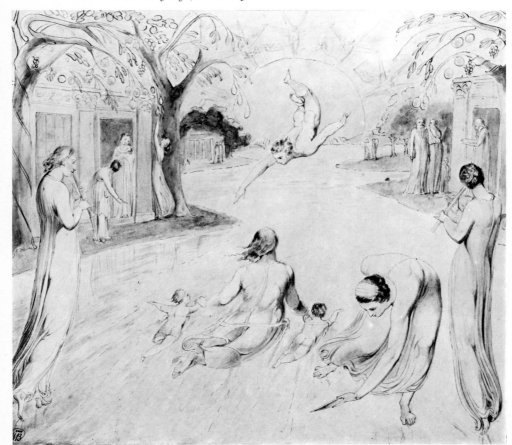

'This world of Imagination is the world of Eternity; it is the divine bosom into which we shall all go after the death of the Vegetated body. This World of Imagination is Infinite & Eternal, whereas the world of Generation, or Vegetation, is Finite & Temporal. There Exist in that Eternal World the Permanent Realities of Every Thing which we see reflected in this Vegetable Glass of Nature. All Things are comprehended in their Eternal Forms in the divine body of the Saviour, the True Vine of Eternity, the Human Imagination, who appear'd to Me as Coming to Judgment among his Saints & throwing off the Temporal that the Eternal might be Establish'd; round him were seen the Images of Existences according to a certain order Suited to my Imaginative Eye. . . .'

There follows a detailed account of the various groups of figures.

This conception of the collective Being of the 'divine humanity' is already clearly stated in *The Four Zoas*:

Then those in Great Eternity met in the Council of God
As one Man, for contracting their Exalted Senses
They behold Multitude, or Expanding they behold as one,
As One Man all the Universal family; & that One Man
They call Jesus the Christ, & they in him & he in them
Live in perfect harmony, in Eden the land of life,
Consulting as One Man above the Mountain of Snowdon
Sublime.

It may well be a stumbling-block to art critics that Blake so greatly admired the diagrams in William Law's Boehme, where, as W. B. Yeats (himself the author of a comparably bewildering mystical structure) wrote, 'one lifts a flap of paper to discover both the human entrails and starry heavens. William Blake thought these diagrams worthy of Michael Angelo, but remains himself almost unintelligible because he never drew the like.' *The Last Judgment* is the nearest Blake came to a visual depiction of his spiritual cosmos; but long passages in both *The Four Zoas* and *Jerusalem* describe the 'fourfold'

93 *Jacob's Ladder, c.* 1800

94 *The Angel of the Divine Presence clothing Adam and Eve with Skins*, 1803

95 *The Last Supper*

interior city. Foster Damon in his *Blake Dictionary* has drawn a chart of Golgonooza: a square within a circle from whose central 'Throne of God' creation issues – a diagram of a type familiar to students of C.G. Jung, and called (by analogy with Tibetan Buddhist art) a 'mandala'. Jung's patients often produced these 'mandalas' in the course of analysis, as symbols of the integration of the psyche. Far from suggesting that Blake's 'mandalas' are an expression of his personal imbalance, I wish only to draw attention to the diagrammatic character of a certain kind of vision; that, for example, of Ezekiel's Wheels, or the Four Living Creatures round the Throne; of the Apocalyptic City of St John the Divine; or indeed of Dante's Mountain of Hell and Purgatory. To these visionaries Blake himself often turned, as to his imaginative next of kin.

130

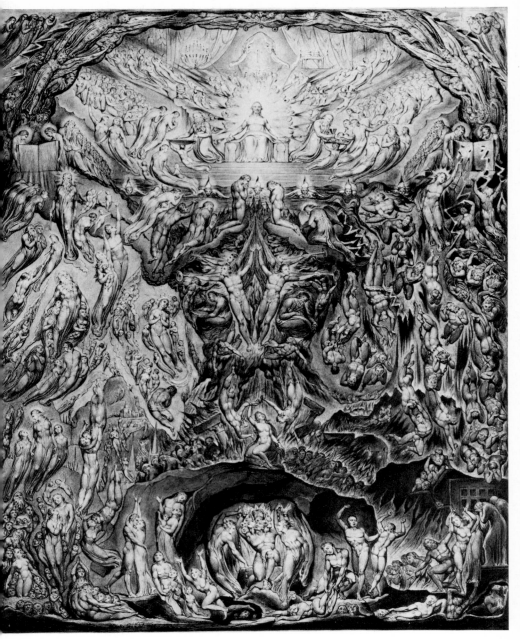

96 *The Last Judgment* (The watercolour version in the Petworth Collection)

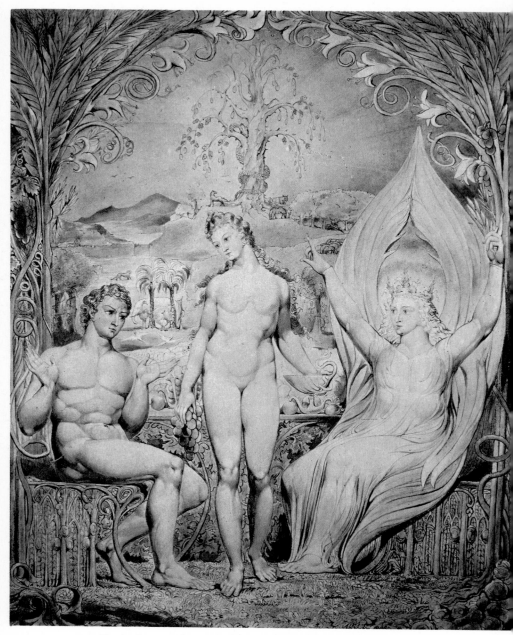

97 *Raphael conversing with Adam and Eve*, from *Paradise Lost*, 1808
(Museum of Fine Arts, Boston)

Spiritual Enemies

William Hayley was a country gentleman whose eccentricity was the writing and publishing of verse. His poetry was perhaps no worse than a great deal of bad verse now forgotten; it is chiefly for his life of his friend Cowper that he is remembered in his own right. His natural son, Thomas Adolphus, was for a time apprenticed to Flaxman as a sculptor. After his son's death in 1800 he engaged Blake to make an engraving of the boy's head. Hayley was not particularly pleased with this work – he was always given to meddling with artists he had himself commissioned, even 'improving' Flaxman's designs for him – but he may have been touched by the letter Blake wrote to him about his son:

'Thirteen years ago I lost a brother & with his spirit I converse daily & hourly in the Spirit & See him in my remembrance in the regions of my imagination. I hear his advice & even now write from his Dictate. Forgive me for Expressing to you my Enthusiasm which I wish all to partake of Since it is to me a Source of Immortal Joy: even in this world by it I am the companion of Angels. May you continue to be so more & more & to be more & more persuaded that every Mortal loss is an Immortal Gain. The Ruins of Time builds Mansions in Eternity.'

Flaxman suggested to Hayley that he should employ Blake as the engraver of the plates for his proposed life of Cowper; and that he might, incidentally, be able to assist him to obtain other work by introductions to his friends. Both Hayley and Blake welcomed Flaxman's suggestion that Blake should move to the village of Felpham, in Sussex, near Hayley's residence at Eartham. Yet, as Mona Wilson observes in her *Life*, Blake might have accounted his corporeal friend Flaxman

133

a spiritual enemy had he seen a letter he wrote to Hayley: 'You may naturally suppose that I am highly pleased with the exertion of your usual Benevolence in favour of my friend Blake, & as such an occasion offers you will perhaps be more satisfied in having the portraits engraved under your own eye, than at a distance, indeed I hope that Blake's residence at Felpham will be a mutual comfort to you & him, & I see no reason why he should not make as good a livelihood there as in London, if he engraves & teaches drawing, by which he may gain considerably, as also by making neat drawings of different kinds, but if he places any dependence on painting large pictures, for which he is not qualified either by habit or study, he will be miserably deceived.'

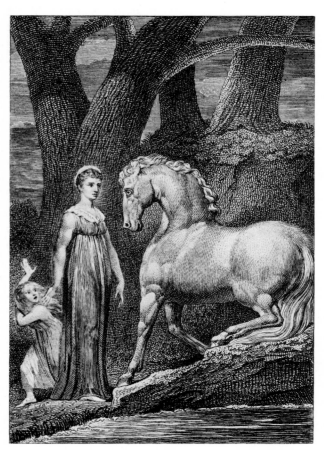

98 Illustration for Hayley's *Ballads. The Horse*, 1805

99 Illustration for Hayley's
Ballads. The Eagle, 1805

Had Flaxman written in a different vein, would Hayley
perhaps have refrained from the well-meant discouragement
which he seems to have given from the first to Blake's grander
ideas? Was he, in finding Blake commissions to paint minia-
tures of his friends, conscientiously carrying out Flaxman's
instructions? 'Neat drawings of different kinds' were the last
thing for which Blake's genius fitted him, unless we so describe
his sublime *Job* series. If Hayley's kindness was misdirected
from the outset, was it not in part the fault of Flaxman?
Blake, in gratitude, wrote in terms which put Flaxman to
shame:

'You, O Dear Flaxman, are a Sublime Archangel, My
Friend & Companion from Eternity; in the Divine bosom in
our Dwelling place. I look back into the regions of Remini-
scence & behold our ancient days before this Earth appear'd
in its vegetated mortality to my mortal vegetated Eyes. I see
our houses in Eternity, which can never be separated, tho' our

Mortal vehicles should stand at the remotest corners of heaven from each other.'

Hayley kept 'our good Blake' busy with this and that, conscientiously trying to fill his time so that he should not indulge in 'visions'. Blake worked on the engraving of the plates for the life of Cowper, besides making a series of medal-lion heads of the poets for Hayley's library. For a broad-sheet, *Little Tom the Sailor* (the poem written by Hayley), Blake made head- and tail-pieces; the broadsheet was to be sold as a charity for the widowed mother of the boy. Hayley's *Ballads*, with illustrations by Blake, were to be sold for Blake's own profit; but the venture was a financial failure. Southey in a review ridicules Hayley's verses, and adds a word on the illustrator:

143

98–100

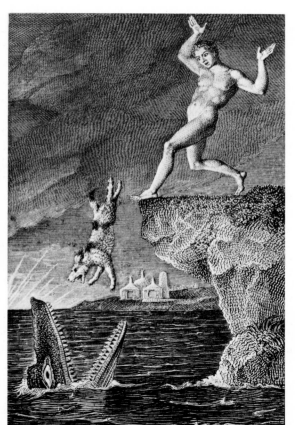

100 Illustration for Hayley's *Ballads.* Frontispiece: *The Dog,* 1805

'The poet has had the singular good fortune to meet with a painter capable of doing full justice to his conceptions; and, in fact, when we look at the delectable frontispiece to this volume, which represents Edward starting back, Fido *volant*, and the crocodile *rampant*, with a mouth open like a boot-jack to receive him we know not whether most to admire the genius of Mr William Blake or of Mr William Hayley.'

One can see what Southey means; the picture is very funny but it was not meant to be. If Blake can be blamed, it is for not having heeded his own advice: 'The eagle never lost so much time as when he submitted to learn of the crow.'

Ruskin admired *The Horse*, another of the series; and so did Yeats. Rosetti praised the *Hermit's Dog* and *The Eagle*. ('When thou seest an Eagle, thou seest a portion of Genius; lift up thy head!')

The 'good Blake', always industrious, scarcely ever refused any work offered him; but he did refuse to paint hand-screens for Cowper's relation Lady Hesketh; and he did unburden his growing irritation in his notebook:

> *When H———y finds out what you cannot do,*
> *That is the very thing he'll set you to.*

But Blake's Angels had known what they were about when they sent him to his 'three years' slumber beside the ocean' at Felpham. He had never before lived in the country. He and Catherine had loved to go on country rambles on the south side of the Thames, where, about Peckham Rye and neighbouring Kent villages, there were lanes, elms and harvest-fields. Now both sea and country lanes were at their door. We see Mrs Blake 'courting the embraces of Neptune'; and for Blake his six-roomed cottage was for a time – until growing irritation with his employer made his position intolerable – paradise. He wrote to Flaxman on his arrival:

'It is a perfect Model for Cottages &, I think, for Palaces of Magnificence, only Enlarging, not altering its proportions, & adding ornaments not principals. Nothing can be more Grand

than its Simplicity & Usefulness. Simple without Intricacy, it seems to be the Spontaneous Effusion of Humanity, congenial to the wants of Man.'

101 That cottage is immortalized in one of the pages of *Milton*, the poem he wrote at Felpham. We see the poet walking in his garden while one of the 'daughters of inspiration' descends towards him from the tops of some neighbouring trees.

Blake was overwhelmed by the glory of nature; but characteristically, neither then nor at any time did he see nature as other than human; and the visionary experience here described culminated in an epiphany of the Grand Man of the heavens:

> *My Eyes more & more*
> *Like a Sea without Shore*
> *Continue Expanding,*
> *The Heavens commanding,*
> *Till the Jewels of Light,*
> *Heavenly Men beaming Bright,*
> *Appear'd as One Man*
> *Who Complacent began*
> *My limbs to infold*
> *In his beams of bright gold;*
> *Like dross purg'd away*
> *All my mire & my clay.*

This vision of the spiritual sun is gloriously illustrated in Plate 47 of *Milton*, and described in that poem in mythological terms as an encounter with Los, the Apollo of Blake's spiritual world.

Blake never depicted or described the least flower or tiniest insect but some fairy or small spirit of life inhabited it; 'for everything is human! mighty! sublime!' Nor was he above seeing (and drawing) fairies. These he regarded as the living spirits of the vegetable world, belonging to nature, and as such mortal. An episode is recorded by Alan Cunningham in his short memoir of Blake: '"Did you ever see a fairy's funeral, madam?" he once said to a lady who happened to sit by him in company. "Never, sir," was the answer. "I have!" said

Blake, "but not before last night. I was walking alone in my garden; there was great stillness among the branches and flowers, and more than common sweetness in the air; I heard a low and pleasant sound, and I knew not whence it came. At last, I saw the broad leaf of a flower move, and underneath I saw a procession of creatures of the size and colour of green and grey grasshoppers, bearing a body laid on a rose-leaf which they buried with songs, and then disappeared. It was a fairy funeral."'

Blake was no more attracted to seascape- than to landscape-painting. But *The Waters prevailed upon the Earth* and other paintings may indeed owe something to his four years' neighbourhood with Neptune. His trees – or Tree, for it is always the one Tree that he depicts, stylized according to its good or its evil aspect – are depicted with minutely observed natural detail, like the bole of the elm in 'The Little Girl Found'; and he *102* had a preoccupation with roots, in which Samuel Palmer was to follow him. His skies and clouds, as rich in the radiance of their colouring as Turner's, are still to be seen in the ever-varying and beautiful gilded skies of London, the aspect of natural beauty most familiar to a child of city streets. One

101 Blake's cottage at Felpham, from *Milton*, 1804–8

might call Blake a painter of sky-scapes; indeed almost every page of his illuminated books is luminous like a sky. Blake, like Turner, supremely admired the paintings of Claude. He later communicated this admiration to Samuel Palmer, pointing out to his young disciple 'that in these, when minutely examined, there were, upon the focal lights of the foliage, small specks of pure white which made them appear to be glittering with dew which the morning sun had not yet dried up. . . . His description of these genuine Claudes, I shall never forget. He warmed with his subject, and it continued through an evening walk. The sun was set; but Blake's Claudes made sunshine in that shady place.'

Blake admired Constable too. Examining some of his work, he exclaimed 'Why, this is vision'; to which the more prosaic Constable replied that he 'took it to be painting'.

102 *Songs of Experience*, 1789–94. 'The Little Girl Found'

103 Illustrations
to William
Cowper's poem,
'The Task'
c. 1802. Left,
Winter; right,
Evening

By the beginning of 1802 Blake was restive at Felpham. He
confided to Butts that 'When I came down here, I was more
sanguine than I am at present.' While he was kept busy
'Engraving the small plates for a New Edition of Mr Hayley's
Triumphs of Temper from drawings by Maria Flaxman, sister
to my friend the Sculptor', he was contrasting in his heart the

141

apparent kindness of Hayley with the real understanding of Thomas Butts. Even at Felpham, he found time to produce for Butts works which came (as he wrote in November 1802) 'from my Head & my Heart in Unison'. Of not one work done for Hayley could that truly be said.

The crisis came in an unexpected manner. In the summer of 1803 Blake found in the garden of his cottage a soldier, called in by the gardener, it seems, to cut the grass. Blake did not like soldiers; he was against war as such, and against the war of English intervention in France in particular. He ordered the intruder out, and when he protested, threw him out by main force. Ill-advised words followed, reported as 'Damn the King, and damn all his soldiers, they are all slaves'; and some remarks about Napoleon more fitted to the mouth of a French than of an English poet. On this occasion Hayley came to Blake's defence in fine style, and he was acquitted. No doubt he was innocent. Yet the words imputed to him were such as he might well have spoken in anger, and his Felpham neighbours would have been aware of his political views; he was not the man to conceal them.

Blake was to continue to work for Hayley for a time after his return to London, and to write to him in a friendly manner.

The works done for Butts at Felpham are listed in Blake's letters. They include the *Riposo* (*The Holy Family in Egypt*) which Blake considered his best picture 'in many respects'. He wrote to Butts in July 1803 that: 'I have now on the Stocks the following drawings for you: 1. Jephthah sacrificing his Daughter; 2. Ruth & her mother in Law & Sister; 3. The Three Maries at the Sepulcher; 4. The Death of Joseph; 5. The Death of the Virgin Mary; 6. St Paul Preaching; & 7. The Angel of the Divine Presence clothing Adam & Eve with Coats of Skins.

'These are all in great forwardness, & I am satisfied that I improve very much & shall continue to do so while I live, which is a blessing I can never be too thankful for both to God & Man.'

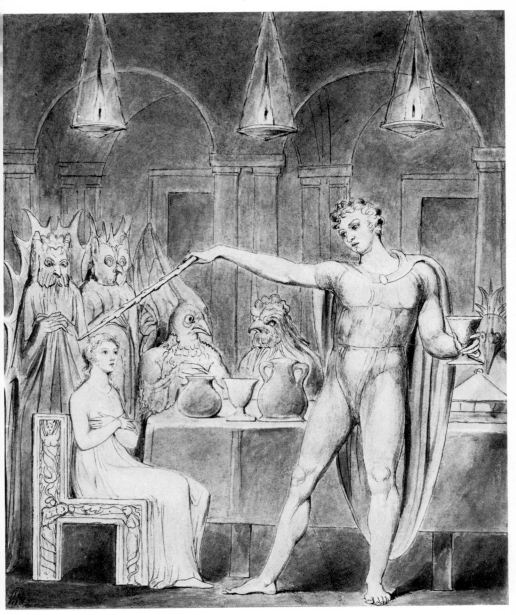

104 *Comus with the Lady Spellbound, c.* 1801

The drawings numbered 5 and 7 are indeed among Blake's finest works.

Blake had also been working for other 'masters': 'But none can know the Spiritual Acts of my three years' Slumber on the banks of the Ocean, unless he has seen them in the Spirit, or unless he should read My long Poem descriptive of those Acts; for I have in these three years composed an immense number of verses in One Grand Theme, Similar to Homer's Iliad or Milton's Paradise Lost, the Persons & Machinery entirely new to the Inhabitants of Earth (some of the Persons Excepted). I have written this Poem from immediate Dictation, twelve or sometimes twenty or thirty lines at a time, without Premeditation & even against my Will; the Time it has taken in writing was thus render'd Non Existent, & an immense Poem Exists which seems to be the Labour of a long Life, all produc'd without Labour or Study. I mention this to show what I think the Grand Reason of my being brought down here.'

The poem *Milton* was, of course, the labour of a long life: Blake's own. His immense reading, his impassioned thought on the poetic and moral issues of which he treats, his continuous observation of man and nature, bore fruit. He himself was the Mental Traveller in land of imagination, where:

> . . . *the Babe is born in joy*
> *That was begotten in dire woe;*
> *Just as we Reap in Joy the fruit*
> *Which we in bitter tears did sow.*

As with Coleridge (whose *Kubla Khan* no opium could have evoked, had his mind and imagination been less richly stored with his readings in philosophy, poetry and unnumbered books), Blake's effortless composition of his great poem was the reward of year-long labours.

The theme of *Milton* is poetic inspiration as a way of redemption from the tyrannous law of 'Satan, the Selfhood', framer of 'natural religion', the maker of moral laws. I have read this poem many times; and while there may be greater

144

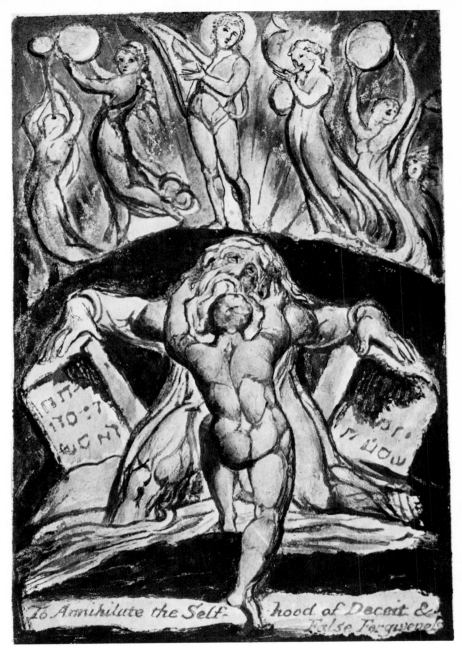

105 *Milton*. Plate 18, 1804–8

themes attempted in *Jerusalem*, *Milton* is of all Blake's longer poems the most delightful. The influence of Felpham's natural beauty is to be sensed in the exquisite passages on flowers, insects, trees and birds; and there are passages of sustained eloquence equal to Milton himself.

104–10
105 The plates of *Milton* are not on the whole so magnificent as those of *Jerusalem*, but two or three are very fine. On Plate 18, the poet pulls down the familiar figure of Urizen (Satan) with his Tables of the Law. Plate 16 illustrates the 'inspired man', a Michelangelesque nude, casting off 'the rotten rags of memory' in 'the grandeur of inspiration'. On Plate 42 an eagle, somewhat resembling the one Blake designed for Hayley, hovers over two sleeping figures on a sea-washed rock. Plates 32 and 37 are identical, but in reverse: one shows William, in the light of day, with a star or comet falling to his foot; on the reverse plate, Robert, in the mystery of the night, is William's counterpart. It is implied, perhaps, that Robert is one of the 'authors in eternity' who dictated the poem to his mortal brother.

The etching of the plates was no doubt done after Blake's return to London, at the end of 1803 – and perhaps some of the composition also; the title-page is dated 1804, but none of the three copies known to exist was printed before 1808.

Blake's relationship to Milton – lifelong and intimate – was at once one of admiration of the poet who was for him type and exemplar of 'the inspired man', and disagreement with the Puritan theologian. In *The Marriage of Heaven and Hell* (1790–3) Blake had already defined the ground of his disagreement: Milton had allowed the demon Reason to curb the energy of his Desire: 'Those who restrain desire do so because theirs is weak enough to be restrained; and the restrainer or reason usurps its place & governs the unwilling. . . . The history of this is written in Paradise Lost, & the Governor or Reason is call'd Messiah.' But 'this history has been adopted by both parties. It indeed appear'd to Reason as if Desire was cast out; but the Devil's account is, that the Messiah fell & form'd a heaven of what he stole from the Abyss.'

146

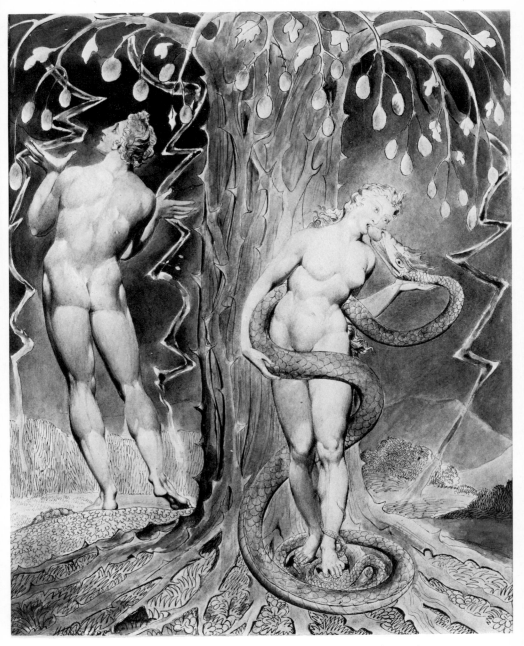

106 *Temptation and Fall*, from *Paradise Lost*, 1808 (Museum of Fine Arts, Boston)

This usurpation, and the building of the Hell of the 'ratio of the five senses' is the theme of *Milton*. By exposing the deceiver, the poet Blake undertook to release the poet Milton (type of the 'inspired man') from the bondage of rationalism; the mind of the human ego, or 'selfhood', as Blake termed it. Long after, in 1825, he told the diarist Crabb Robinson:

'I saw Milton in imagination, and he told me to beware of being misled by his *Paradise Lost*. In particular he wished me to shew the falsehood of his doctrine that the pleasure of sex arose from the Fall. The Fall could not produce any pleasure.'

Darrell Figgis (editor of *Paintings of William Blake*, 1925) thought that the first of Blake's designs for Milton's poems was the single separate drawing entitled *Satan watching the Endearments of Adam and Eve*. 'He floats, wingless, above the endearments of the pair. He holds his head in his hands, and looks with horror on the "pleasures of sex", here found in exercise before the Fall.'

104 Of the two sets of watercolour drawings for *Comus* which Blake made, one must date from the Felpham period; for Blake wrote to Flaxman in 1801 that a friend – 'Mr Thomas' – had commissioned a set of designs, to be sent care of Flaxman. Neither set is dated.

Blake was to make his first series of drawings for *Paradise Lost* soon after the completion of his own poem, *Milton*, in 1807. In the following year he made another and finer series for Butts. In both, the original idea of the pleasure of sex existing before the Fall is retained. Blake had written, in *The Marriage of Heaven and Hell*, that 'the original Archangel, or possessor of the command of the heavenly host, is call'd the Devil or Satan, and his children are call'd Sin & Death. But in the Book of Job, Milton's Messiah is call'd Satan.' The illustrations to *L'Allegro* and *Il Penseroso* (1816) were probably the last works Butts bought from Blake. Those to *L'Allegro* include the 'spiritual form' of the lark, which in the poem *Milton* is Blake's symbol of poetic inspiration, soaring towards Milton's

108 'watch-towre in the skies'. The illustrations to the *Hymn on the*

148

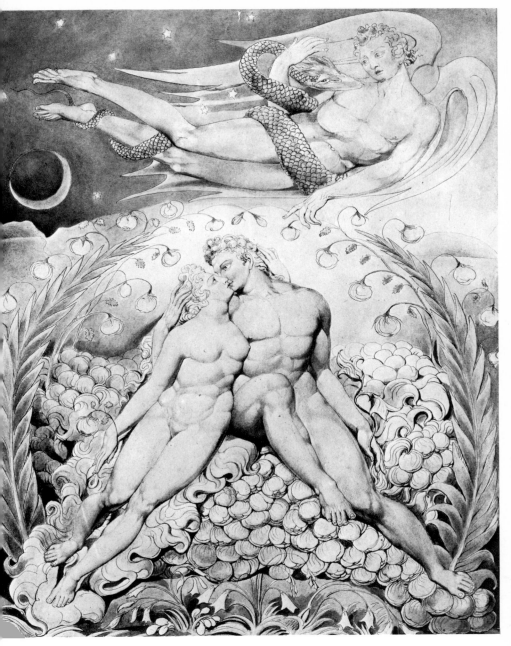

107 *Satan watching the endearments of Adam and Eve*, from *Paradise Lost*, 1808. The finished version (Museum of Fine Arts, Boston)

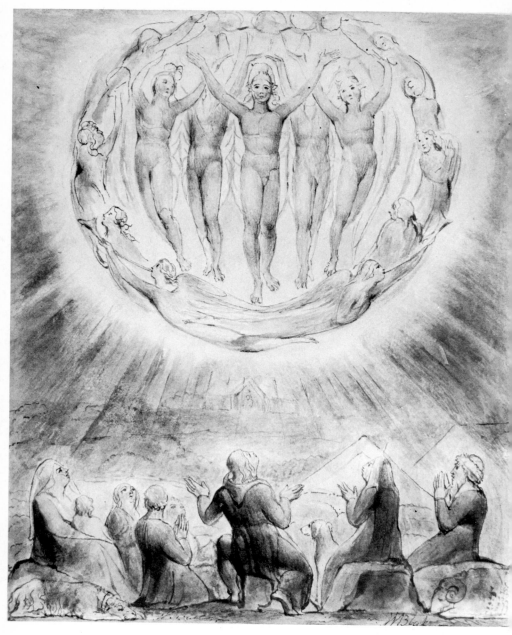

108 From *Hymn on the Morning of Christ's Nativity, c.* 1809. *Shepherds and the Choir of Angels*

109 *Paradise Lost, c. 1807–8. The First Temptation*

Morning of Christ's Nativity, which include the beautiful *Descent of Peace*, belong to an earlier period, about 1809.

The series of twelve drawings for *Paradise Regained* belonged to Linnell, the younger artist who befriended Blake in his last years (see p. 175), which suggests that they were made at about the same time (1816) as the *L'Allegro* and *Il Penseroso*. Blake's identification of Satan with the worldly wisdom of human reason and the moral law is brought out clearly. Satan, in *Christ's Ugly Dream*, is the same figure of Urizen who, on the title-page of *Visions of the Daughters of Albion*, pursues Oothoon, Blake's eloquent pleader for sexual freedom. In his *Milton* the poet (Plate 18) is shown pulling down the image of the same figure. *Christ's Ugly Dream*, as Figgis points out, is a foreshadowing of the more terrible vision of *Job* (Plate 11): 'With Dreams upon my bed thou searest me & affrightest me with Visions.'

110
46

105

Here we see 'Milton's Messiah' as the impostor whose cloven foot reveals his true nature. From first to last Blake was consistent in his affirmation that the God of Deism – 'Natural Religion' – is the Satan of the Prophets and of the Everlasting Gospel of 'Jesus, the Imagination'.

The sacrifice of his integrity as an artist for profit was for Blake an impossibility. During the years with Hayley he tried to silence his conscience in obedience to the good advice of his 'natural friends'. To begin with he had endeavoured 'with my whole might' to 'chain my feet to the world of Duty & Reality; but in vain! The faster I bind, the better is the Ballast, for I, so far from being bound down, take the world with me in my flights & often it seems lighter than a Ball of wool rolled by the wind. . . . Alas! wretched, happy, ineffectual labourer of time's moments that I am! Who shall deliver me from this spirit of Abstraction & Improvidence?'

But Blake knew at heart that the voice that urged him to obey 'Duty and Reality' in order to make money was the voice of the Devil. Six months after his arrival in Felpham, in January 1802, he was confiding to Butts that the Inspirers

110 *Paradise Regained, c.* 1807–8. *Christ's Ugly Dream*

would not let him escape from them: 'I am under the direction
of Messengers from Heaven, Daily & Nightly; but the nature
of such things is not, as some suppose, without trouble or care.
Temptations are on the right hand & left; behind, the sea of
time & space roars & follows swiftly; he who keeps not right

153

onwards is lost, & if our footsteps slide in clay, how can we do otherwise than fear & tremble? . . . But if we fear to do the dictates of our Angels, & tremble at the Tasks set before us; if we refuse to do Spiritual Acts because of Natural Fears or Natural Desires! Who can describe the dismal torments of such a state!'

And finally – no myth or metaphor this time – Blake made his decision, heroic under the circumstances (the letter, again, is to Butts):

'And now, My Dear Sir, Congratulate me on my return to London, with the full approbation of Mr Hayley & with Promise – But, Alas!

'Now I may say to you, what perhaps I should not dare to say to anyone else: That I can alone carry on my visionary studies in London unannoy'd, & that I may converse with my friends in Eternity, See Visions, Dream Dreams & prophecy & speak Parables unobserv'd & at liberty from the Doubts of other Mortals; perhaps Doubts proceeding from Kindness, but Doubts are always pernicious, Especially when we Doubt our Friends. Christ is very decided on this Point; "He who is Not With Me is Against Me." There is no Medium or Middle state; & if a Man is the Enemy of my Spiritual Life while he pretends to be the Friend of my Corporeal, he is a Real Enemy. . . .'

111 *Jerusalem*, 1804–20. Plate 18: Vala, Jerusalem and their children reconciled

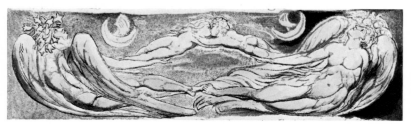

Visions of Albion

Blake returned to London from Felpham at the age of forty-
five, and in the years that followed was to turn material
defeat into spiritual victory. As he later confided to his Note-
book, the Devil holds the money bag; but he faced adversity
industriously and cheerfully:

> *I have Mental Joy & Mental Health*
> *And Mental Friends & Mental wealth;*
> *I've a Wife I love & that loves me;*
> *I've all But Riches Bodily.*

> *I am in God's presence night & day,*
> *And he never turns his face away.*
> *The accuser of sins by my side does stand*
> *And he holds my money bag in his hand.*

Blake made, not for Lambeth, but for his native district, and
took a lease on the first floor at No. 17 South Molton Street.
This was to be his home for nearly seventeen years. Not a
house, this time, or even a six-roomed cottage. He had come
down in the world; but his wants were few, and his childless-
ness, in the circumstances, was fortunate for his art and his
visions. And in a spirit of renewed hope he engraved the
magnificent title-page of a new poem: *Jerusalem: The Emanation* *113*
of the Giant Albion (1804).

It is impossible to know whether Blake had already begun
the poem at Felpham, and, if so, how much was written there.
But as surely as *Milton* breathes the atmosphere of the paradisal
cottage, *Jerusalem* reflects the sombre grandeur of London:

> *In Felpham I heard and saw the Visions of Albion*
> *I write in South Molton Street what I both see and hear*
> *In regions of Humanity, in London's opening streets.*

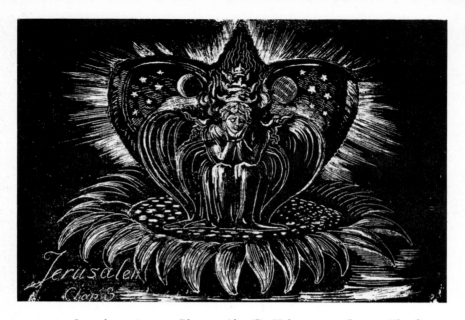

112 *Jerusalem*, 1804–20. Plate 53 (detail): Vala on a sunflower. The figure is reminiscent of Indian deities on lotus thrones, depicted in Moore's *Hindoo Pantheon*, and is an instance of Blake's interest in 'the religions of all nations' as an expression of the one Imagination

17, 80
111–18
121

This great poem, with its superb engraved pages, was to be Blake's companion over many years. It seems likely that he designed the title-page while very little of the poem yet existed in visible form. Southey is said to have seen part of it in 1811: 'a perfectly mad poem called Jerusalem'. None of the five copies printed by Blake is on paper watermarked earlier than 1818, and Keynes believes that Blake continued to add to the poem until 1820. He illuminated only one copy. This is probably the one to which he refers in a letter to George Cumberland written in 1827: 'The Last Work I produced is a Poem entitled Jerusalem the Emanation of the Giant Albion, but find that to Print it will Cost my time the amount of Twenty Guineas. One I have Finish'd. It contains 100 Plates but it is not likely that I shall get a Customer for it.'

He did not. This glorious book passed into the hands of Frederick Tatham after Catherine Blake's death. There are a

156

113 *Jerusalem*, 1804–20. Title-page. The soul's metamorphosis is here completed in the beautiful winged figure of Jerusalem

114 *Jerusalem*, 1804–20. Plate 62 (detail)

few other illuminated pages of great beauty, evidently from another projected copy as different in colour and spirit as one copy of *Songs of Innocence* is from another.

As a poem, it is not so much a work of that 'hammered gold and gold enamelling' in which Blake's greatest disciple Yeats tempered his style, as a gold-mine. Blake's 'visions' do not belong to time, but to the timeless; they are related as parts to a whole, but as parts of the surface of a sphere, all equidistant from the centre, rather than in the time sequence to which in this world we are normally confined. Like dreams, they came to him in single symbolic episodes, or images; there is some attempt at chronology, but the material does not lend itself to this order, any more than would a series of vivid dreams, all relating, perhaps, to an unfolding situation, but not forming a consecutive narrative. Blake added to *Jerusalem* over many years, inserting passages which may be fine in themselves but which further destroyed the continuity.

Visually, every page is beautiful and some are magnificent. The proportion of decoration to script is as perfect as in the *Songs*. There could be no greater contrast than between these lovingly composed pages, and the ill-proportioned pages of Young's *Night Thoughts*, or even the over-large pages of Gray. A single inspiration informs words and decoration alike.

Some of the themes are, nevertheless, extremely obscure. Is the swan-headed maiden on Plate 11 Finola, daughter of Lir,

158

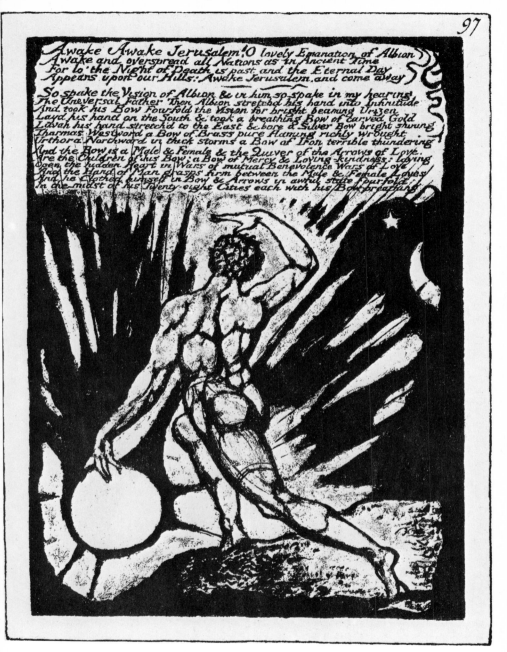

Awake Awake Jerusalem! O lovely Emanation of Albion
Awake and overspread all Nations as in Ancient Time
For lo! the Night of Death is past and the Eternal Day
Appears upon our Hills: Awake Jerusalem, and come away

So spake the Vision of Albion & in him so spake in my hearing
The Universal Father Then Albion stretchd his hand into Infinitude
And took his Bow Fourfold the Vision for bright beaming Urizen
Layd his hand on the South & took a breathing Bow of carved Gold
Luvah his hand stretchd to the East & bore a Silver Bow bright shining
Tharmas Westward a Bow of Brass pure flaming richly wrought
Urthona Northward in thick storms a Bow of Iron terrible thundering

And the Bow is a Male & Female & the Quiver of the Arrows of Love,
Are the Children of this Bow: a Bow of Mercy & Loving-kindness: laying
Open the hidden Heart in Wars of mutual Benevolence Wars of Love
And the Hand of Man grasps firm between the Male & Female Loves
And he Clothed himself in Bow & Arrows in awful state Fourfold
In the midst of his Twenty-eight Cities each with his Bow breathing

115 *Jerusalem,* 1804–20. Plate 97: Los

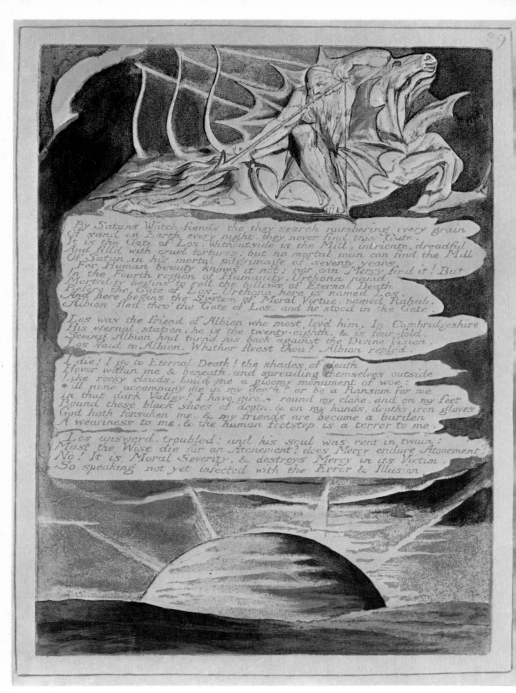

By Satans Watch-fiends tho they search numbering every grain
Of sand on Earth every night. they never find this Gate.
It is the Gate of Los. Withoutside is the Mill, intricate, dreadful
And filld with cruel tortures: but no mortal man can find the Mill
Of Satan. in his mortal pilgrimage of seventy years,
For Human beauty knows it not: nor can Mercy find it! But
In the Fourth region of Humanity, Urthona namd
Mortality begins to roll the billows of Eternal Death
Before the Gate of Los. Urthona here is named Los.
And here begins the System of Moral Virtue, named Rahab.
Albion fled thro' the Gate of Los, and he stood in the Gate.

Los was the Friend of Albion who most loved him. In Cambridgeshire
His eternal station. he is the twenty-eighth. & is four-fold.
Seeing Albion had turnd his back against the Divine Vision.
Los said to Albion. Whither fleest thou? Albion replyd

I die! I go to Eternal Death! the shades of death
Hover within me & beneath. and spreading themselves outside
Like rocky clouds. build me a gloomy monument of woe:
Will none accompany me in my death? or be a Ransom for me
In that dark Valley? I have girn round my cloke. and on my feet
Bound these black shoes of death. & on my hands. deaths iron gloves
God hath forsaken me. & my friends are become a burden
A weariness to me. & the human footstep is a terror to me.

Los answerd. troubled: and his soul was rent in twain.
Must the Wise die for an Atonement? does Mercy endure Atonement?
No! It is Moral Severity, & destroys Mercy in its Victim.
So speaking not yet infected with the Error & Illusion

116 *Jerusalem*, 1804–20. Plate 39

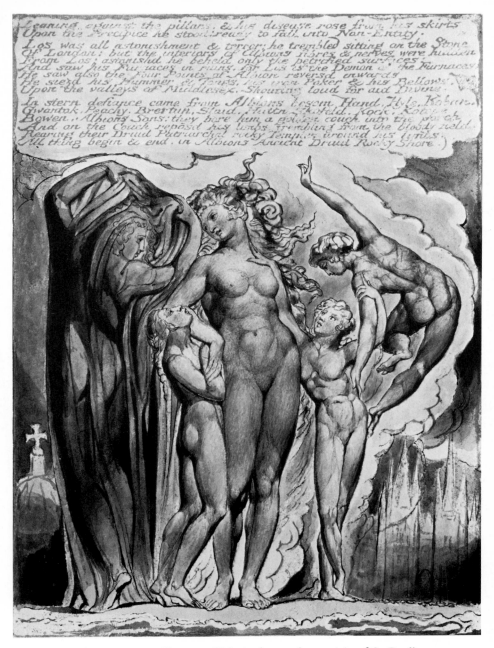

leaning against the pillars, & his disease rose from his skirts
Upon the Precipice he stood: ready to fall into Non-Entity.

Los was all astonishment & terror: he trembled sitting on the Stone
Of London: but the interiors of Albions fibres & nerves were hidden
From Los; astonished he beheld only the petrified surfaces;
And saw his Furnaces in ruins, for Los is the Demon of the Furnaces;
He saw also the Four Points of Albion reversd inwards
He siezd his Hammer & Tongs, his Poker & his Bellows,
Upon the valleys of Middlesex, Shouting loud for aid Divine.

In stern defiance came from Albions bosom Hand, Hyle, Koban,
Gwantok, Peachy, Brereton, Slaid, Hutton, Skofeld, Kock, Kotope,
Bowen. Albions Sons: they bore him a golden couch into the porch
And on the Couch reposd his limbs, trembling from the bloody field.
Rearing their Druid Patriarchal rocky Temples around his limbs.
(All things begin & end, in Albions Ancient Druid Rocky Shore.)

117 *Jerusalem*, 1804–20. Plate 32. Vala is the tutelary spirit of St Paul's; Jerusalem, the soul, and bride of Jesus, of Westminster Abbey and spiritual religion

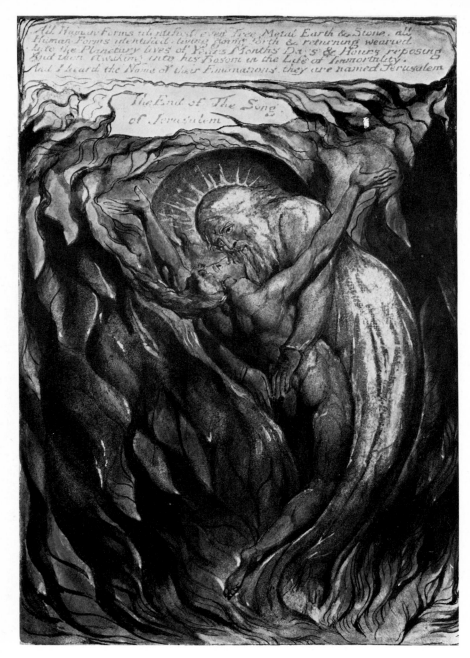

118 *Jerusalem*, 1804–20. Plate 99: *The Union of the Soul with God*

changed into a swan by her stepmother, or Sabrina, named on the text of the page? Who are the man-headed horses who draw the plough on Plate 29? What is the serpent-wheeled chariot of Plate 41? Whose is the terrible face, which seems to belong to the Expressionist art of a century later, surrounded by what appear to be peacock-feathers? *114*

The pages of *Jerusalem* are Blake at his most Blakean. The figures are executed in his fully evolved and simplified linear style, that outline without volume which Roger Fry disliked but which is perfectly adapted to the novel technique Blake had invented. The linear decoration is itself calligraphic, merging harmoniously with the script. Grand, grotesque or lovely forms depict, as in some visual Divine Comedy, inner states of soul.

Blake can be horrific, but he is never, like his friend Fuseli, obscene; he never incites to evil by presenting it as alluring, but describes it, in the spirit of Dante, with prophetic purity.

In *Jerusalem* the reduction of Michelangelesque forms to linear terms is complete. It is the style of Blake's creation, fully realized in its own terms, and in Plate 97 for example, pointing *115* forward to such artists as Rouault. Many like Plate 46, *Vala* *117* *and Jerusalem*, and Plate 99, *The Union of the Soul with God*, are superb; all the old flow of vital energy is there, but with a new grandeur and maturity of vision. As Anthony Blunt has *118* written: 'Innocence is impossible to recapture, but here the artist has expressed the final state to which man can aspire by means of love and imagination after passing through the dark stage of Experience.'

Several of the separate plates are more highly finished than those which combine text and decoration, for instance the Frontispiece, in which Man enters by a dark door into the *17* 'regions of the grave' of earthly life, and the flame-enveloped figure (Orc?) of Plate 26. The depiction of Albion before Jesus, crucified upon the Tree of Life (Plate 76), is the most moving *121* depiction of the relationship between the mortal and the divine humanity known to me. It has the completeness of an icon, in which there is nothing superfluous and nothing lacking.

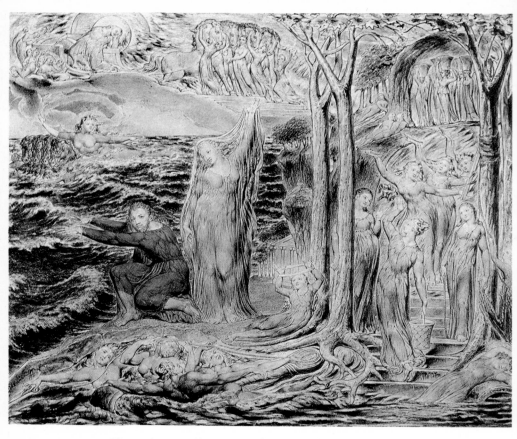

119 Illustration to Thomas Taylor's translation of Porphyry's *De Antro Nympharum*, 1821. The kneeling figure is Odysseus, in the act of throwing the girdle lent him back to the sea-goddess Leucothea. Pallas Athene stands behind him, pointing to the heavenly world from which souls 'descend' into generation, to be woven into the mortal garments by the nymphs of the Cave, working at their looms and shuttles. The Three Fates are in the water of the estuary opening into 'the sea of time and space', drawing yarn from a distaff held by the sea-god Phorcis. Atropos holds the shears. The figures with full and empty buckets illustrate a Platonic parable from the same work. *(See Ill 1, pages 2 and 192)*

120 *Illustrations of the Book of Job, c.* 1821. Plate 14: *The Morning Stars sang* ▶ *Together.* One of the watercolour drawings made for Thomas Butts

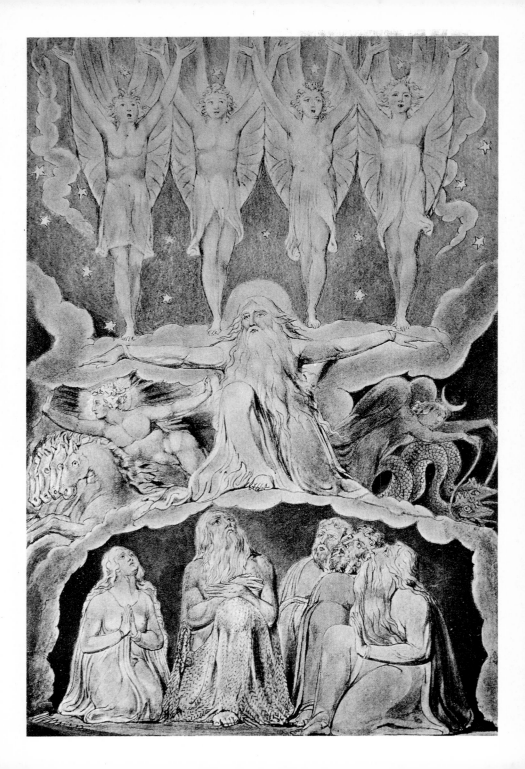

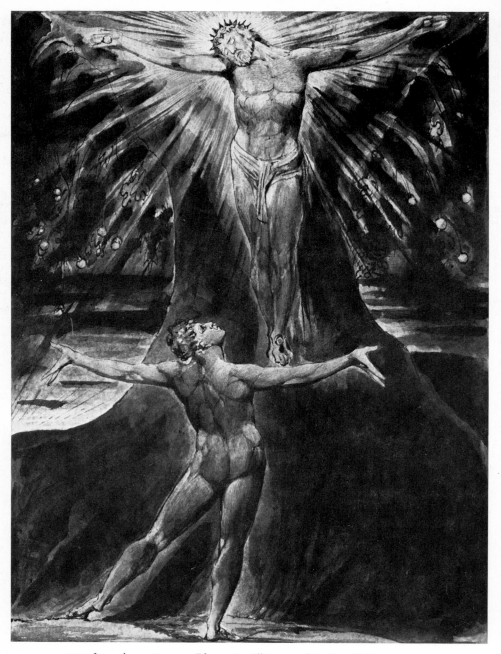

121 *Jerusalem*, 1804–20. Plate 76: *Albion worshipping Christ*

122 Illustration to Blair's *The Grave*, 1808, designed by Blake but engraved by Schiavonetti. The Counsellor, King, Warrior, Mother and Child in the Tomb

During the years in South Molton Street, *Jerusalem* was Blake's life, but not his livelihood. When he left Felpham it was understood that he was to continue to work for Hayley, and there was much correspondence on the plates of the *Life of Romney* which was to follow Cowper's *Life*. (Only one of the plates in the life of Cowper was, in the end, both designed and engraved by Blake; five more were engraved after other artists.) Flaxman wrote to Hayley saying that he had seen 'two or three noble sketches by Blake', and offering to see to it that Blake's engraving of these should fit in with the other designs. But all this came to nothing; Hayley employed Caroline Watson instead of Blake, who was gradually ousted from the project. Blake finally engraved only one of the eleven plates, after Romney; the portrait of Romney which he drew and engraved was not used.

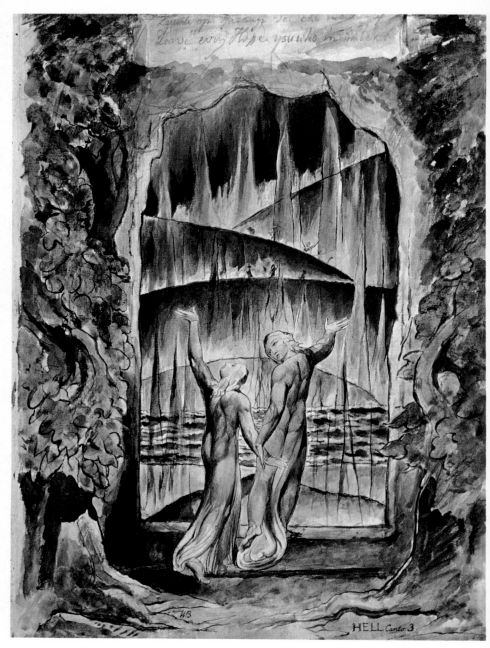

123 Illustration to Dante's *Divine Comedy*, 1824–7. *The Inscription over the Gate of Hell*

For all his industry, Blake again and again found himself in a similar situation; and at a certain point, a reputation for failure becomes self-perpetuating.

Meanwhile, an apparently more promising project was in the air. In 1805, two years after Blake's return to London, an engraver turned publisher named Cromeck commissioned him to make a series of designs for Blair's *Grave*, on the understanding that Blake should also be the engraver. A list of subscribers was opened, the reputation of Blake being the main attraction. Fuseli, always a faithful friend, wrote the foreword. The list of subscribers was long and contained many names distinguished in the art world of the day. But the designs once in his hands, Cromeck gave them to the engraver Schiavonetti, a pupil of the 'smooth' (to use Blake's word for him) Bartolozzi. Blake was doubly enraged: at the spoiling of his work, and at the financial loss. Gilchrist calculated that Cromeck made about £1,800 from sales of the book, of which £500 went to Schiavonetti and only £20 to Blake.

14, 15, 122

Still worse, seeing Blake at work on his composition of *The Canterbury Pilgrims*, Cromeck went to Blake's old acquaintance Stothard and proposed the subject to him as an original idea of his own, without mentioning that Blake was working on it. Cromeck in due course published an engraving from Stothard's painting, at great profit to himself. Blake's long friendship with Stothard was broken with much indignation on both sides, and again he was cheated of hope of financial reward for his work.

124

In desperation Blake arranged an exhibition in his brother's shop at 28 Broad Street, and there in 1809 his own *Canterbury Pilgrims* (a 'fresco') was shown together with fifteen other paintings. The prospectus advertised Blake's intention to make an engraving, and invited subscriptions. But Blake was no match for the Cromecks of this world; few visited the obscure exhibition, and only three or four copies of the *Descriptive Catalogue* now exist. Among those who did see the exhibition were the diarist Crabb Robinson and Charles Lamb (an admirer

of Blake's poems, as also was Coleridge). To Lamb's credit, he preferred Blake's *Canterbury Pilgrims* to Stothard's, calling it 'A work of wonderful power and spirit, hard and dry, yet with grace.' He was also delighted by the *Descriptive Catalogue*, declaring that Blake's analysis of the characters in Chaucer's 'Prologue' was the finest criticism of that poem he had ever read. Southey, hostile as ever, described Blake's (now lost) painting of the *Ancient Britons* as 'one of his worst pictures, which is saying much'. This was the work which attracted most attention at the time; Lamb mentions it in his account of the exhibition.

Needless to say, Blake found few subscribers for his engraving. The tempera was bought by the faithful Butts. The bitterest irony in the story of Blake's failures and humiliations is that he was never unknown; on the contrary, he was in the heart of London's art world, and knew all the most famous

124 *The Canterbury Pilgrims*, 1810. Blake wrote: 'This Print is the Finest that has been done or is likely to be done in England'

artists and engravers of his day. And yet he failed where they succeeded, ousted by men of inferior talents and passed over by lifelong friends.

J. B. Bronowski has seen economics as a cause of Blake's failure: he points to the decline of the craft of copper-plate engraving as cheaper methods of reproduction were invented. But David Erdman probably comes nearer to the truth in seeing the question as being, rather, why should Blake have failed where others – Stothard, Bartolozzi, Schiavonetti and the rest – succeeded? His genius was of a magnitude, and of a nature, to call in question too many accepted values. He was the Samson predestined to pull down a civilization founded upon the accepted ideas, verities and platitudes of his day. Against the really new the passive resistance of every society is mustered; and Blake's (or Swedenborg's) New Age is even now still only in its birth-pangs.

125 *The Spiritual Form of Nelson Guiding Leviathan, in whose wreathings are enfolded the Nations of the Earth.* Exhibited 1809

It is hard enough that Blake, in 1814, was engraving, not his own, but Flaxman's designs for *Hesiod*; but to picture him – he must have been working at the time on some of his finest designs, the series of *L'Allegro* and *Il Penseroso* commissioned, need it be said, by Butts – thankful to execute soup-tureens for the Wedgwood catalogues, is almost unbearable. Another piece of hack-work was the engraving of some plates for Rees' *Cyclopedia*. An example of sculpture selected by Flaxman (author of the article) was the Laocoön, which took the fifty-seven-year-old Blake to the Royal Academy's Antique School to make a drawing of the cast. His famous *Laocoön* 126 engraving was the enduring outcome of this revisiting of an old haunt. 'What! you here, Meesther Blake?' said Keeper Fuseli; 'we ought to come and learn from you, not you from us.' Tatham, who records the incident, adds that Blake took his place among the students with simple, cheerful joy in his work.

126 *Laocoön*, drawing, *c.* 1815, for an article in Rees' *Cyclopedia*

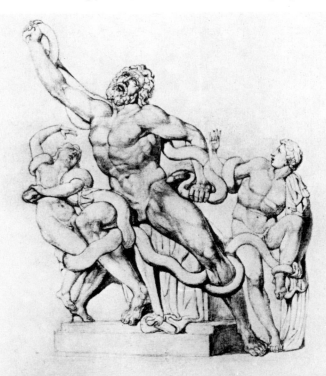

Portrait of
M^{rs} Blake . 1820

J. L. fecit

127 Portrait of Blake by John Linnell, 1820

The Interpreter

For the six years following the 1809 exhibition at Broad Street we have little trace of Blake. He lived on in obscurity in South Molton Street, ceaselessly engaged in writing and painting, even though he was selling few pictures. It must have been during this period that he wrote many of the poems that were burned by Frederick Tatham, Mrs Blake's executor, after the poet's death. Tatham truly admired Blake, and recalled, long after, his first walk in Blake's company, which was 'like walking with the Prophet Isaiah'. But he belonged to the 'Apostolic Church' of Edward Irving, and presumably found some of Blake's prophecies – Isaiah or no – incompatible with that narrower creed. Blake could perhaps no longer afford the copper plates for the engraving of these later manuscripts as illuminated books, for which purchasers were so few. But they were, he said, 'the delight and study of archangels'; 'published elsewhere, and beautifully bound'.

But from the summer of 1818 a new circle of friends began to gather about him. George Cumberland, though he lived in Bristol, did not forget Blake, and sent him a young artist, John Linnell, who was to become the friend and supporter of his declining years. Even as a young man, Linnell had that capacity to cope with the affairs of this world which Blake so notably lacked. At the time he met Blake he was working mainly as a portrait-painter, and asked Blake's help in the engraving of a portrait. Through Linnell, Blake later (1824) met Samuel Palmer (then aged nineteen), who more than any other was the inheritor of something of Blake's vision. Palmer was the moving spirit of a group of young painters of his own generation known as the Shoreham Ancients, so named because Samuel Palmer and his father lived at Shoreham, and because

they were in total revolt against the aesthetics of 'the moderns' of their day, desiring, like Blake himself, a return to the 'Everlasting Gospel' of art, the Platonic and Plotinian philosophy of ideal form and ideal beauty. George Richmond, later to become a fashionable portrait-painter, Edward Calvert (born in 1799 and the oldest member of the group), supreme among engravers, F. O. Finch, a watercolour-painter, and the Tatham brothers, painter and architect, met weekly to discuss their work, and frequented Shoreham, Palmer's 'valley of vision', where Blake himself was a guest on at least one occasion. Linnell was a little older than these young enthusiasts (and not strictly one of the Shoreham group), but had early befriended Palmer, who later became his son-in-law.

Another group of new friends of an older generation were John Varley, a landscape-painter, and the watercolourists Richter and Holmes. These forerunners and founders of the new English watercolour school Blake used to meet frequently at John Varley's house in Titchfield Street, within easy walking distance of South Molton Street. From them he learned (so his biographer Gilchrist thinks) 'to add greater fullness and depth of colour to his drawings'. Linnell had been Varley's pupil and it was he, presumably, who introduced Varley to Blake, soon after his meeting with him, in 1818.

At last, in Varley, Blake had a friend who did not consider his visions 'mad'. Varley was an astrologer, and apparently a highly professional and successful one. Sceptical Gilchrist admits that his predictions were astonishingly accurate. He was evidently also a student of other esoteric subjects, and it was under his encouragement and in his company that Blake was encouraged to draw (in a light-hearted spirit, as it seems) those *128* strange 'spirit heads', authentic sketches of some of his spiritual visitants. One is again reminded of Swedenborg, who conversed with spirits of the departed almost as an everyday matter. These drawings – less imaginatively inspired, be it said, than Blake's more serious work – have a more-than-lifelike quality which bears witness, at least, to his astonishing power of visual

128 *The Man who taught Blake Painting* Spirit head drawn for John Varley, *c.* 1819–20

fantasy. These heads illustrate his own assertion that 'He who does not imagine in stronger and better lineaments, and in stronger and better light than his perishing and mortal eye can see, does not imagine at all. The painter of this work asserts that all his imaginations appear to him infinitely more perfect and more minutely organized than any thing seen by his mortal eye. Spirits are organized men.'

The forms these beings take often seems to derive from Blake's Gothic studies; many of the drawings are of kings and queens: Wallace and Edward the First, and other historical personages, vividly characterized. The ghost of a flea is one *129–30* horribly memorable bloodthirsty demon. Linnell made a copy of Blake's drawing of this monster (and other of Blake's 'visions') for *Zodiacal Physiognomy*, as a type of the sign of Gemini. Alan Cunningham remembered how Varley (who probably believed in Blake's visions in a more literal sense than did Blake himself) described the conception of that 'naked figure with a strong body and a short neck – with burning eyes

129 Drawing for *The Ghost of a Flea*, 1819

which long for moisture, and a face worthy of a murderer, holding a bloody cup in its clawed hands, out of which it seems eager to drink. I never saw any shape so strange, nor did I ever see any colouring so curiously splendid – a kind of glistening green and dusky gold, beautifully varnished. "But what in the world is it?" "It is a ghost, sir, – the ghost of a flea – a spiritualization of the thing!" "He saw this in a vision then," I said. "I'll tell you all about it, sir. I called on him one evening, and found Blake more than usually excited. He told me he had seen a wonderful thing – the ghost of a flea! 'And did you make a drawing of him?' I inquired. 'No, indeed,' said he, 'I wish I had, but I shall, if he appears again!' He looked earnestly into a corner of the room, and said, 'there he is – reach me my things – I shall keep my eye on him. There he comes! his eager tongue whisking out of his mouth, a cup in his hand to hold blood and covered with a scaly skin of gold and green;' – as he described him so he drew him."'

Whatever the explanation of this faculty, it was part of the make-up of Blake's genius. Yet such visualizations seem not to have come from his supreme world of imagination, 'Eden', but from some intermediate realm, Yeats' *Hodos chameleontos*, peopled by shifting forms and images. These spirit heads have

178

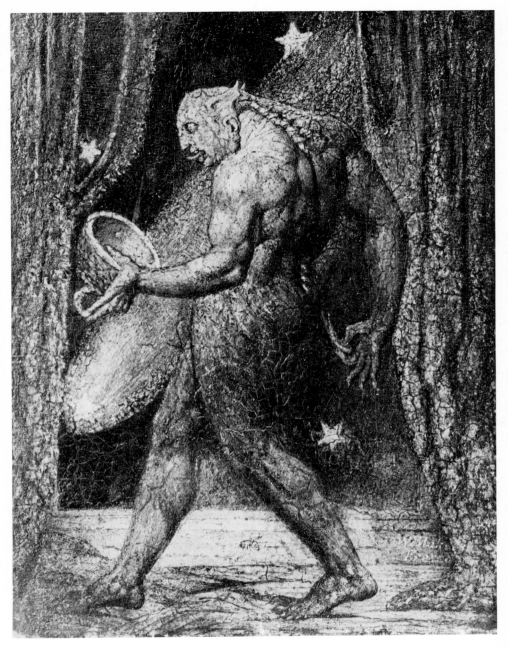

130 *The Ghost of a Flea, c. 1819–20*

in an exaggerated degree a characteristic we find in all Blake's depictions: the 'stronger and better lineaments' of spiritual individuality. Sometimes, accustomed as we are to the reticences of the fleshly veil (altogether absent in Blake's faces and forms), the impact of this unveiled purity of character and expression is like a shock. There is none among the historical or Biblical personages whom he depicted whose face and form alike are not expressive, in this total sense, of the character proper to them.

Blake's interest in human character and human types is most clearly expressed in his *Canterbury Pilgrims* (see p. 170) and in the essay he wrote on it for his *Descriptive Catalogue*. Here his view of character has some affinity with the theory of astrology, which is a science concerned with the description and classification of types:

'The characters of Chaucer's Pilgrims are the characters which compose all ages and nations: as one age falls, another rises, different to mortal sight, but to immortals only the same; for we see the same characters repeated again and again, in animals, vegetables, minerals, and in men; nothing new occurs in identical existence; Accident ever varies, Substance can never suffer change nor decay.'

As with that other spiritualist poet Yeats (who had read all Balzac and in *A Vision* described with extraordinary insight human types in terms of his twenty-eight 'phases of the moon'), characterization is a strong and unexpected element in Blake's work as an artist. His poetry, by contrast, seems to relate purely to an archetypal world, in which 'character' has no place.

As often happens when there is some inner transformation or development, outer circumstances also changed. In this happier phase of his life Blake moved (in 1821) from South Molton Street to No. 3 Fountain Court, off the Strand, a house belonging to a brother-in-law. It was a 'quiet court' when Blake lived there, with a glimpse of the Thames. It seemed a squalid place to Crabb Robinson:

'He was at work, engraving, in a small bedroom – light, and

131, 132 Illustrations for
Thornton's *Virgil*, 1820.
The uncut versions

looking out on a mean yard – everything in the room squalid
and indicating poverty, except himself. . . . There was but one
chair in the room, besides that on which he sat. On my putting
my hand to it, I found that it would have fallen to pieces if I
had lifted it. So, as if I had been a Sybarite, I said, with a smile,
"Will you let me indulge myself?" and sat on the bed near him.
During my short stay there was nothing in him that betrayed
that he was aware of what to other persons might have been
even offensive – not in his person, but in all about him.'

Even Crabb Robinson seems to have sensed the special
atmosphere of the 'House of the Interpreter', as the Shoreham
Ancients called that poor room (the reference is to Bunyan's
Pilgrim's Progress). Samuel Palmer used to kiss the threshold
when he visited him. Palmer recalls Blake as 'one of the very
few who cannot be depressed by neglect, and to whose name
rank and station could add no lustre. Moving apart, in a sphere
above the attraction of worldly honours, he did not accept
greatness but confer it. He ennobled poverty, and by his
conversation and the influence of his genius, made two small

rooms in Fountain Court more attractive than the threshold of princes.'

Most seminal of Blake's works, for his young disciples, was the series of seventeen woodcuts illustrating a school edition of the *Pastorals* of Virgil, edited by Dr Thornton. (Thornton was a physician and noted botanist, author of several elegantly illustrated quartos and folios on the Linnaean system of plant-classification. He was also a friend of Varley's, at whose house Blake probably met him.) These were Blake's only woodcuts. 'The rough, unconventional work of a mere prentice hand at wood-engraving' (according to Gilchrist), they have the energy and invention of great art, and recall Blake's lifelong love of Albrecht Dürer, whose *Melancholia* (inspiration likewise of Milton's *Il Penseroso*) was always beside his work-table.

2, 12, 131–3

Thornton's publishers ridiculed Blake's work. 'This man must do no more,' was their verdict, and the blocks were given to be re-cut by one of their regular hands. For once Blake had natural friends to thank that these lovely works were not altogether and forever ruined. At a dinner-party, Thornton met several artists – Thomas Lawrence, James Ward, Linnell and others – who all expressed their admiration for Blake's work in general and the woodcuts in particular. The Doctor restored the designs with a defensive apology: 'The illustrations of this English Pastoral are by the famous BLAKE, the illustrator of Young's *Night Thoughts*, and Blair's *Grave*; who designed and engraved them himself. This is mentioned as they display less art than genius, and are much admired by some eminent painters.'

The publishers had already cut down sixteen of Blake's seventeen blocks to fit their pages; providentially in eight instances proofs remain of the unmutilated and beautiful

133 Illustration for Thornton's *Virgil*, 1820

134 Drawing for
Thornton's *Virgil*, 1820

originals. In these images of the Earthly Paradise are there perhaps glimpses of Shoreham as well as memories of Felpham? For Blake had visited Palmer there, and stayed in his house. These works were the inspiration of Calvert and Palmer, who both surpassed Blake in technique though not in conception.

Samuel Palmer, in 1824, recorded in his notebook that intense and new delight Blake's woodcuts had brought to the Shoreham circle:

'I sat down with Mr Blake's Thornton's *Virgil* woodcuts before me, thinking to give to their merits my feeble testimony. I happened first to think of their sentiment. They are visions of little dells, and nooks, and corners of Paradise; models of the exquisitest pitch of intense poetry. I thought of their light and shade, and looking upon them I found no word to describe it. Intense depth, solemnity, and vivid brilliancy only coldly and partially describe them. There is in all such a mystic and dreamy glimmer as penetrates and kindles the inmost soul, and gives complete and unreserved delight, unlike the gaudy daylight of this world. They are like all that wonderful artist's works the drawing aside of the fleshly curtain, and the glimpse which all the most holy, studious saints and sages have enjoyed, of that rest which remaineth to the people of God.'

> *Calvert and Wilson, Blake and Claude*
> *Prepared a rest for the people of God,*
> *Palmer's phrase, but after that*
> *Confusion fell upon our thought.*

So Yeats links the names of the Shoreham Ancients with that of Claude, whom Blake himself had taught them to admire.

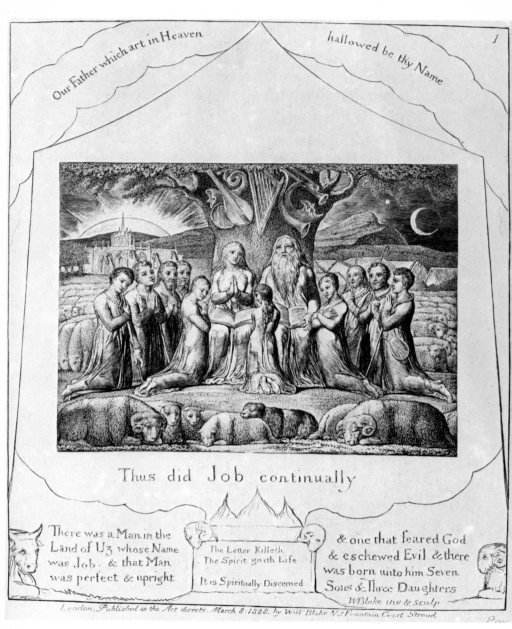

135 *The Book of Job*, 1825. Plate 1: 'Thus did Job continually'

King and Priest in his own Household

The commission for the twenty-two *Illustrations of the Book of Job* came from Linnell, in 1821, when Blake was sixty-five. Linnell had seen the series of watercolour drawings Blake had made for Butts, and he commissioned a second series for himself. He paid Blake £5 per plate which enabled him to work on the engravings. These illustrations, and the later, unfinished, *Dante* series, are Blake's enduring master-works; as familiar to us as Bach's *B-minor Mass* or Shakespeare's *King Lear*, and equal in conception to these, or to any of those Florentine paintings he so ardently admired. They are supreme masterpieces of the engraver's art. The clean strokes create skies brilliant as with Northern Lights; the very aspect of God has been given that majestical whirlwind form, which prompted Robert Frost's Eve to exclaim:

It's God.
I'd know him from Blake's picture anywhere.

Had not Blake's patron Hayley been a foolish egoist, and his friend Flaxman content to 'help' Blake by passing on hack-work, might we not have had other works as great from a spirit whose like is so seldom in 'the world of generation'? It is sad to reflect that as Samuel Palmer's father-in-law, Linnell was as insensitive to the younger man's genius as Hayley and Flaxman had been to Blake's.

The engraving of the plates for the reduced drawings made by Blake for Linnell occupied three years. The surrounding decorations are sketchily indicated in only two or three of the drawings, and were evidently conceived in terms of the engraved designs. In them Blake frequently reverts to the Gothic style of *Songs of Innocence and Experience*, and

incorporates lettering into the designs with a mastery born of his lifelong practice of combining text and design.

Blake's *Illustrations of the Book of Job* are more than an illustration of the Bible; they are in themselves a prophetic vision, a spiritual revelation, at once a personal testimony and replete with Blake's knowledge of Christian Cabbala, Neoplatonism, and the mystical theology of the Western Esoteric tradition as a whole. They are a complete statement of Blake's vision of man's spiritual drama. The true God is the 'God within', enthroned in every human soul; the 'divine humanity' whose lineaments are those of Job himself. 'Satan, the Selfhood' is permitted to tempt Job. It is this Selfhood who makes havoc of Job's world; and as Satan assumes power, so the interior vision darkens and the 'God within' falls into the 'deadly sleep' of spiritual amnesia (Plate 5). Satan's supreme deception (Blake had given expression to this realization in *Milton*) is his claim to be God; a god external to the soul, framer of the moral law based upon the natural order of 'one law for the lion and ox'. Job's three friends are clearly based upon his own Zoas: Tharmas (the sensual man), Luvah (the man of feeling), and Urizen (the reasoner). The beautiful figure of Elihu, who, in
139 Plate 12, ushering the first light of dawn among the fading stars, causes Job to look up in hope, is evidently Los, the poetic imagination, who 'kept the divine vision in time of trouble'.

142 In Plate 20 the sorrows through which Job, enslaved by his own ego, has passed, vanish like a dream. Blake had himself passed through long years of darkness, and knew the truth: 'for tho' on Earth things seem Permanent, they are less permanent than a Shadow, as we all know too well'. The glorious nature-poetry of the Hebrew poem is expressed no less in those 'men seen afar', the Stars of the Morning, than in the splendid theriomorphic forms of Behemoth and Leviathan
141 (Plate 15), greatest of all Blake's exultant depictions of 'evil, or energy' in serpent-form, whose 'life delights in life'.

The series begins and ends with a symbolic expression of Blake's belief that Christianity is 'the liberty both of body &

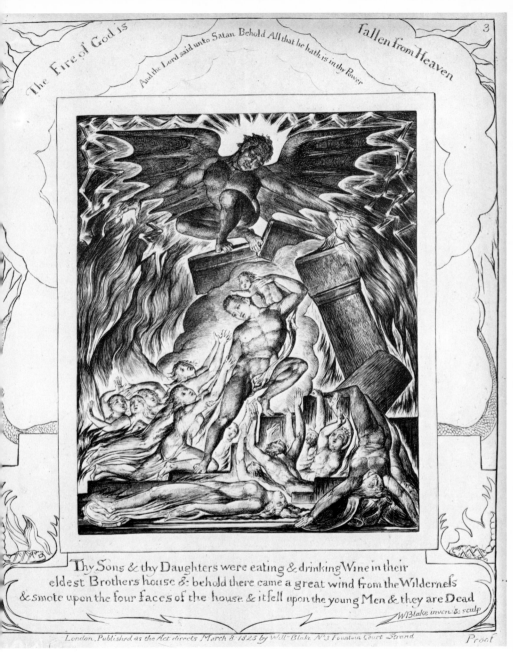

The Fire of God is **fallen from Heaven**

And the Lord said unto Satan Behold All that he hath is in thy Power

3

Thy Sons & thy Daughters were eating & drinking Wine in their eldest Brothers house & behold there came a great wind from the Wilderness & smote upon the four faces of the house & it fell upon the young Men & they are Dead

WBlake inven: & sculp

London. Published as the Act directs March 8 1825 by Will Blake N 3 Fountain Court Strand

Proof

136 *The Book of Job*, 1825. Plate 3: 'The Fire of God is fallen from Heaven'

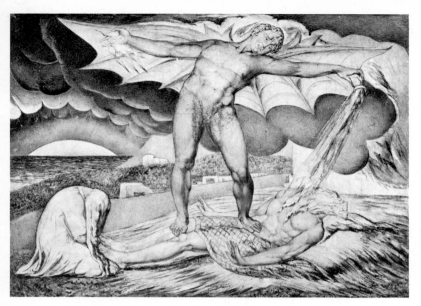

137 *Satan smiting Job with sore Boils, c. 1826–7*

mind to exercise the Divine Arts of Imagination, Imagination the real & eternal World of which this Vegetable Universe is but a faint shadow. . . . Let every Christian, as much as in him lies, engage himself openly & publicly before all the World in some Mental pursuit for the Building up of Jerusalem.' In the first plate, Job and all his family are 'worshipping God' under the Tree of Life, on which hang their musical instruments, as untouched as on a Calvinist Sabbath. In the last plate, each has taken his instrument, and all are playing and singing with that joyful and tireless industry in things of spirit which for Blake was the essence of Christianity. All bear their part in making the music of Heaven.

As in *A Vision of the Last Judgment*, many of the *Job* engravings are formalized in the manner of spiritual diagrams. One world opens from another: those 'four worlds', or regions of consciousness, of Blake's own symbolic thought, derived from the Jewish esoteric tradition of the Cabbala, and the similar fourfold cosmology of Neoplatonism.

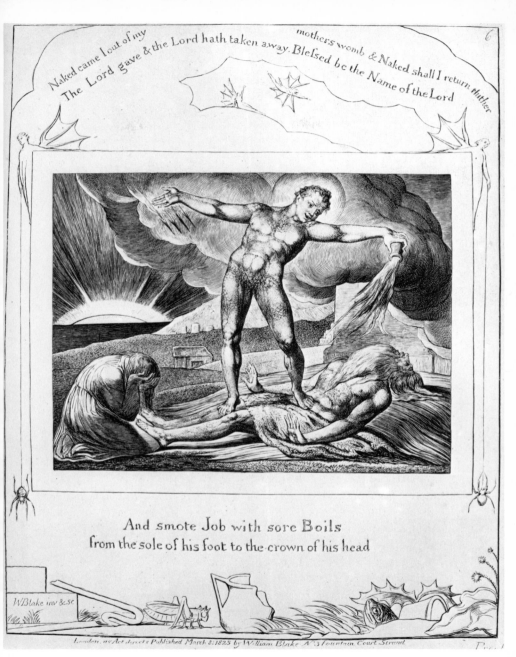

138 *The Book of Job*, 1825. Plate 6: 'And smote Job with sore Boils'

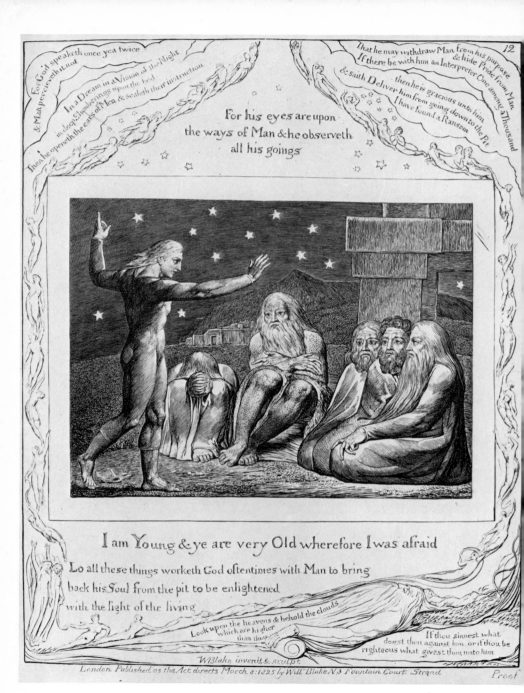

139 *The Book of Job*, 1825. Plate 12: 'I am Young and ye are very Old'

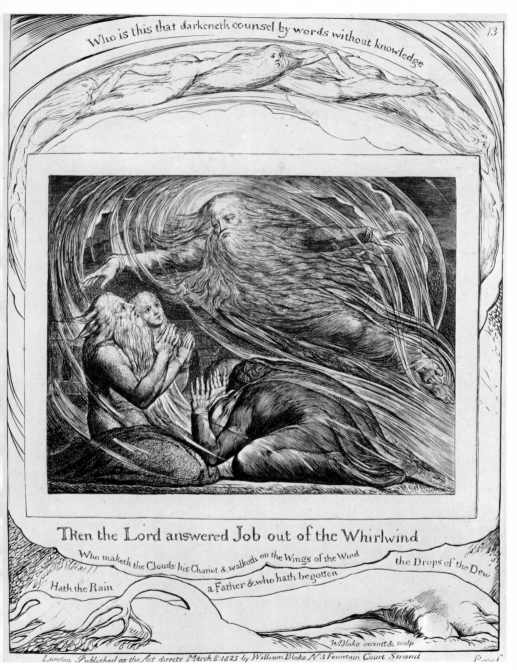

140 *The Book of Job*, 1825. Plate 13: 'Then the Lord answered Job out of the Whirlwind'

The two preliminary sets of watercolour drawings are scarcely less beautiful than the finished work. The engravings are the greater work, for they unite with grandeur of conception the consummate craftsmanship which was the fruit of Blake's years of practice in the engraver's art. When he had completed the set, he added to each during the actual process of engraving a border reminiscent of his illuminated books, in which text and decoration are harmoniously combined. Angels and devils, insects and tendrils surround the designs, as though Blake was reluctant to relinquish each deeply considered and lovingly executed plate.

The *Job* series won Ruskin's admiration: 'It is of the highest rank in certain characters of imagination and expression; in the mode of obtaining certain effects of light. . . . In expressing conditions of glaring and flickering light, Blake is greater than Rembrandt.'

One would like to know why, and for whom, Blake, in 1821, painted his fine illustration of a Neoplatonic mythological 1, 119 treatise – Porphyry's *De Antro Nympharum* – which he had read with delight (in Thomas Taylor's translation) years before, and whose influence is evident in the Lambeth Books. The Arlington Court tempera is scarcely in Thomas Butts' vein; and after about 1810 Butts bought fewer pictures – no doubt his house was already filled from floor to ceiling. It is likely, too (as Darrell Figgis suggested), that Blake at this time, his pride wounded by the failure of so many projects begun in hope, would not have been easy to approach. When it was discovered some years ago at Arlington Court in Devonshire the painting still bore the label of the picture-framer, Linnell's father, but this does not necessarily mean that it had belonged to either of the Linnells.

One would like to think it was painted for George Cumberland, friend both of Blake and Thomas Taylor, the translator of Porphyry. There is no evidence that this is so, though its discovery in the West Country supports the idea, since Cumberland lived in Bristol.

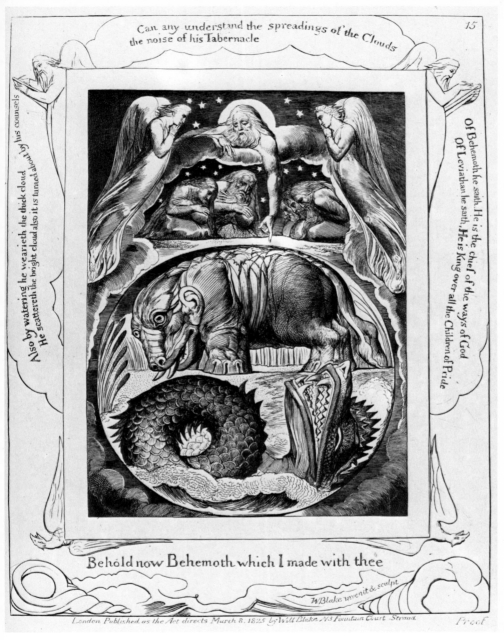

141 *The Book of Job*, 1825. Plate 15: 'Behold now Behemoth'

The work is a fine example of Blake's late style. As in the *Job* series, there is the suggestion of an interpenetration of worlds or modes of consciousness. Porphyry interprets the Homeric 'cave of the nymphs', scene of Odysseus' return to Ithaca, as sacred to the mysteries of generation. The incarnating souls 'descend' from a radiant world, and on the looms of the nymphs are woven into earthly bodies. The principal figures in the painting are Odysseus and the goddess Athene, the divine wisdom: a figure not unlike the Dante series Blake painted soon afterwards. The sleeping figure in the sun-chariot suggests the drowsy 'God within' of *Job* 5; the Platonic 'cave' of generation in which the nymphs with urns on their heads are standing suggests the 'cave' of *Job* 2 and 14. In both cases the 'cave' symbolizes, as for Plato, this world.

It seems likely that the tempera was painted shortly before the *Job* series. It also looks forward to the last series of designs Blake was to create, before his tireless industry and delight in his work diminished as his body failed him: the illustrations to Dante. He was at work on these literally on his death-bed. He made over one hundred drawings – many of them mere sketches – and seven engravings, possibly none of them completed, but none the less among his greatest works. 'What you call finished is not even begun,' he had exclaimed to Moser, defender of the 'high finish' of 'paltry blots and blurs'. So, conversely, we see in Blake's beginnings the great conceptions of the 'divine originals' of his imagination.

It was Linnell who, after the completion of the *Job* series, proposed to Blake a series of Dante illustrations. Palmer recalls a visit he paid, with Linnell, on 9 October 1824: 'We found him lame in bed, of a scalded foot (or leg). There, not inactive, though sixty-seven years old, but hard-working on a bed covered with books sat he up like one of the Antique patriarchs, or a dying Michael Angelo. Thus and there was he making in the leaves of a great book (folio) the sublimest designs for his (not superior) Dante. . . . He designed them (100 I think) during a fortnight's illness in bed.'

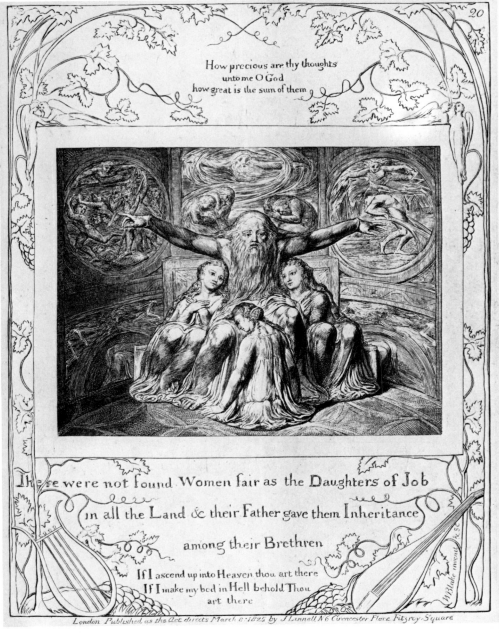

142 *The Book of Job*, 1825. Plate 20: 'Daughters of Job'

Blake set to work to learn Italian in order to read Dante in the original, using Cary's translation as a crib. He was a naturally gifted linguist, reading French fairly well, and Latin, Greek and Hebrew a little.

Like Milton, Dante was, for Blake, a friend and peer in 'great eternity' in whom he nevertheless (as with Milton) found many grave faults. 'Dante saw devils where I saw none,' he told Crabb Robinson. He saw in Dante 'a mere politician and atheist, busied about this world's affairs. . . . Yet he afterwards spoke of Dante being then with God.' The tempera of *143* Dante's head painted for Hayley's library shows, on one side, a fetter; on the other, a glimpse of Ugolino and his sons in *34* prison – a theme Blake had illustrated in *The Marriage of Heaven and Hell*. The caption reads: 'Does thy God, Oh priest, take such vengeance as this?' Geoffrey Keynes possesses another *144* (later) tempera version of this work, in which angels of mercy look down upon the scene of suffering. Milton, Blake criticized for his Puritanical sexual morality; Dante, for his cruelty. Both were worshippers of the moral god, Urizen. His depiction of Hell Gate makes it clear that Blake understood Dante's Hell to be this world, where Satan-Urizen is censed by a worshipping iron-crowned ecclesiastic who kneels before him.

> *Though thou art worshipped by the names divine*
> *Of Jesus and Jehovah, thou art still*
> *The Son of Morn in weary night's decline*
> *The Lost Traveller's dream under the hill.*

It is likely that 'the hill' of these familiar lines is Dante's Mountain of Purgatory, with the hells under it.

Blake's criticisms of Dante are by no means directed against the Catholic faith; on the contrary, the vengeful morality which appalled him in Dante is that of the rational Deism of his own England, against which he waged a lifelong mental fight. Gilchrist reluctantly admitted the admiration Blake in his later years evidently felt, not only for Gothic art, or certain

143 *Dante's Head*, one of a series of heads of poets painted to decorate
Hayley's library at Felpham, 1800–3

144 *Ugolino with his sons and grandsons in Prison*, 1827

145 *Devils fighting.* Plate 12, *Divine Comedy*, 1824–7

Catholic mystics (especially St Teresa of Avila), but for the Catholic religion:

'If it *must* be told, that he did not go to church, it should also be told that he was no scoffer at sacred mysteries; and, although thus isolated from the communion of the faithful, ever professed his preference of the Church to any sort of sectarianism. On one occasion he expressed the uneasiness he should have felt (had he been a parent) at a child of his dying unbaptized. One day, rather in an opposing mood, I think, he declared that the Romish Church was the only one which taught forgiveness of sins.'

'Forgiveness of sins' was the cornerstone of Christianity, as understood by Blake; this conception is to be found throughout

198

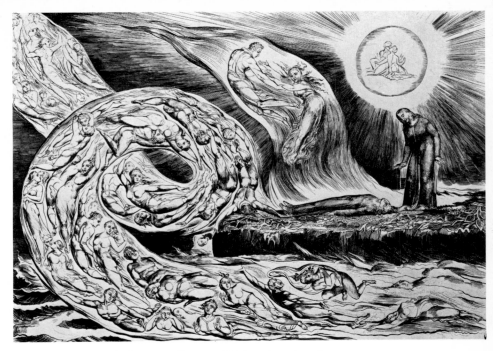

146 *The Whirlwind of Lovers.* Plate 10, *Divine Comedy*, 1824–7

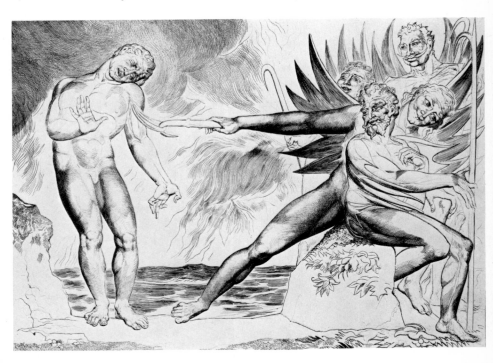

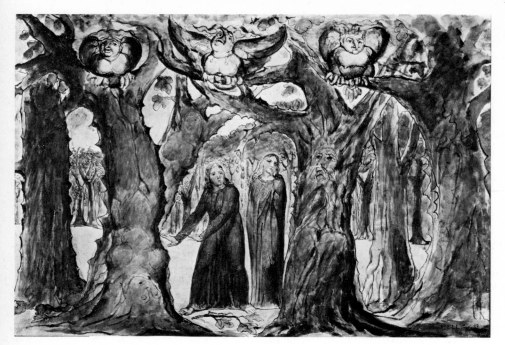

148 *The Wood of Self Murderers. Divine Comedy*, 1824–7

his work from first to last; and it is the central theme of his *Everlasting Gospel*, written in about 1818.

Dante's hells are the states of souls under the tyranny of the unforgiving 'God of this World', 'The Accuser': 'these States Exist now. Man Passes on, but States remain for Ever; he passes thro' them like a traveller who may as well suppose that the places he has passed thro' exist no more, as a Man may suppose that the states he has pass'd thro' Exist no more.' In this, though in no other sense, Hell is eternal.

Albert S. Roe in his commentary on the Dante plates interprets the work in this sense; as with Milton's works, as with the *Book of Job*, Blake does not merely illustrate, but raises the conception of his original into a new world of meaning.

200

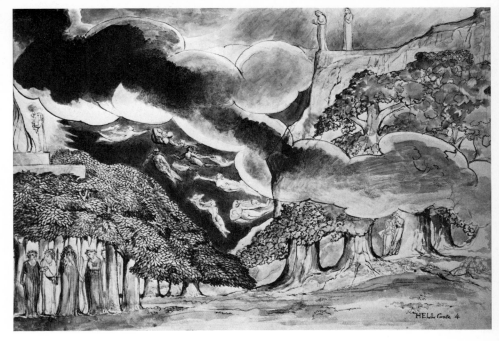

149 *Homer and the Ancient Poets. Divine Comedy*, 1824–7

Dante is the Traveller who explores the 'States'; progressing, as all Mental Travellers must, from the cave or grave of the hells of this world (where spiritual journeys begin) through the circles of purgatory (in which suffering is rendered tolerable by a realization that it is not without use in the purification of souls), to the world of spiritual light. In Blake's terms, he traverses 'the circle of Destiny', which embraces every possible human experience.

Distinguish therefore States from Individuals in these States.
States change, but Individual Identities never change nor cease,
You cannot go to Eternal Death in that which can never Die.

And Blake adds: 'The imagination is not a State: it is the Human existence itself.'

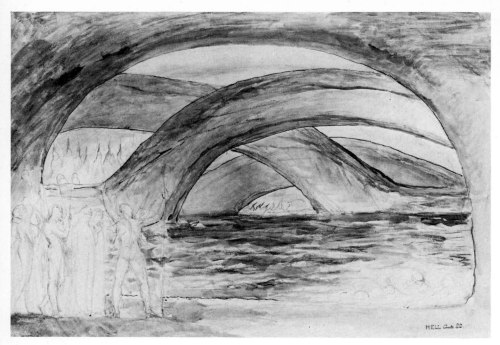

150 *Devils with Dante and Virgil, by the side of the Pool. Divine Comedy,* 1824–7

151 *The Primaeval Giants sunk in the Soil. Divine Comedy,* 1824–7

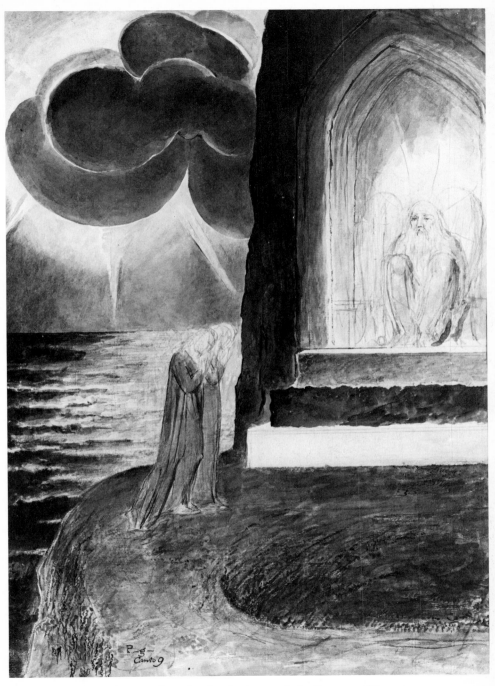

152 *Dante and Virgil approaching the Angel who guards the Entrance of Purgatory.*
Divine Comedy, 1824–7

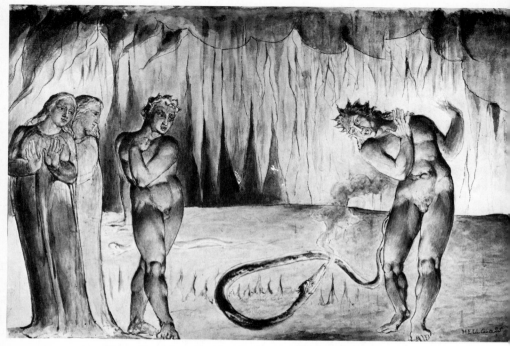

153 *Buoso Donati attacked by the Serpent. Divine Comedy,* 1824–7

In about 1824, perhaps stimulated by the gatherings of the
Ancients, Blake made a series of watercolours illustrating
Bunyan's *Pilgrim's Progress.* Some of these may have been
finished by Mrs Blake after his death. His beautiful engraving
155 on pewter, *The Man sweeping the Interpreter's Parlour,* seems to
have been completed about the same time from a plate laid
aside many years before. In its finished state it is one of the
finest and most vigorous of Blake's prints.

Blake's *Last Judgment* is his own expression of the 'circle of
Destiny'; of the 'States' of the heavens and the hells and the
purgatories. The first version of this great theme was painted
in 1808 for the Countess of Egremont – a commission obtained
for Blake by Ozias Humphrey the miniaturist. Blake wrote
two descriptions of the picture: one for Ozias Humphrey to

204

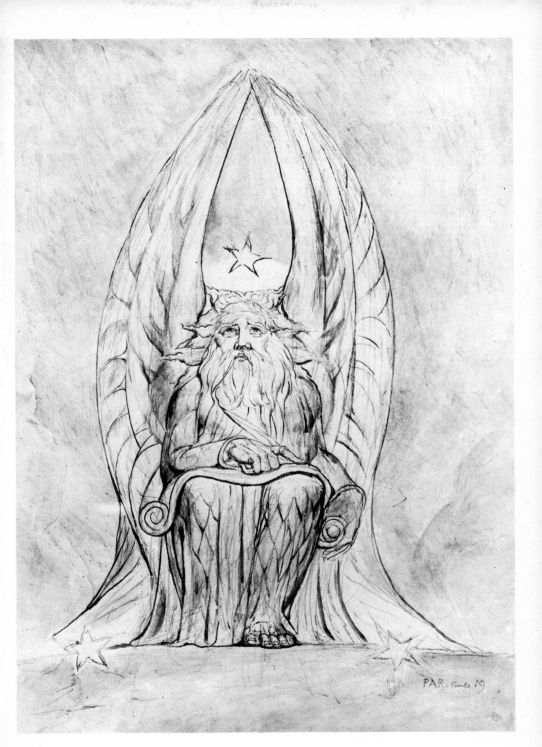

present to the Countess; another in his Notebook for the year 1810. He had long ago reached a realization beyond the Christian doctrine of an eternity of hell for the damned, and of bliss for the righteous; and indeed he criticized (in *Milton*) Swedenborg himself (whose conception of the Grand Man underlies Blake's vision of the universal collective human kingdom), because he was 'a Samson shorn by the churches', and subscribed to this barbaric doctrine.

He had reached the profounder perspectives of the Indian philosophies, of the Buddhist 'wheel', on which all states are illusory, good and evil alike:

'. . . I do not consider either the Just or the Wicked to be in a Supreme State, but to be every one of them States of the Sleep which the soul may fall into in its deadly dreams of Good & Evil when it leaves Paradise following the Serpent.'

Blake was working on his final version of *The Last Judgment*, the great fresco (now lost), during the period of his work on Dante. There is no question but that this work was a final attempt to give a complete expression to his vision of the human 'circle of Destiny', in its relation to the 'supreme state' wherein 'Around the Throne Heaven is open'd & Nature of Eternal Things Display'd All Springing from the Divine Humanity.'

155 *The Man sweeping the Interpreter's Parlour, c.* 1822

156 George Cumberland's visiting-card, 1827

During his last months, Blake was 'too much attached to Dante to think much of anything else'. His last completed work was a visiting card for Mr. Cumberland with joyous figures enacting the descent and return of souls, an abridged version of the Arlington Court tempera painting. His young friend Frederick Tatham had commissioned a coloured impression of *The Ancient of Days*, Blake's own singular favourite among all his works. Blake finished it to the utmost point of perfection, making it as beautiful in colour as already grand in design; patiently working on it till within a few days of his death. After he 'had frequently touched upon it, and had frequently held it at a distance, he threw it from him, and with an air of exulting triumph exclaimed, "There! That will do! I cannot mend it."'

54

As he said these words – so the story continues – 'his glance fell on his loving Kate, no longer young or beautiful, but who had lived with him in these and like humble rooms, in hourly companionship, ever ready helpfulness, and reverent sympathy, for now forty-five years. . . . "Stay!" he cried, "Keep as you are! *you* have ever been angel to me: I will draw you!" And a portrait was struck off by a hand which approaching death – few days distant now – had not weakened nor benumbed.' The last work to come from Blake's hand was this hasty pencil drawing (now lost) of the faithful companion of his life's hard journey. He died singing his own songs of praise and joy in the vision which illuminated his death, as it had sustained and inspired his life.

Chronology

1757 Born 28 November at 28 Broad Street, Golden Square, London.

1767 Sent to Pars' drawing school in the Strand. Robert Blake born.

1772 Began seven-year apprenticeship to James Basire; engraver, Great Queen Street, Lincoln's Inn Fields.

1782 Married Catherine Boucher 18 August; moved to 23 Green Street, Leicester Fields.

1783 *Poetical Sketches* published.

1784 Moved to 27 Broad Street, Golden Square.

1787 Robert Blake died, February, aged nineteen. Moved to 28 Poland Street.

1788 Plates of *There is No Natural Religion* and of *All Religions are One* etched.

1789 *Songs of Innocence* and *The Book of Thel* completed.

1790 *The Marriage of Heaven and Hell* begun.

1791 Moved to 13 Hercules Buildings, Lambeth. The first part of *The French Revolution* printed by Johnson, book-keeper of St Paul's Churchyard; never published.

1793 Completed *For Children, The Gates of Paradise, The Marriage of Heaven and Hell, Visions of the Daughters of Albion, America: A Prophecy.*

1794 Completed *Songs of Innocence and of Experience, The First Book of Urizen, Europe: A Prophecy.*

1795 Completed *The Song of Los, The Book of Ahania, The Book of Los.*

1796 *Vala, or The Four Zoas* begun. Designs for Young's *Night Thoughts* begun.

1797 Engravings for Young's *Night Thoughts* published.

1799 Introduced by John Flaxman to William Hayley.

1800 Moved, September, to Felpham, near Bognor, Sussex, under the patronage of Hayley. *Little Tom the Sailor* published.

1802 Hayley's *Ballads* with Blake's engravings published. .

1803 Quarrel with Trooper Scofield of the Royal Dragoons, in August. Returned to London, September, to live at 17 South Molton Street.

1804 Trial for sedition 11 January at Chichester Assizes. Acquitted. The plates for *Milton* and *Jerusalem* begun.

1805 Blair's *Grave* published with Blake's designs engraved by Schiavonetti.

1808 *Milton* completed.

1809 *The Canterbury Pilgrims.* Exhibition of pictures at 28 Broad Street; with *A Descriptive Catalogue.*

1818 *Jerusalem* completed. *For the Sexes: The Gates of Paradise* published. Laocoön plate engraved.

1821 Moved to 3 Fountain Court, Strand. Wood engravings for Thornton's *Pastorals of Virgil.*

1825 Engravings for *Illustrations of the Book of Job* published. Designs for Dante's *Inferno* begun.

1827 Seven plates for Dante's *Inferno* engraved. Died at Fountain Court, 12 August. Buried in Bunhill Fields.

Select Bibliography

BLAKE'S WORKS

The Complete Writings of William Blake, ed. G. Keynes (1966). New York, Oxford University Press (1966). Now the standard edition.

The Note Book of William Blake called The Rossetti Manuscript, ed. G. Keynes (1935). With a Facsimile of the Note Book (1935) – the contents of this sketch book and commonplace book, used by Blake, 1793–1818, are included in the Nonesuch editions, 1925 and 1927.

The Letters of William Blake, ed. G. Keynes (1956). Revised edition, 1968. This collection contains letters to Blake and other valuable material.

William Blake. Being all his woodcuts photographically reproduced in Facsimile. Introduction by L. Binyon (1902).

The Drawings and Engravings of William Blake. Introductory Text by L. Binyon. Edited by G. Holme (1922).

William Blake's Designs for Gray's Poems. Reproduced full size in Monochrome or Colour from the unique copy belonging to His Grace the Duke of Hamilton. Introduction by H.J.C. Grierson (1922).

Illustrations to Young's 'Night Thoughts'. Done in Water Colour by William Blake. Thirty pages reproduced from the Original Water Colours in the Library of W. White. Introductory essay by G. Keynes; Cambridge, Mass. (1927).

Pencil Drawings, ed. G. Keynes (1927).

Illustrations of The Book of Job. Being All the Water Colour Designs, Pencil Drawings and Engravings reproduced in Facsimile. Introduction by L. Binyon and G. Keynes; New York (1935).

Illustrations of The Book of Job. Reproduced in Facsimile from the Original 'New Zealand' Set made about 1823–4. Note by P. Hofer; New York (1937).

Blake. Reproductions of paintings. Introductions and Notes by G. Keynes (1945).

Blake's Illustrations to 'The Divine Comedy', by A.S. Roe; Princeton (1954).

Blake's Pencil Drawings (Second Series), ed. G. Keynes (1956).

William Blake's Illustrations to The Bible, ed. G. Keynes (1957).

Blake's Grave: A Prophetic Book. Being William Blake's Illustrations for Robert Blair's *The Grave*, arranged as Blake directed. With a commentary by F.S. Damon; Providence, Rhode Island (1953).

Vala, or The Four Zoas, ed. G.E. Bentley, Jr; Oxford (1963). New York, Oxford University Press (1963). A facsimile edition.

William Blake, by M. Butlin (1966). Thirty-two plates, some in colour, of paintings in the Tate Gallery.

Bibliography of William Blake. Reprint, New York, Kraus (1968).

Note: The Blake Trust has produced facsimiles of the following Illuminated Books: *Jerusalem*, *Songs of Innocence*, *Songs of Innocence and Experience*, *The Book of Urizen*, *Visions of the Daughters of Albion*, *The Marriage of Heaven and Hell*, *America: a Prophecy*, *The Gates of Paradise*, *The Book of Thel*, *Milton*, and *Europe: a Prophecy*.

OTHER WORKS

The Painting of William Blake, by D. Figgis (1925).

The Engraved Designs of William Blake, by L. Binyon (1926). New York, Da Capo (1926).

Blake's Illustrations to 'The Divine Comedy', by A.S. Roe; Princeton (1954).

A Study of the Illuminated Books of William Blake, Poet, Printer and Prophet, by G. Keynes (1965).

The Life of William Blake, by A. Gilchrist, 2 vols (1863). Revised edition. The best edition of this classic biography is that edited by Ruthven Todd in Everyman's Library.

The Life of William Blake, by M. Wilson (1927). Revised edition with additional notes, 1948. The standard biography, originally published by the Nonesuch Press.

A Man without a Mask: William Blake, 1757–1827, by J. Bronowski (1944). A Marxist view of Blake.

Blake and Rossetti, by K. Preston (1944).

William Blake: The Politics of Vision, by M. Schorer; New York (1946).

Tracks in the Snow. Studies in English Science and Art, by R. Todd (1946). Contains an interesting study of Blake, and other original material on his contemporaries.

Fearful Symmetry. A Study of William Blake by N. Frye; Princeton (1947). An unreliable but inspiring critical study.

Blake Studies. Notes on his Life and Works, by G. Keynes (1949). Contains a bibliography of writings by G. Keynes on Blake.

English Blake, by B. Blackstone (1949). Hamden, Conn., Shoe String (1949).

William Blake, by H.M. Margoliouth (1951). Hamden, Conn., Shoe String (1951).

William Blake's 'Jerusalem', ed. J.H. Wicksted (1953). A commentary on the facsimile published by the William Blake Trust.

Blake – Prophet against Empire, by D.V. Erdman (1954). Princeton U. Press (1954). Blake's political thoughts admirably discussed.

The Art of William Blake, by A. Blunt; Columbia (1960). Original material on visual sources.

Hidden Riches, by D. Hirst (1964). Original material on the Swedenborgian and Cabalistic sources of Blake's symbolism.

William Blake and the Age of Revolution, by J. Bronowski; New York (1965).

William Blake: an Introduction to the Man and to his Work, by R. Lister (1968). Presents Blake as a worthy craftsman.

Blake and Tradition, by K. Raine, 2 vols; New York (1968), London (1969). Andrew Mellon Lectures, 1962.

Blake Records, G.E. Bentley, Jr. 1969. A complete source-book of all references to Blake in contemporary sources; written in narrative form.

'The Meredith Family, Thomas Taylor and William Blake', by James King, *Studies in Romanticism* Vol XI Number 2, Spring 1972.

List of Illustrations

Dimensions are in inches and centimetres

Hell c. 1790–3. Plate 24 (detail): Nebuchadnezzar. Whole plate $5\frac{4}{5} \times 3\frac{9}{10}$ (14·8 × 10)

33 *The Marriage of Heaven and Hell* 1790–3. Title-page. Plate 6 × 4 (15·2 × 10·2)

34 *The Marriage of Heaven and Hell c.* 1790–3. Plate 16 (detail): Ugolino and his sons in prison. Whole plate $6\frac{1}{2} \times 4$ (16·5 × 10·2)

35 *Songs of Experience* 1789–94. Frontispiece. Hand-printed book. Plate $4\frac{3}{8} \times 2\frac{3}{4}$ (11 × 7). British Museum

36 *For Children: The Gates of Paradise* 1793. Plate 11: Aged Ignorance. Engraving $2\frac{1}{4} \times 2\frac{1}{8}$ (5·7 × 5·4). British Museum

37 *Songs of Experience* 1789–94. Title-page. Hand-printed book. Plate $4\frac{7}{8} \times 2\frac{13}{16}$ (12·3 × 7·2)

38 *Songs of Experience* 1789–94. Plate 39: The Sick Rose. Hand-printed book. Plate $4\frac{13}{32} \times 2\frac{5}{8}$ (11·2 × 6·7). British Museum

39 *Songs of Experience* 1789–94. Plate 46: London. Hand-printed book. Plate $4\frac{3}{8} \times 2\frac{5}{8}$ (11·3 × 6·8). British Museum

40 *Songs of Experience* 1789–94. Plate 42: The Tyger. $4\frac{3}{8} \times 2\frac{7}{16}$ (11·1 × 6·2). British Museum

41 *For Children: The Gates of Paradise* 1793. Plate 2: Water. Engraving $2\frac{11}{16} \times 2\frac{1}{2}$ (6·5 × 6·3). British Museum

42 *For Children: The Gates of Paradise* 1793. Plate 3: Earth. Engraving $2\frac{5}{8} \times 2\frac{1}{2}$ (6·65 × 6·35). British Museum

43 *For Children: The Gates of Paradise* 1793. Plate 4: Air. Engraving $2\frac{5}{8} \times 2\frac{5}{8}$ (6·65 × 6·05). British Museum

44 *For Children: The Gates of Paradise* 1793. Plate 5: Fire. Engraving $3\frac{1}{4} \times 2\frac{5}{8}$ (8·25 × 6·65). British Museum

45 *For Children: The Gates of Paradise* 1793. Plate 16. Engraving $2\frac{1}{10} \times 1\frac{4}{5}$ (5·4 × 4·5)

46 *Visions of the Daughters of Albion* 1793. Title-page. $14\frac{3}{8} \times 10\frac{1}{8}$ (36·5 × 26)

47 *Visions of the Daughters of Albion* 1793. Frontispiece. $14\frac{3}{8} \times 10\frac{1}{8}$ (36·5 × 26)

48 *America: A Prophecy* 1793. Plate 10. 9 × $6\frac{1}{2}$ (22·9 × 16·6)

49 *America: A Prophecy* 1793. Plate 1. $8\frac{4}{5} \times 6\frac{1}{5}$ (22·3 × 15·7)

50 *America: A Prophecy* 1793. Plate 2. $7\frac{9}{10} \times 6\frac{2}{5}$ (19·6 × 16·3)

51 *Europe* 1794. Page 9: Mildew blighting ears of corn. 9 × $6\frac{2}{5}$ (22·9 × 16·3). British Museum

52 *America: A Prophecy* 1793. Cancelled plate: A Dream of Thiralatha. $6\frac{7}{8} \times 9\frac{1}{4}$ (17·3 × 23·5)

53 *Europe* 1794. Plate 10. $9\frac{3}{10} \times 6\frac{7}{10}$ (23·7 × 17·1)

54 *The Ancient of Days* 1794. Watercolour, black ink and gold paint, over a relief etched outline painted in yellow $9\frac{1}{4} \times 6\frac{5}{8}$ (23·5 × 17). Whitworth Art Gallery, University of Manchester

55 *The Book of Urizen* 1794. Plate 7: $11\frac{3}{8} \times 9\frac{1}{4}$ (29 × 23·5)

56 *The Book of Urizen* 1794. Title-page. $11\frac{3}{8} \times 9\frac{1}{4}$ (29 × 23·5). British Museum

57 *The Book of Urizen* 1794. Plate 6: $11\frac{11}{32} \times 9\frac{1}{4}$ (28·8 × 23·5). British Museum

58 *Death of Ezekiel's Wife* 1794.

Line engraving 14 × $18\frac{7}{8}$ (35·5 × 48·1). British Museum

59 *Vala* manuscript 1795–1804. Page 26. $16\frac{3}{8} \times 12\frac{7}{8}$ (41·6 × 32·7)

60 *God creating Adam* 1795. Colour print, watercolour 17 × $21\frac{1}{8}$ (43·2 × 53·8). Tate Gallery, London

61 *Newton* 1795. Colour print, watercolour $18\frac{1}{8} \times 23\frac{5}{8}$ (46 × 60·1). Tate Gallery, London

62 *Nebuchadnezzar* 1795. Colour print, watercolour $17\frac{5}{8} \times 24\frac{3}{8}$ (44·8 × 63). Tate Gallery, London

63 *Hecate c.* 1795. Colour print, watercolour $17\frac{1}{4} \times 22\frac{7}{8}$ (43·7 × 58). Tate Gallery, London

64 *The House of Death c.* 1795. Colour print, watercolour $12\frac{1}{2} \times 17\frac{3}{4}$ (31·6 × 45). Tate Gallery, London

65 *Pity c.* 1795. Colour print, watercolour $16\frac{3}{4} \times 21\frac{1}{4}$ (42·5 × 53·9). Tate Gallery, London

66 *God judging Adam* 1795. Colour print, watercolour 17 × $21\frac{1}{8}$ (43·2 × 53·8). Tate Gallery, London

67 *Good and Evil Angels* 1795. Colour print, watercolour $18\frac{1}{8} \times 23\frac{5}{8}$ (46 × 60·1). Tate Gallery, London

68 *The Marriage of Heaven and Hell c.* 1790–3. Page 4 (detail). Whole plate 14 × $10\frac{7}{16}$ (38 × 26·5)

69 Drawing for *Glad Day* 1780. Pencil 8 × $11\frac{1}{4}$ (20·4 × 28·5). Victoria and Albert Museum, London

70 *Joseph of Arimathea preaching to the Inhabitants of Britain* 1794. Relief etching, coloured

$3\frac{1}{32} \times 4\frac{3}{16}$ (7·7 × 10·7). British Museum

71 Vitruvian Man, from Cornelius Agrippa's *Three Books of Occult Philosophy*, page 268, 1651

72 *Glad Day* c. 1794. Colour print worked up with brush $10\frac{3}{4} \times 7\frac{7}{8}$ (27·3 × 20). British Museum

73 Young's *Night Thoughts* 1797. Title-page of 'Night the First'. Engraving. British Museum

74 Illustration to Gray's *Poems*. Early 1790s. Plate 5: 'A Pindaric Ode' $16\frac{1}{2} \times 12\frac{1}{2}$ (42 × 31·8). Courtesy Paul Mellon Collection

75 *Vala* manuscript 1795–1804. Page 7. $16\frac{1}{2} \times 12\frac{1}{2}$ (40·8 × 31·7)

76 Illustration to Gray's *Poems*. Early 1790s. Plate 3: 'Ode on the Death of a Favourite Cat'. $16\frac{1}{2} \times 12\frac{1}{2}$ (40 × 31·8). Courtesy Paul Mellon Collection

77 Illustration to Gray's *Poems*. Early 1790s. Plate 10: 'On a Distant Prospect of Eton College'. $16\frac{1}{2} \times 12\frac{1}{2}$ (40 × 31·8). Courtesy Paul Mellon Collection

78 *The Procession from Calvary* c. 1799–1800. Tempera on canvas $10\frac{1}{2} \times 14\frac{7}{8}$ (26·6 × 37·7). Tate Gallery, London

79 *Soldiers casting Lots for Christ's Garments* 1800. Watercolour $16\frac{1}{2} \times 12\frac{1}{4}$ (42 × 31·1). Fitzwilliam Museum, Cambridge

80 *Jerusalem* 1804–20. Plate 25. $8\frac{1}{2} \times 6\frac{1}{4}$ (21·6 × 15·7). Kerrison Preston Collection

81 *Songs of Experience*. Plate 52: 'To Tirzah' c. 1801. $8\frac{1}{2} \times 5\frac{1}{8}$ (21·6 × 13)

82 *Satan, Sin and Death*. Illustration to *Paradise Lost* c. 1808. Book II, 645 ff. Watercolour $19\frac{1}{2} \times 15\frac{13}{16}$ (49·6 × 40·4) H. E. Huntington Library (USA)

83 *Famine* 1805. Pencil and watercolour $11\frac{5}{8} \times 15\frac{3}{8}$ (29·7 × 39·8). Museum of Fine Arts, Boston

84 *David delivered out of Many Waters*. Watercolour c. 1800–5. $16\frac{3}{8} \times 13\frac{5}{8}$ (41·6 × 34·7). Tate Gallery, London

85 *The Body of Abel found by Adam and Eve*. Tempera on wood c. 1826–7. $12\frac{3}{8} \times 15\frac{5}{8}$ (41·6 × 34·7). Tate Gallery, London

86 *Ezekiel's Vision*. Watercolour $15\frac{9}{16} \times 11\frac{5}{8}$ (39·5 × 29·7). Museum of Fine Arts, Boston

87 *The Wise and Foolish Virgins* c. 1826. Watercolour $15\frac{3}{4} \times 13\frac{1}{8}$ (39·9 × 33·2). Tate Gallery, London

88 *The Lord answers Job out of the Whirlwind* c. 1799. Watercolour $15\frac{1}{2} \times 13$ (39·4 × 33·1). National Gallery of Scotland, Edinburgh

89 *The Nativity* c. 1800. Tempera on copper $10\frac{1}{2} \times 14\frac{1}{2}$ (26·7 × 36·9). Collection Mrs William T. Tonner (USA)

90 *The Agony in the Garden* c. 1799–1800. Tempera on canvas $10\frac{5}{8} \times 15$ (27 × 38·1). Tate Gallery, London

91 *Michael binding Satan* c. 1805. Watercolour $14\frac{1}{4} \times 12\frac{13}{16}$ (32·8 × 26·2). Fogg Art Museum, Cambridge, Mass.

92 *The River of Life* c. 1800–5. Watercolour $12 \times 13\frac{1}{4}$ (30·5 × 33·8). Tate Gallery, London

93 *Jacob's Ladder* c. 1800. Water-colour $14\frac{3}{8} \times 11\frac{1}{2}$ (37 × 29·3) British Museum

94 *The Angel of the Divine Presence clothing Adam and Eve with Skins* 1803. Watercolour $15\frac{1}{32} \times 11\frac{1}{4}$ (38·2 × 28·4). Fitzwilliam Museum, Cambridge

95 *The Last Supper*. Tempera on canvas 12×9 (30·5 × 48·3). Rosenwald Collection, National Gallery, Washington

96 *The Last Judgment* 1808. Watercolour $19\frac{7}{8} \times 15\frac{3}{4}$ (50·6 × 40·1). H. M. Treasury and the National Trust (Egremont Collection, Petworth). *Photo* Courtesy of the National Gallery

97 *Raphael conversing with Adam and Eve*, from *Paradise Lost* 1808. Book V, 443–450. Watercolour $15\frac{9}{10} \times 9\frac{1}{2}$ (49·6 × 39·2). Museum of Fine Arts, Boston

98 Illustration for William Hayley's *Ballads* 1805. *The Horse*. Engraving $4\frac{1}{4} \times 2\frac{7}{8}$ (10·8 × 7·3). British Museum

99 Illustration for William Hayley's *Ballads* 1805. *The Eagle*. Engraving $5\frac{9}{16} \times 3\frac{7}{8}$ (14 × 9·85). British Museum

100 Illustration for William Hayley's *Ballads* 1805. Frontispiece: *The Dog*. Engraving $6\frac{1}{2} \times 5\frac{1}{2}$ (16·5 × 14). British Museum

101 *Milton* 1804–8. Plate 36 (*detail*). British Museum

102 *Songs of Experience* 1789–94. Page 3 of 'The Little Girl Found'. Plate $4\frac{2}{5} \times 2\frac{7}{10}$ (11·2 × 6·9)

103 Illustrations to William Cowper's poem 'The Task' c. 1802. *Winter*, Book IV, 120–129. *Evening*, Book IV,

243–260. Both tempera on panel $31\frac{3}{8} \times 11$ (79.6×28). Collection Rev. B. T. Vaughan Johnson. *Photos courtesy Sir Geoffrey Keynes*

104 *Comus with the Lady Spellbound* c. 1801. Watercolour $8\frac{3}{4} \times 7\frac{1}{16}$ (22.3×17.9). H. E. Huntington Library (USA)

105 *Milton* 1804–8. Plate 18. $6\frac{3}{5} \times 4\frac{1}{3}$ (16.9×11.9)

106 *Temptation and Fall* from *Paradise Lost* 1808. Pen and watercolour $19\frac{5}{8} \times 15\frac{1}{4}$ (49.8×38.7). Museum of Fine Arts, Boston

107 *Satan watching the endearments of Adam and Eve* from *Paradise Lost* 1808. Book IV, 366. Watercolour $15\frac{3}{10} \times 19\frac{1}{5}$ (38.9×49.6). Museum of Fine Arts, Boston

108 *Hymn on the Morning of Christ's Nativity* c. 1809. *Shepherds and the Choir of Angels.* $6\frac{1}{4} \times 5$ (15.7×12.7). H. E. Huntington Library (USA)

109 *The First Temptation*, from *Paradise Lost* c. 1807–8. Watercolour $6\frac{1}{2} \times 5\frac{1}{4}$ (16.5×13.3). Fitzwilliam Museum, Cambridge

110 *Christ's Ugly Dream*, from *Paradise Regained* c. 1807–8. Book IV, 401–425. Watercolour $6\frac{1}{2} \times 5\frac{1}{4}$ (16.5×13.3). Fitzwilliam Museum, Cambridge

111 *Jerusalem* 1804–20. Plate 18 (detail). $8\frac{3}{5} \times 6\frac{1}{5}$ (21.9×15.7)

112 *Jerusalem* 1804–20. Plate 53 (detail)

113 *Jerusalem* 1804–20. Title-page. $8\frac{7}{10} \times 6\frac{1}{5}$ (22.1×15.7)

114 *Jerusalem* 1804–20. Plate 62 (detail). Whole plate $8\frac{3}{5} \times 6\frac{3}{10}$

(21.9×16). British Museum

115 *Jerusalem* 1804–20. Plate 97. $8\frac{1}{10} \times 5\frac{3}{4}$ (20.6×14.6)

116 *Jerusalem* 1804–20. Plate 39. $8\frac{7}{10} \times 6\frac{1}{5}$ (22.1×15.7). From a facsimile in the British Museum

117 *Jerusalem* 1804–20. Plate 32. $8\frac{1}{2} \times 6\frac{1}{4}$ (21.6×15.7). Kerrison Preston Collection

118 *Jerusalem* 1804–20. Plate 99. $8\frac{9}{10} \times 6$ (22.6×15.2)

119 Illustration to Porphyry's *De Antro Nympharum* 1821. Tempera $16 \times 19\frac{1}{2}$ (40.7×49.6). The National Trust (Arlington Court, Devon)

120 *Illustrations to the Book of Job* c. 1821. Plate 14. Watercolour $15\frac{3}{4} \times 11\frac{13}{16}$ (40×30). From a facsimile edition of the copy in the Pierpont Morgan Library, N.Y.

121 *Jerusalem* 1804–20. Plate 76. $8\frac{4}{5} \times 6\frac{2}{5}$ (22.2×16.3)

122 Illustration to Blair's *The Grave* 1808. Design by Blake, etched by Schiavonetti. $5\frac{1}{2} \times 8\frac{7}{8}$ (13.9×22.7)

123 Illustration to Dante's *Divine Comedy* 1824–7. *Inscription over the Gate of Hell.* Watercolour $20\frac{3}{4} \times 14\frac{3}{4}$ (52.7×37.4). Tate Gallery, London

124 *The Canterbury Pilgrims* 1810. Engraving $12\frac{1}{4} \times 37\frac{5}{8}$ (31×95.5). British Museum

125 *The Spiritual Form of Nelson Guiding Leviathan, in whose wreathings are enfolded the Nations of the Earth.* Exhibited 1809. Tempera on canvas $30 \times 24\frac{5}{8}$ (76.2×62.7). Tate Gallery, London

126 *Laocoön* c. 1815. Drawing for an article in Rees' *Cyclopedia*

(published in 1820). $12\frac{5}{8} \times 9$ (32.1×22.9). Mr Henry J. Crocket (USA)

127 *Portrait of Blake* by John Linnell 1820. Pencil. Fitzwilliam Museum, Cambridge

128 *The Man who taught Blake Painting* c. 1819–20. Pencil $10\frac{1}{4} \times 8\frac{1}{8}$ (26.1×21). Tate Gallery, London

129 *The Ghost of a Flea* 1819. Pencil $7\frac{3}{8} \times 6$ (19×15.2). Tate Gallery, London

130 *The Ghost of a Flea* c. 1819–20. Tempera mixture on panel $8\frac{1}{2} \times 6\frac{1}{8}$ (21.6×15.5). Tate Gallery, London

131–3 Illustrations for Thornton's *Virgil.* Woodcuts $1\frac{1}{2} \times 3\frac{1}{2}$ (3.54×8.4). British Museum

134 Drawing for Thornton's *Virgil: Thenot.* Courtesy Sir Geoffrey Keynes

135 *The Book of Job* 1825. Plate 1. Engraving $8\frac{3}{4} \times 6\frac{11}{16}$ (22.3×17). British Museum

136 *The Book of Job* 1825. Plate 3. Engraving $8\frac{3}{4} \times 6\frac{11}{16}$ (22.3×17). British Museum

137 *Satan smiting Job with sore Boils* c. 1826–7. Tempera on wood $12\frac{7}{8} \times 17$ (32.7×43.2). Tate Gallery, London

138 *The Book of Job* 1825. Plate 6. Engraving $8\frac{3}{4} \times 6\frac{11}{16}$ (22.3×17). British Museum

139 *The Book of Job* 1825. Plate 12. Engraving $8\frac{3}{4} \times 6\frac{11}{16}$ (22.3×17). British Museum

140 *The Book of Job* 1825. Plate 13. Engraving $8\frac{3}{4} \times 6\frac{11}{16}$ (22.3×17). British Museum

141 *The Book of Job* 1825. Plate 15. Engraving $8\frac{3}{4} \times 6\frac{11}{16}$ (22.3×17). British Museum

142 *The Book of Job* 1825. Plate 20. Engraving $8\frac{3}{4} \times 6\frac{11}{16}$ ($22 \cdot 3 \times 17$). British Museum

143 *Dante's Head* 1800–3. Possibly tempera overpainted with oil. On canvas $16\frac{3}{4} \times 34\frac{1}{2}$ ($42 \cdot 4 \times 87 \cdot 5$). City Art Gallery, Manchester

144 *Ugolino with his sons and grandsons in Prison* 1827. Tempera on panel $12\frac{3}{4} \times 16\frac{1}{2}$ ($32 \cdot 3 \times 41 \cdot 9$). Courtesy Sir Geoffrey Keynes

145 *Devils Fighting.* Plate 12 to Dante's *Divine Comedy* 1824–7. Engraving $9\frac{1}{4} \times 13$ ($23 \cdot 5 \times 33$). British Museum

146 *The Whirlwind of Lovers.* Plate 10 to Dante's *Divine Comedy* 1824–7. Engraving $9\frac{1}{4} \times 13$ ($23 \cdot 5 \times 33$). British Museum

147 *Ciampolo tormented by Devils.* Plate 41 to Dante's *Divine Comedy* 1824–7. Engraving $9\frac{1}{4} \times 13$ ($23 \cdot 5 \times 33$). British Museum

148 *The Wood of Self Murderers.* Illustration to Dante's *Divine Comedy* 1824–7. Watercolour $14\frac{3}{8} \times 20\frac{3}{4}$ ($37 \cdot 3 \times 52 \cdot 6$). Tate Gallery, London

149 *Homer and The Ancient Poets.* Illustration to Dante's *Divine Comedy* 1824–7. Watercolour $14\frac{5}{8} \times 20\frac{3}{4}$ ($37 \cdot 2 \times 52 \cdot 7$). Tate Gallery, London

150 *Devils with Dante and Virgil by the side of the Pool.* Illustration to Dante's *Divine Comedy* 1824–7. Watercolour $14\frac{5}{8} \times 20\frac{3}{4}$ ($37 \cdot 2 \times 52 \cdot 7$). Tate Gallery, London

151 *The Primaeval Giants sunk in the Soil.* Illustration to Dante's *Divine Comedy* 1824–7. Watercolour $14\frac{5}{8} \times 20\frac{3}{4}$ ($37 \times 52 \cdot 6$). Tate Gallery, London

152 *Dante and Virgil approaching the Angel who guards the Entrance of Purgatory.* Illustration to Dante's *Divine Comedy* 1824–7. Watercolour $20\frac{3}{4} \times 14\frac{5}{8}$ ($52 \cdot 7 \times 37 \cdot 1$). Tate Gallery, London

153 *Buoso Donati attacked by the Serpent.* Illustration to Dante's *Divine Comedy* 1824–7. Watercolour $15\frac{5}{8} \times 20\frac{3}{4}$ ($37 \times 52 \cdot 6$). Tate Gallery, London

154 *The Recording Angel of the Presence.* Illustration to Dante's *Divine Comedy* 1824–7. Birmingham City Museum and Art Gallery

155 *The Man sweeping the Interpreter's Parlour* c. 1822. Engraving $3\frac{1}{8} \times 6\frac{11}{32}$ (8×16). British Museum

156 *George Cumberland's visiting-card* 1827. Engraving $1\frac{3}{16} \times 3\frac{1}{8}$ ($3 \times 7 \cdot 9$). British Museum

Index

Illustration numbers are indicated by italic type

215